LINE OF FIRE

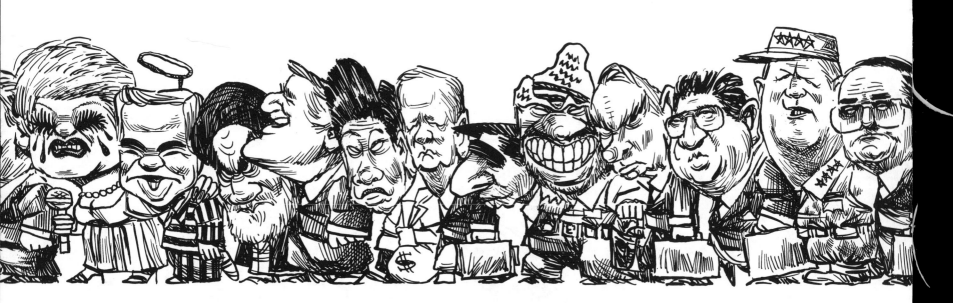

Foreword by Pat Oliphant

L I N E O F F I R E

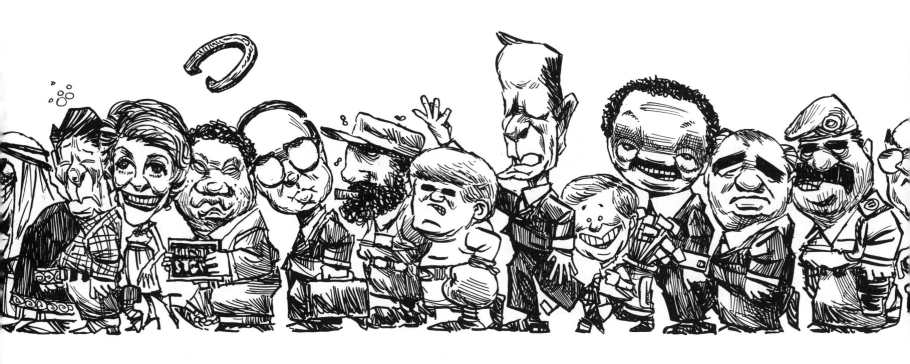

political cartoons by jim morin

Florida International University Press / Miami

Library of Congress Cataloging-in-Publication Data

Morin, Jim.
 Line of fire: political cartoons / by Jim Morin: foreword by Pat Oliphant.
 p. cm.
 ISBN 0-8130-1081-0 (cloth). — ISBN 0-8130-1101-9 (paper)
 1. United States—Politics and government—1989– —Caricatures and
cartoons. 2. United States—Politics and government—1981–1991—
Caricatures and cartoons. 3. American wit and humor, Pictorial.
 I. Title. II. Title: Political cartoons.
 E881.M67 1991
 320.973'0207—dc20 91-11522

Printed in the U.S.A. on acid-free paper ∞

The Florida International University Press is a member of University Presses of Florida, the scholarly publishing agency of the State University System of Florida. Books are selected for publication by faculty editorial committees at each of Florida's nine public universities: Florida A&M University (Tallahassee), Florida Atlantic University (Boca Raton), Florida International University (Miami), Florida State University (Tallahassee), University of Central Florida (Orlando), University of Florida (Gainesville), University of North Florida (Jacksonville), University of South Florida (Tampa), University of West Florida (Pensacola).

Orders for books published by all member presses should be addressed to University Presses of Florida, 15 NW 15th St., Gainesville, FL 32603.

Acknowledgments
Special thanks to *The Miami Herald*'s engraving department for their valuable assistance, and to professional print and broadcast journalists everywhere, whose pursuit and reporting of facts is essential to the process of forming and expressing opinion.

To Elizabeth and Spencer

CONTENTS

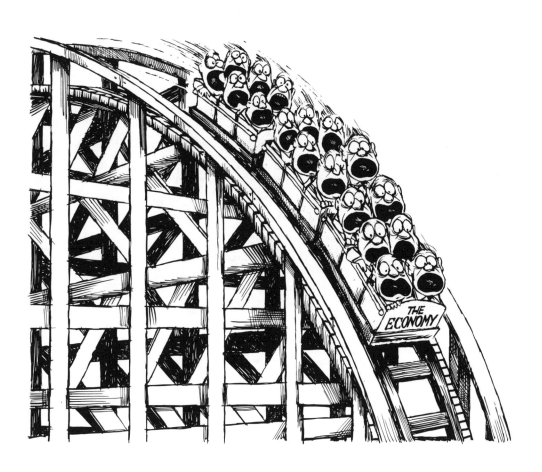

FOREWORD Pat Oliphant

A good number of less-than-positive observations could be made about political cartooning in this day and age, most of it having to do with practitioners of the art who have lost sight of their own vision (if, indeed, they had one to begin with), drawing derivatively to an editor's direction, as they pursue the easy gag of no particular persuasion or virtue, never convincing themselves or anybody else that they may have something of moment to say. It might be said that not many care to apply themselves to the development of their drawing, that having found some safe style that sells, and fearful that change will bring disapproval, these people will draw that same way for the rest of their careers, never venturing, never gaining. It could also be claimed that the grand art of caricature, that mystical distillate blend of character and circumstance, has been abandoned in favor of a casual, close-enough non-likeness rendering of the subject, accompanied by a big identifying label . . . the Hair-Eyebrows-Mustache & Label School.

Rejoice then, dear reader, to know you won't find any of these shortcomings in the work of Jim Morin. He has a clear idea how he feels about issues and he wants you to know about it. He then expresses himself clearly and concisely in a manner that is both exciting and explorative . . . obviously no editor messes with Morin. And as for caricature, look at his assaults on Michael Dukakis (October 19, 1988), or Oliver North (January 8, 1989), but two prime examples of a craftsman at work.

Jim Morin has all the attributes of a first-rate cartoonist, including a signature which is suitably illegible, a fine design and drafting sense, and a cunning eye for the unusual. They have all come together wonderfully in this book.

Apart from all that, Morin is a most pleasant person of amiable and charming wit which, of course, has nothing at all to do with being a good cartoonist. I hope he breaks a leg.

THE FINAL DAZE

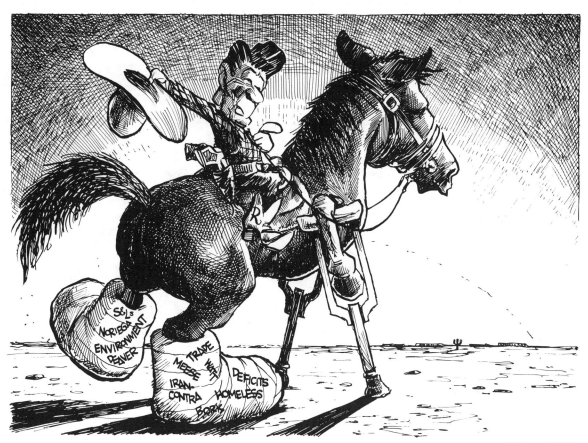

January 6, 1989

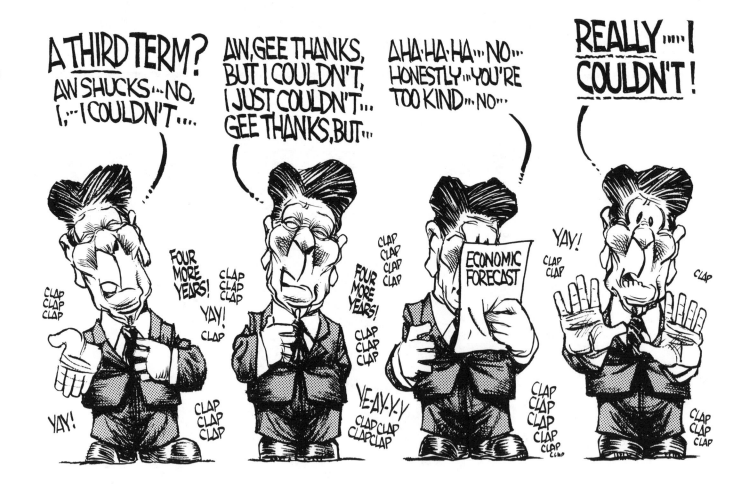

August 13, 1986

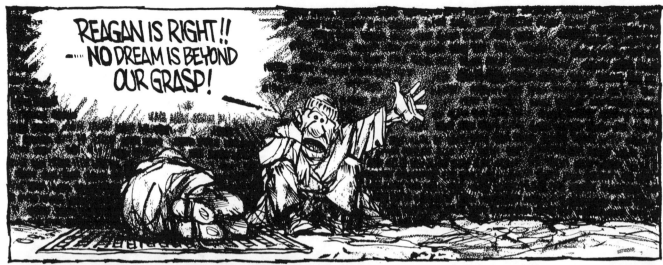

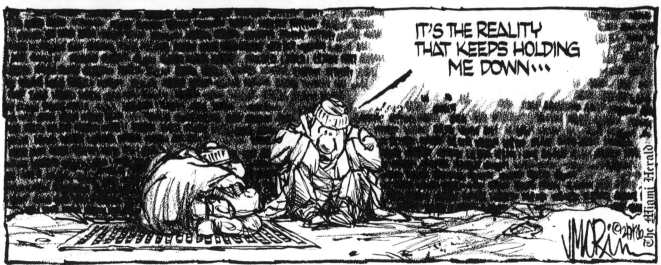

February 9, 1986

Under the Reagan administration, the rich got richer, the poor got poorer.

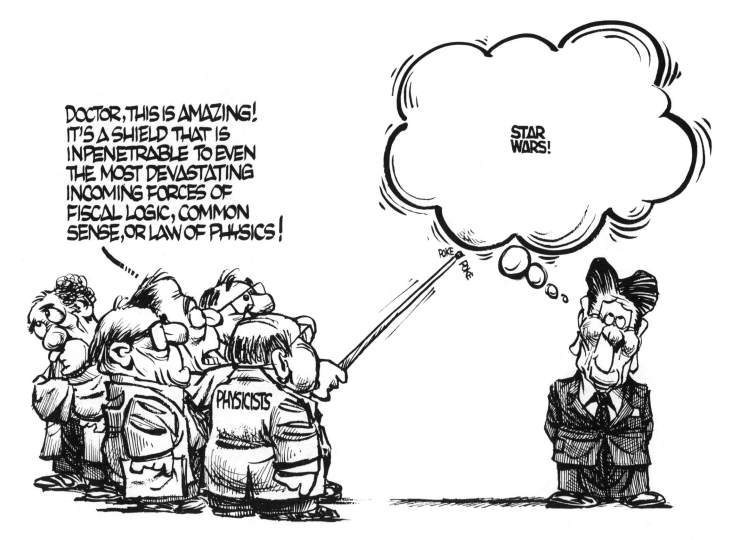

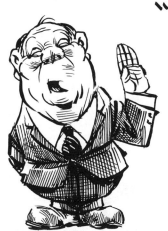

"... I DO SOLEMNLY SWEAR I WILL FAITHFULLY EXECUTE THE PUBLIC OFFICE I AM ABOUT TO HOLD ..."

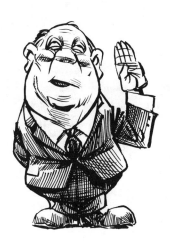

"... AND WILL, TO THE BEST OF MY ABILITY, PRESERVE, PROTECT, AND DEFEND THE CONSTITUTION OF THE UNITED STATES ..."

"... AS WELL AS THE LOBBYING FIRM I'LL BE STARTING IN A FEW YEARS REPRESENTING THE CONTACTS I'LL MAKE WHILE I'M EXECUTING THE OFFICE SO I CAN GO ON TO MAKE BIG BUCKS FOR ME AND MYSELF ..."

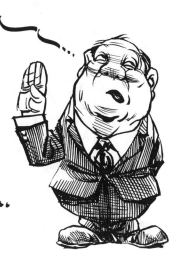

"SO HELP ME GOD ..."

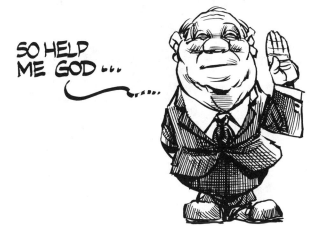

May 27, 1986

6

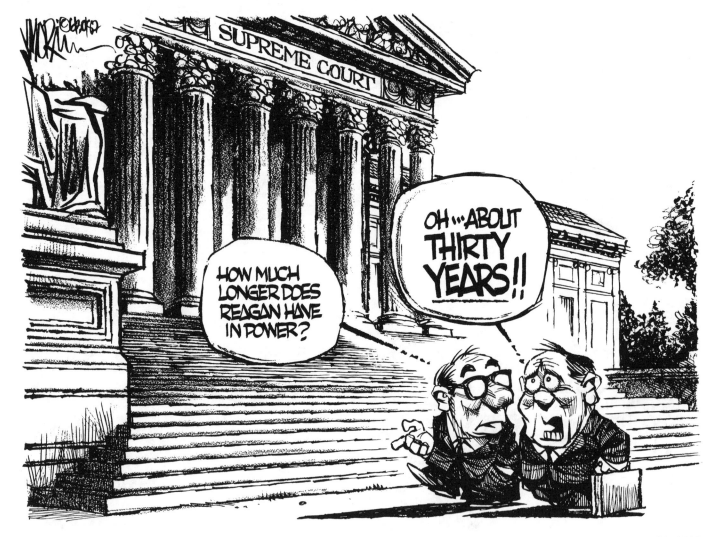

June 30, 1987

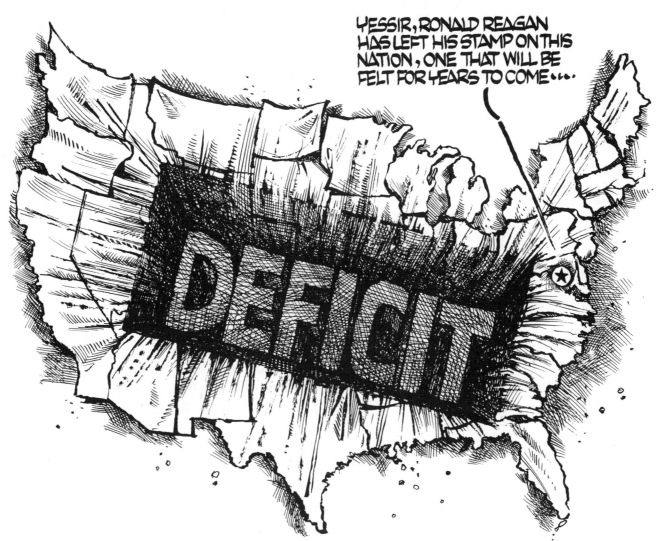

July 17, 1986

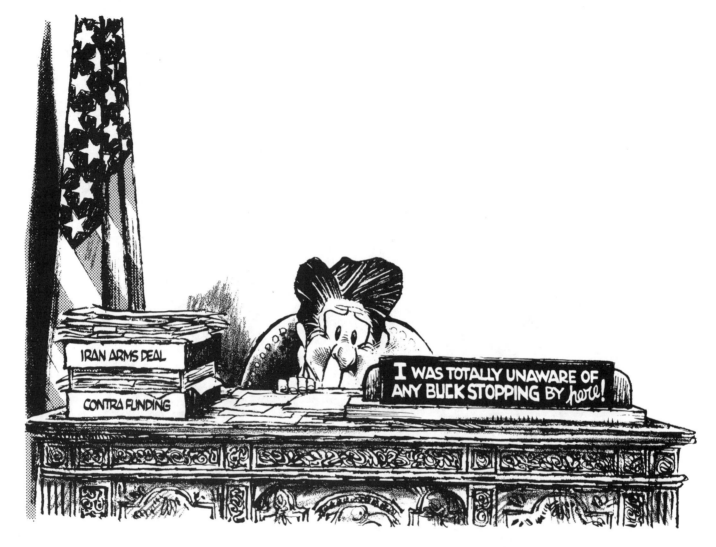

January 14, 1987

The Iran-Contra scandal unfolds.

1976~1980

NOW...

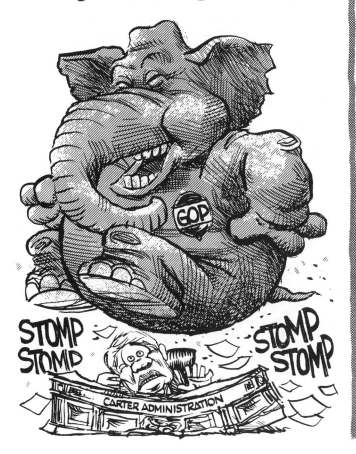

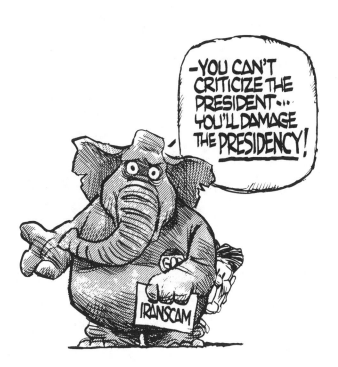

December 28, 1986

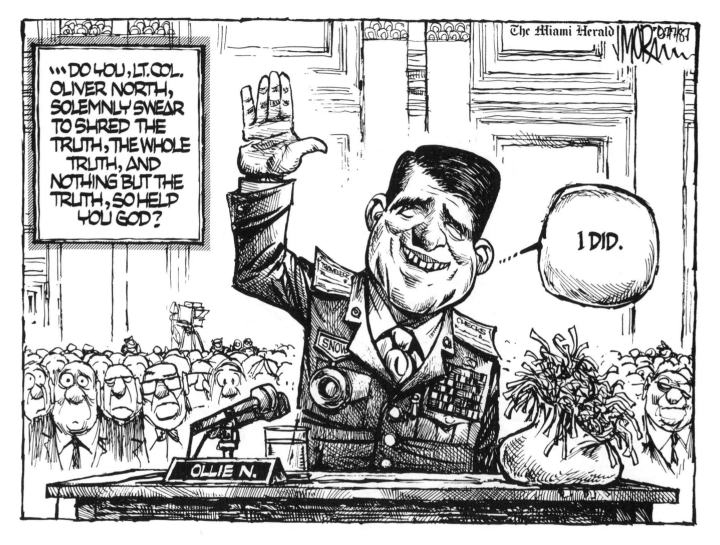

July 7, 1987

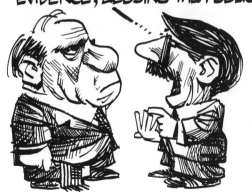

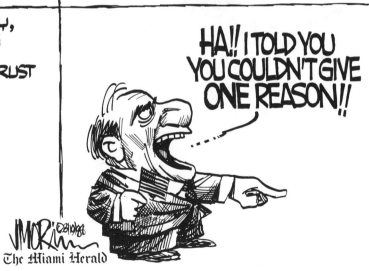

August 19, 1988

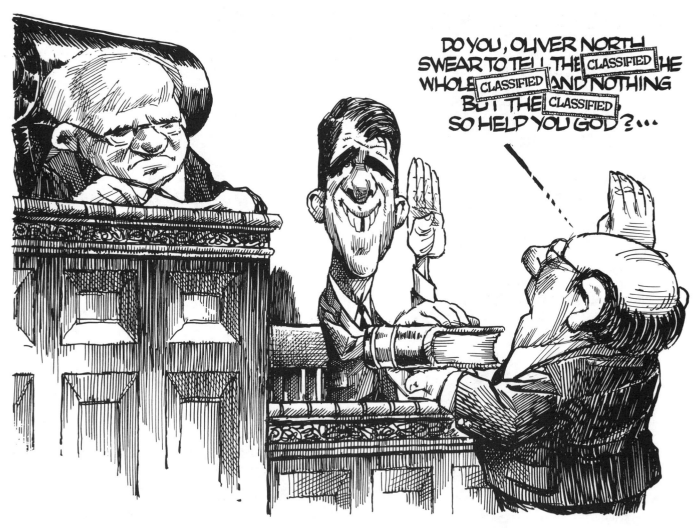

January 8, 1989

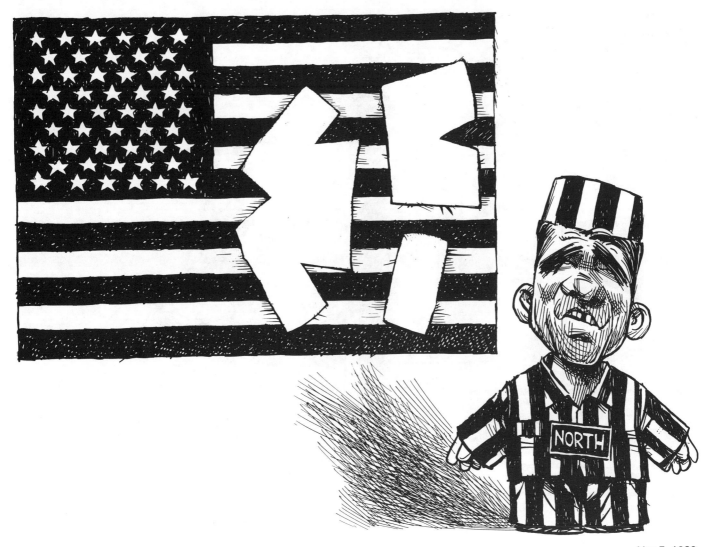

May 7, 1989

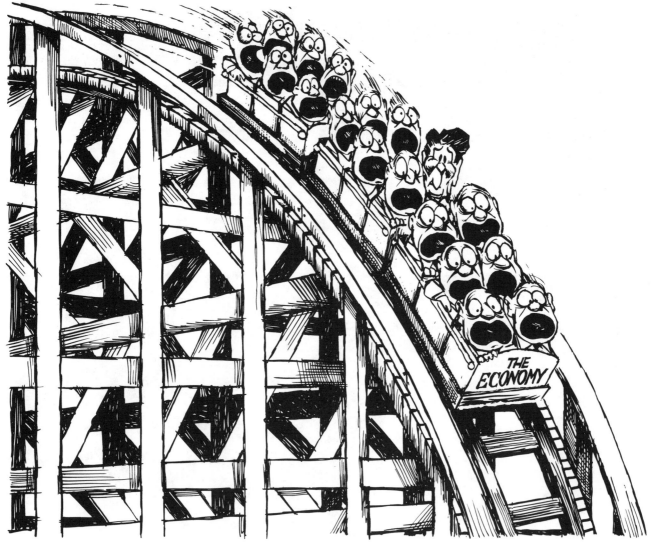

November 6, 1987

The Wall Street crash of 1987. The President is unconcerned.

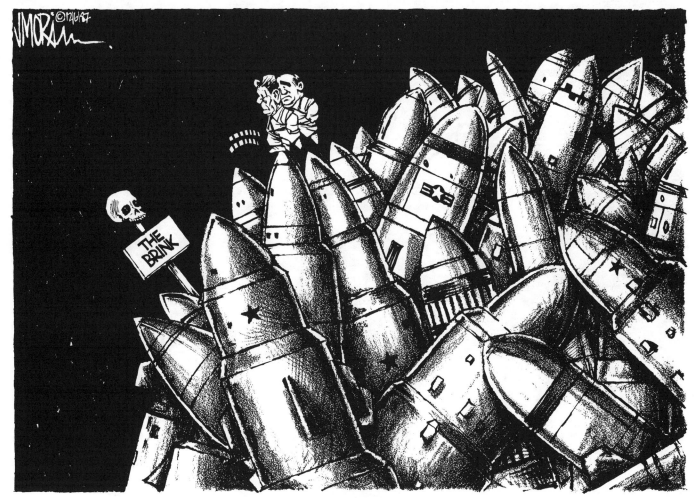

A STEP.

November 3, 1987

Reagan and Gorbachev sign the first U.S.-Soviet arms reduction treaty.

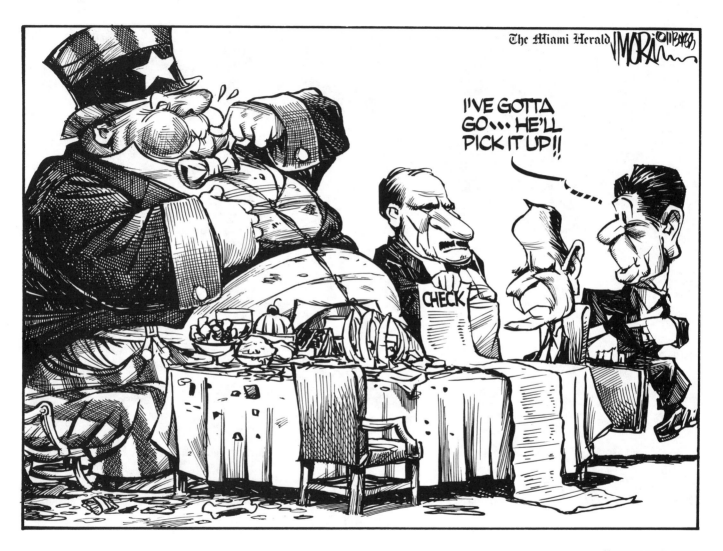

November 30, 1988

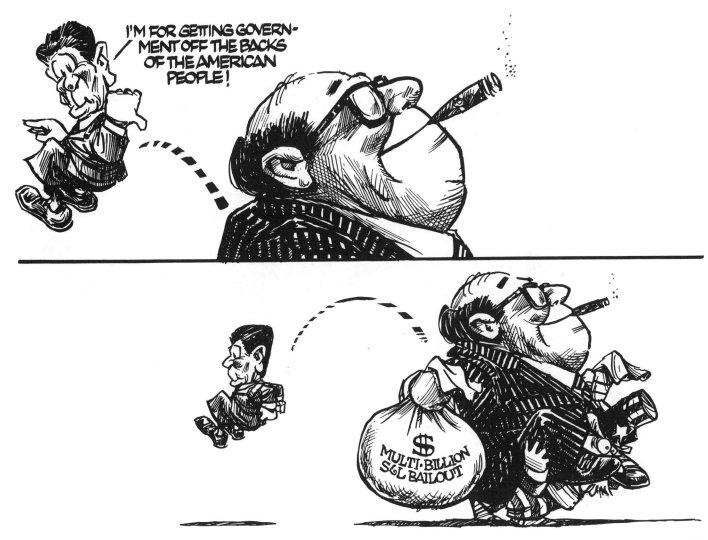

December 30, 1988

Congress and the Reagan administration deregulate the savings-and-loan industry, ultimately creating the greatest economic scandal in U.S. history.

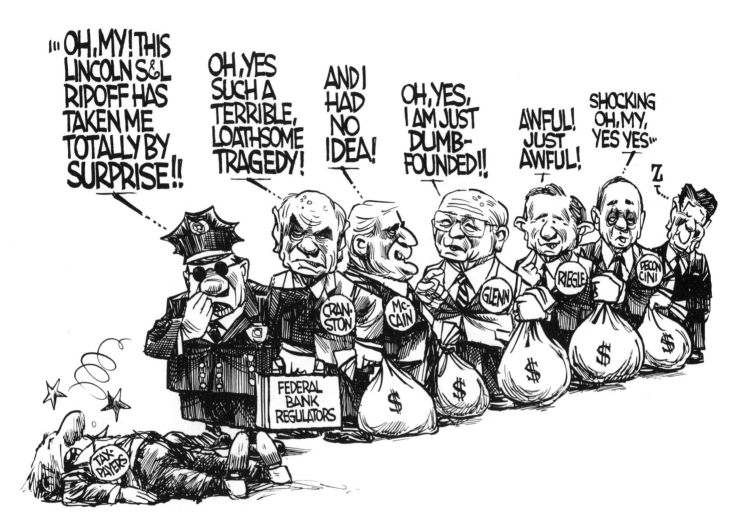

November 24, 1989

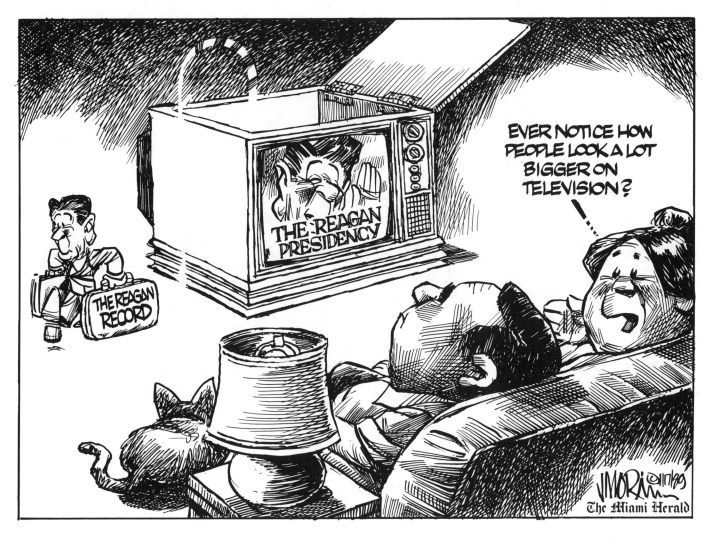

January 17, 1989

President Ronald Wilson Reagan leaves office . . .

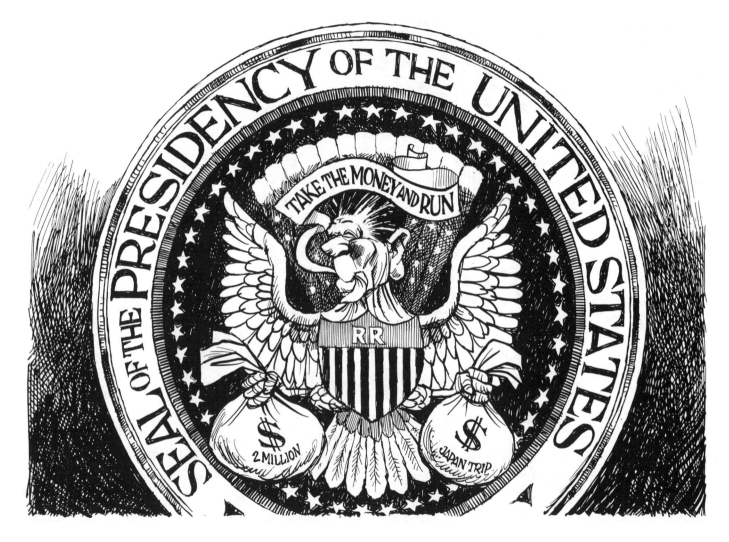

October 24, 1989

. . . and makes big bucks from a series of personal appearances.

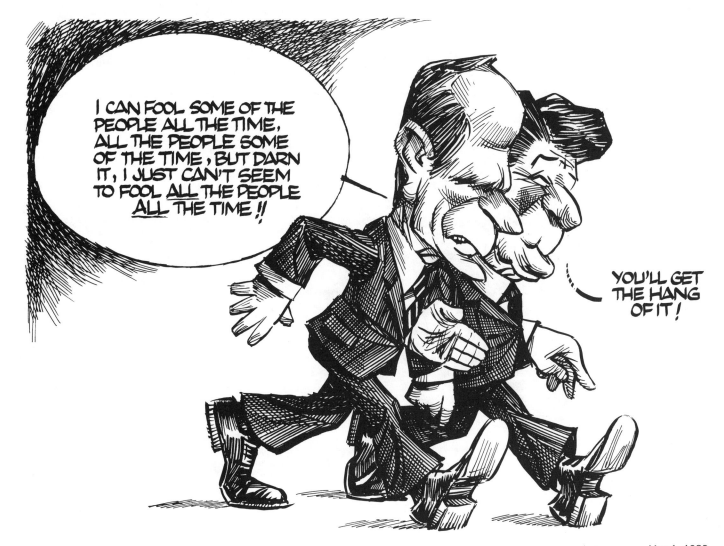

May 1, 1989

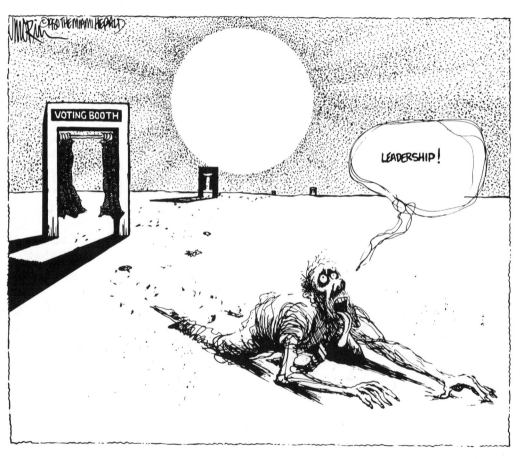

June 8, 1980

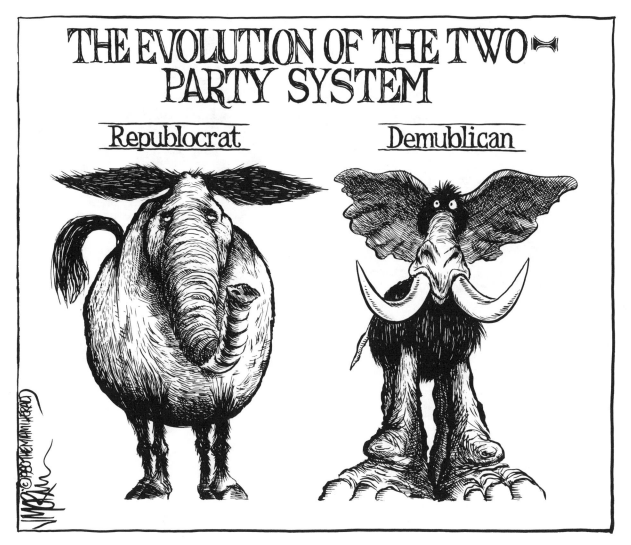

September 11, 1980

24

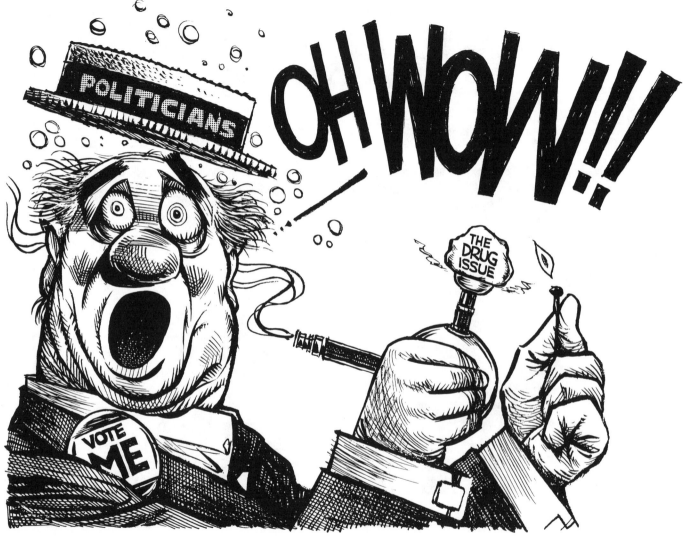

September 14, 1986

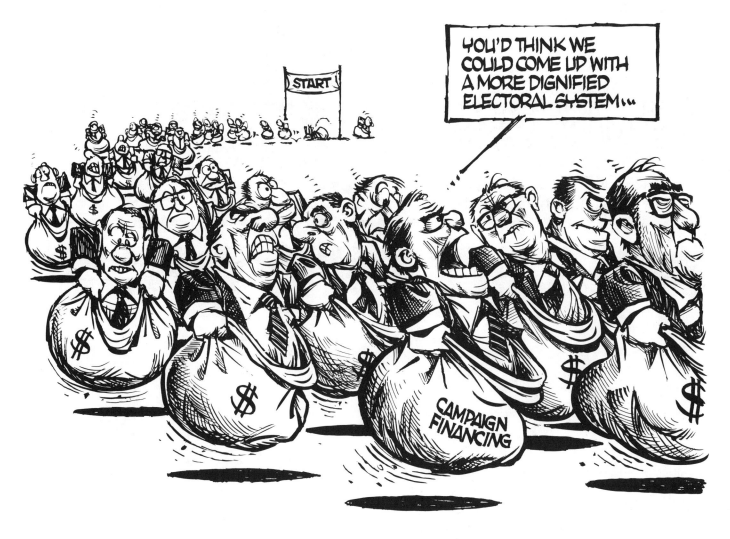

August 5, 1987

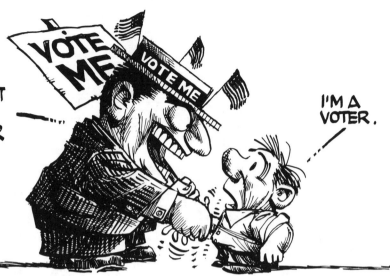

December 15, 1987

The Electoral Process

FIRST I GIVE YOU OUR PAC CAMPAIGN CONTRIBUTION, THEN YOU VOTE FOR OUR BILL.

NO, FIRST I VOTE FOR YOUR BILL, THEN YOU GIVE ME THE CAMPAIGN CONTRIBUTION.

NO, FIRST YOU AGREE TO VOTE FOR THE BILL AND I'LL GIVE YOU THE MONEY NOW.

HOW ABOUT YOU GIVE ME THE MONEY AND I VOTE FOR YOUR BILL AT THE SAME TIME.

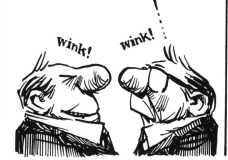

OKAY... LET'S WINK ON IT!

wink! wink!

WHO SAYS WE CONGRESSMEN CAN'T MAKE THE TOUGH DECISIONS?

July 22, 1990

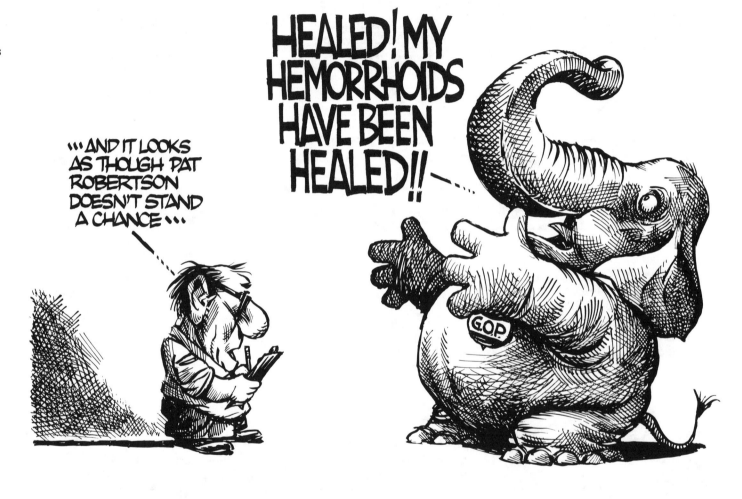

March 13, 1988

Campaign '88, like others before it, produced its share of colorful characters, such as televangelist Reverend Pat Robertson . . .

29

June 10, 1988

. . . and Reverend Jesse Jackson.

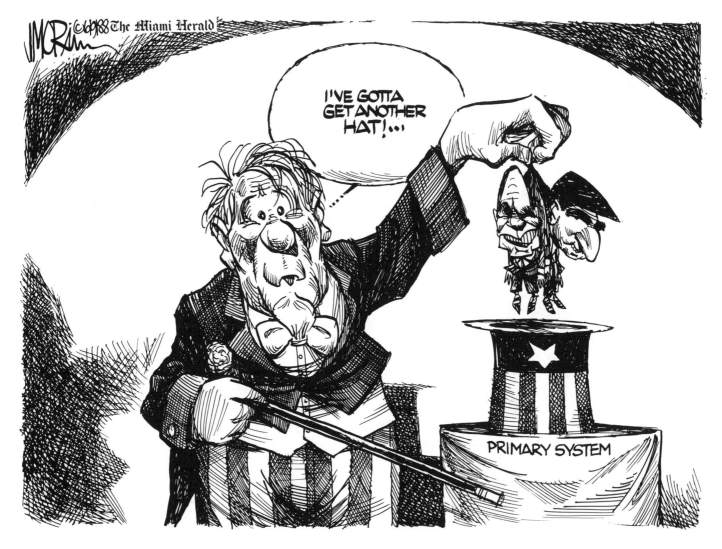

June 9, 1988

The nominees: Vice-President George Bush and Massachusetts' Governor Michael Dukakis.

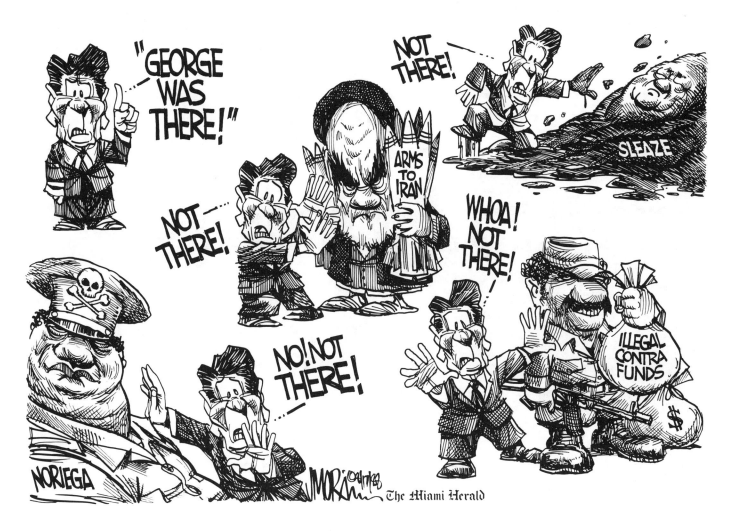

August 17, 1988

The Democrats ask, "Where was George?", linking Bush to his boss's scandals, and the president answers.

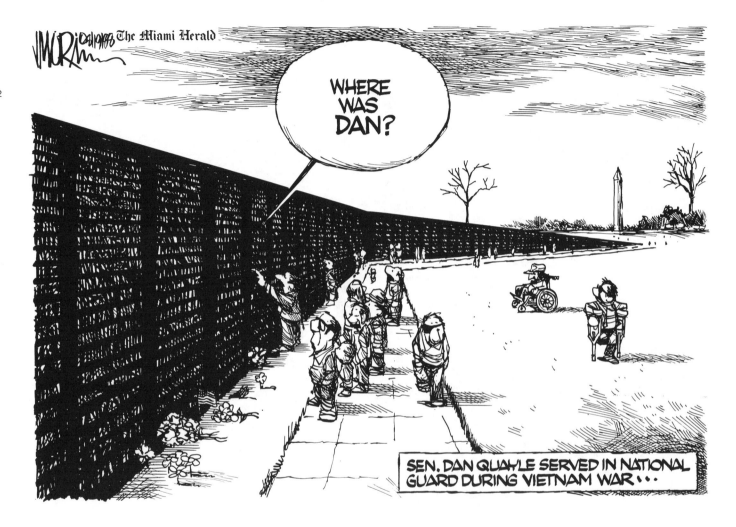

August 19, 1988

George Bush names his vice-presidential nominee.

The Miami Herald

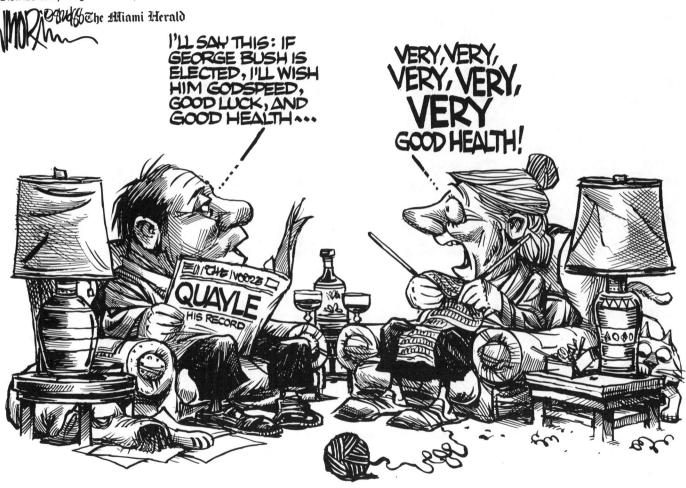

August 26, 1988

34

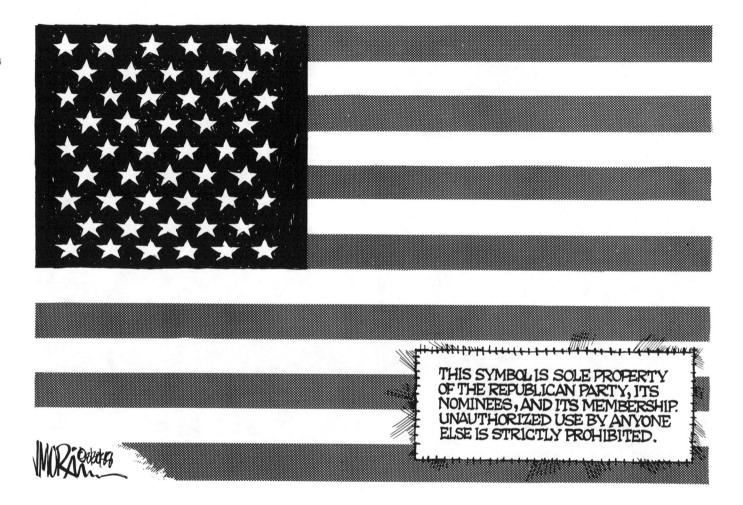

THIS SYMBOL IS SOLE PROPERTY OF THE REPUBLICAN PARTY, ITS NOMINEES, AND ITS MEMBERSHIP. UNAUTHORIZED USE BY ANYONE ELSE IS STRICTLY PROHIBITED.

August 30, 1988

Patriotism becomes an issue.

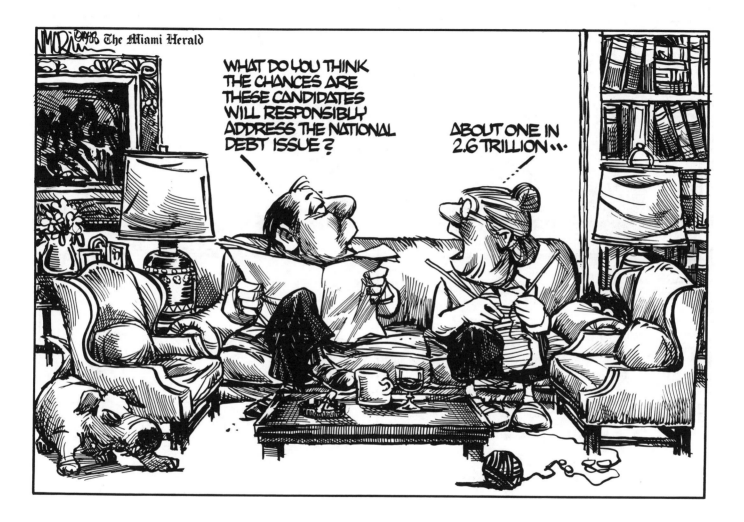

October 3, 1988

36

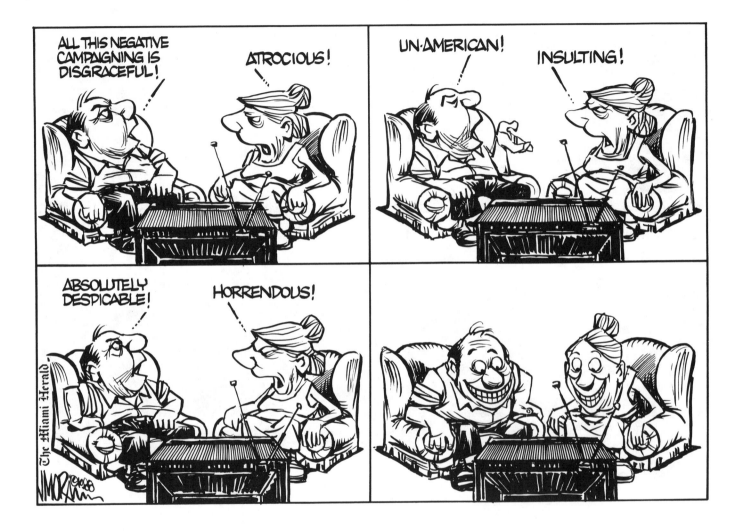

September 13, 1988

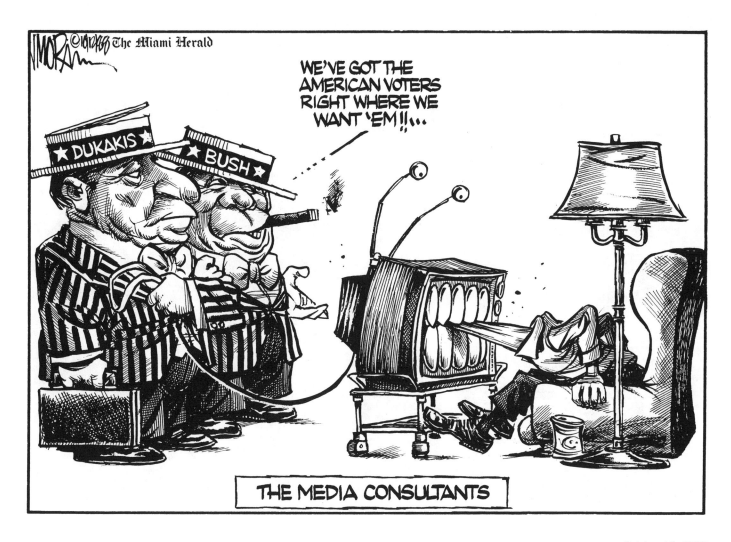

THE MEDIA CONSULTANTS

October 12, 1988

Spontaneous, intelligent argument between the candidates and meaningful confrontation about vital issues give way to image making, "spin control," "sound bites," "photo ops," canned, prerehearsed TV debates, mud slinging, and empty sloganeering.

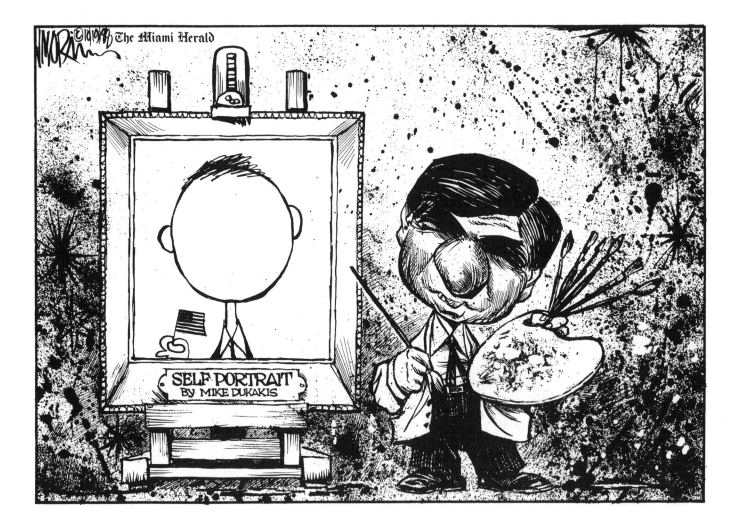

SELF PORTRAIT
BY MIKE DUKAKIS

October 19, 1988

Michael Dukakis loses the election after failing to communicate effectively with the American people.

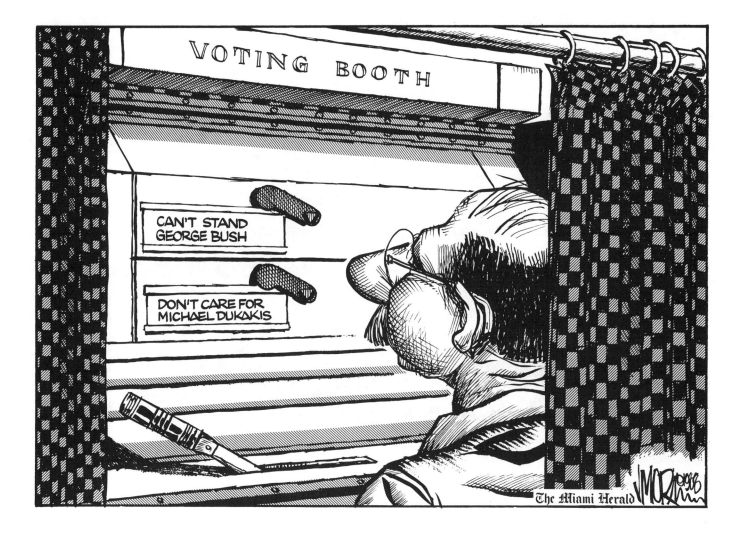

October 28, 1988

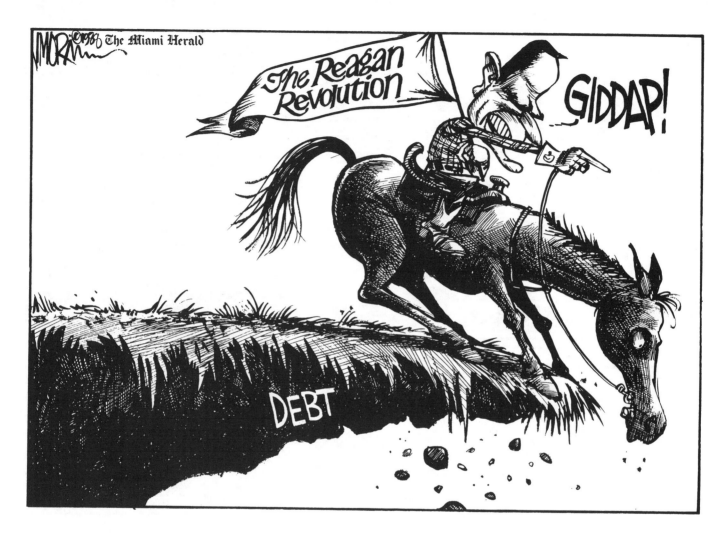

November 1, 1988

A KINDER, GENTLER NATION

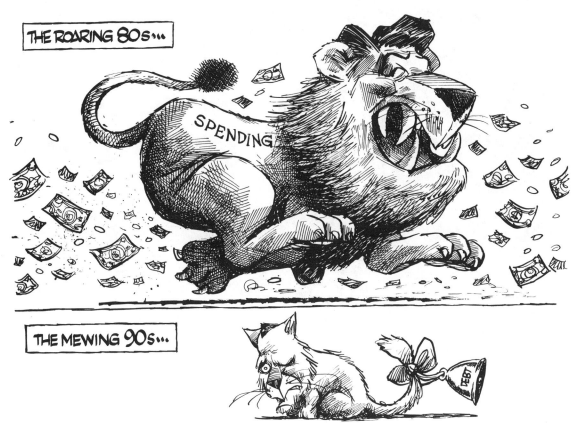

January 22, 1989

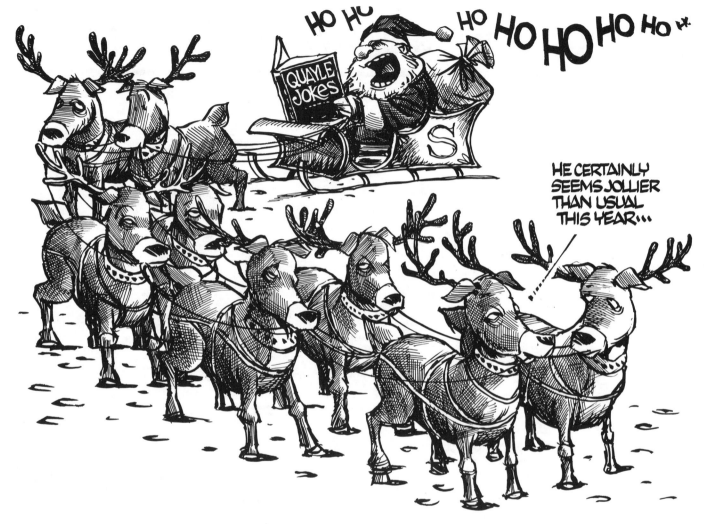

December 11, 1988

Vice-President Quayle becomes a national laughingstock.

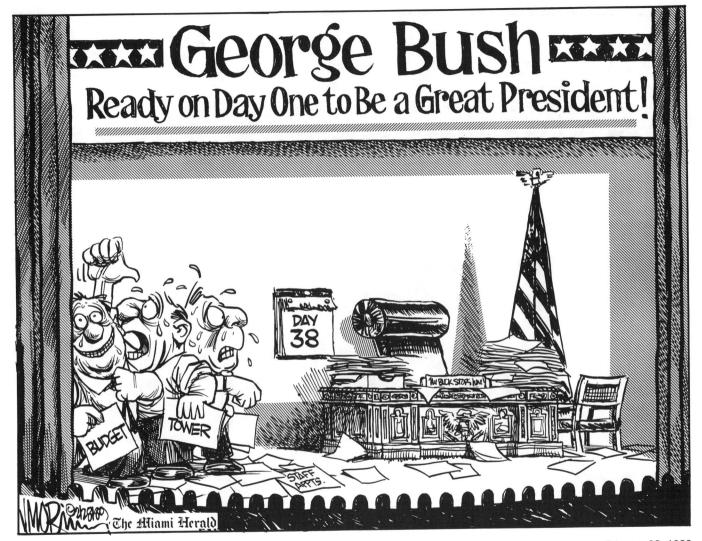

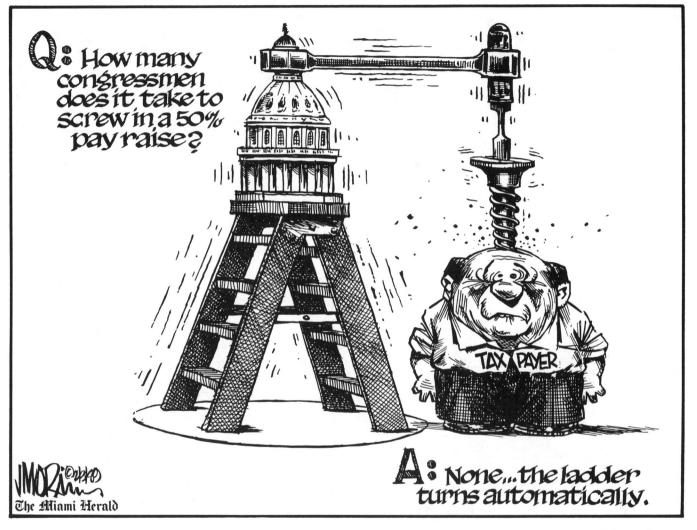

February 3, 1989

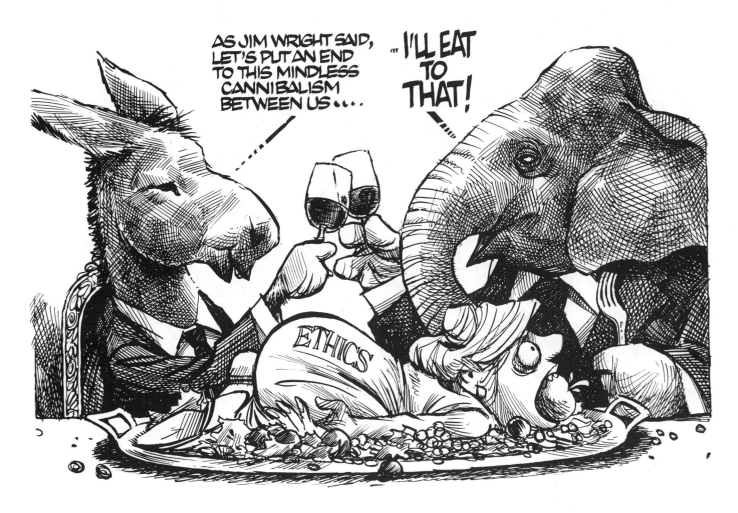

June 2, 1989

Congressional Republicans and Democrats assail one another's ethical transgressions, and then call a truce.

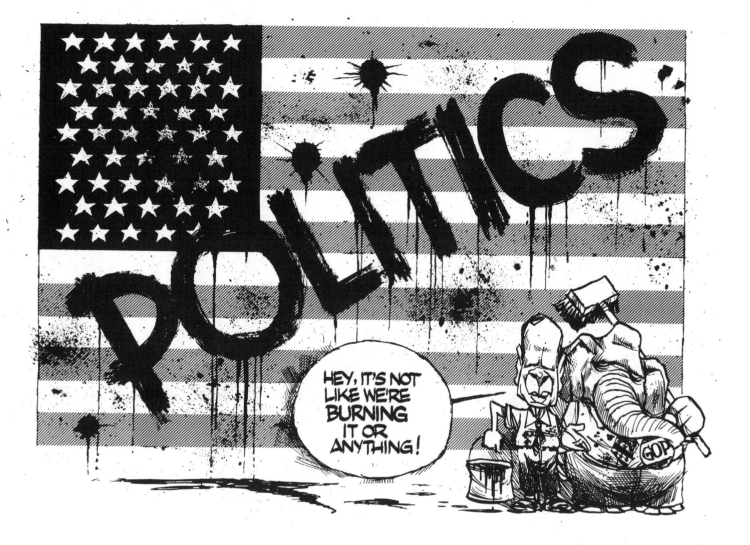

June 30, 1989

President Bush proposes a constitutional amendment to outlaw burning the American flag.

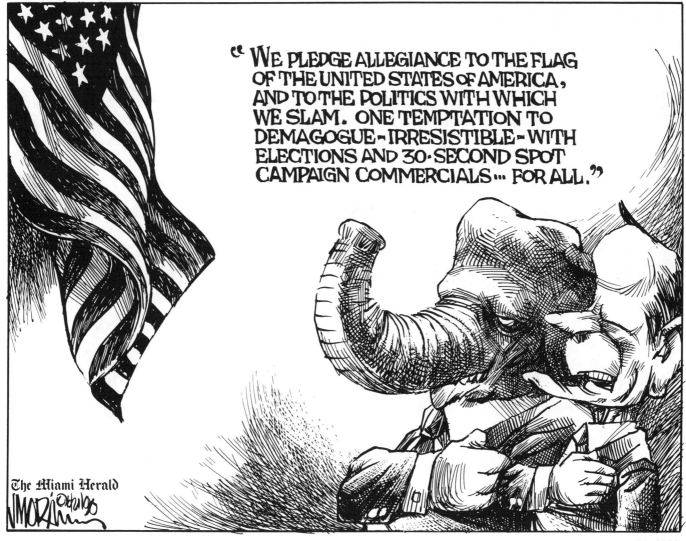

June 21, 1990

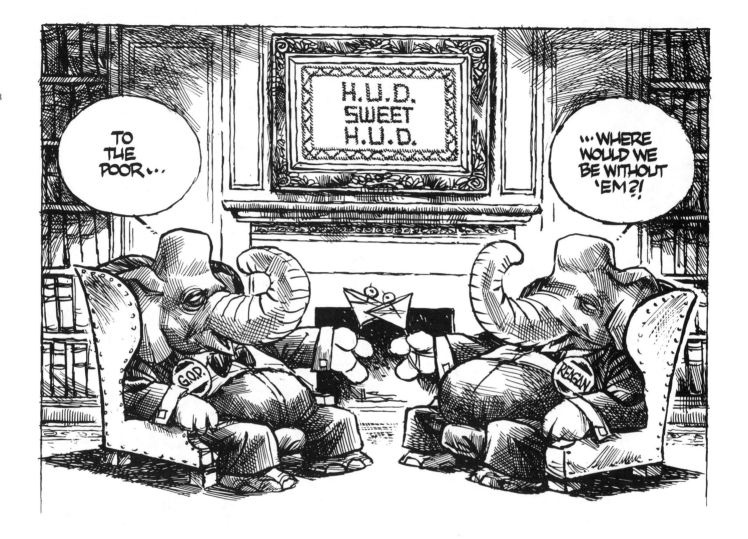

July 18, 1989

Housing and Urban Development grants are awarded to prominent, well-connected Republicans who hire former Reagan administration officials as lobbyists.

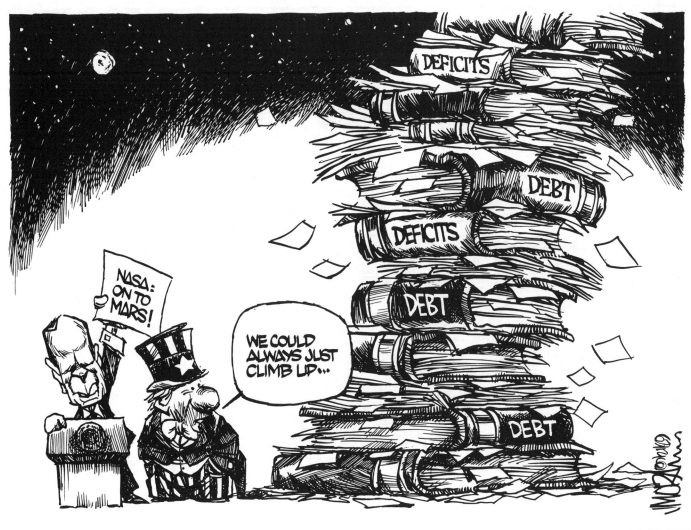

July 21, 1989

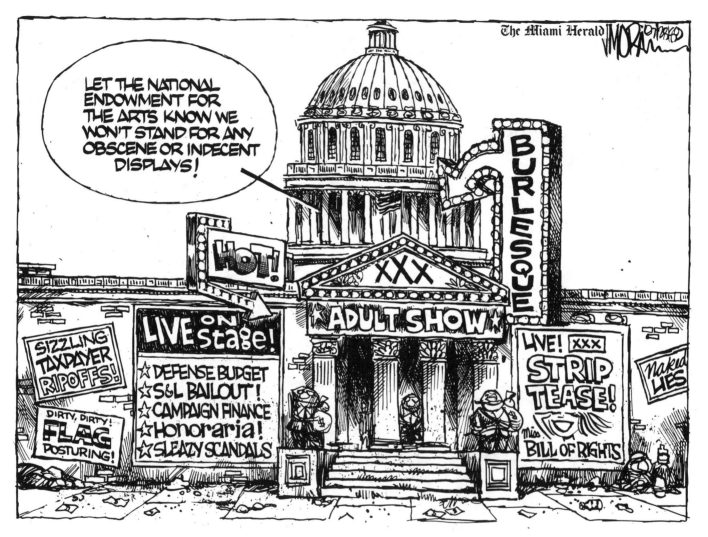

July 28, 1989

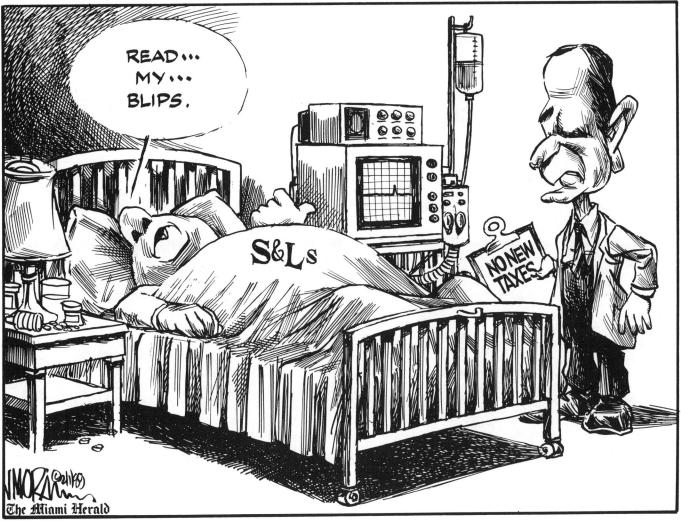

February 1, 1989

Estimated costs for the savings-and-loan bailout escalate higher and higher.

52

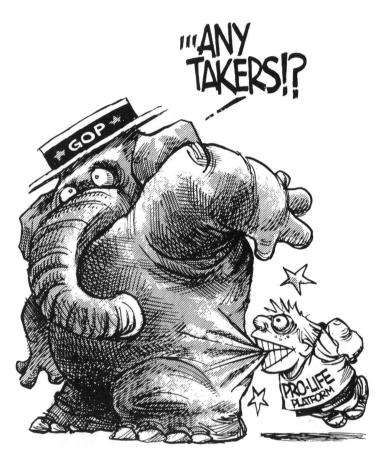

November 9, 1989

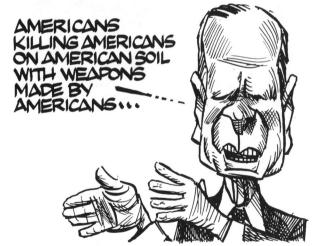
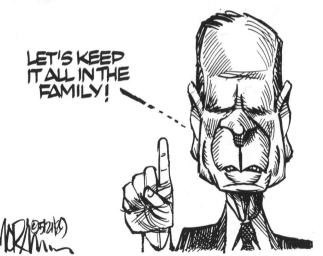

AS PART OF MY NEW ANTI-CRIME PACKAGE, ALL IMPORTED SEMI-AUTOMATIC WEAPONS WILL BE BANNED···

ON THE OTHER HAND, PURCHASE OF AMERICAN-MADE SEMI-AUTOMATIC WEAPONS WILL BE PERMITTED···

AMERICANS KILLING AMERICANS ON AMERICAN SOIL WITH WEAPONS MADE BY AMERICANS···

LET'S KEEP IT ALL IN THE FAMILY!

The Miami Herald

May 21, 1989

ANOTHER SICKO BUYS SOME ASSAULT WEAPONS...

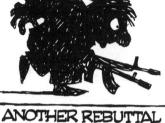

ANOTHER SENSELESS MASS MURDER....

ANOTHER PUBLIC OUTCRY FOR SANE GUN LAWS....

ANOTHER REBUTTAL FROM THE N.R.A.....

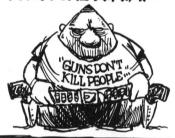

"GUNS DON'T KILL PEOPLE"

ANOTHER GUN CONTROL BILL IS PROPOSED....

ANOTHER FLOCK OF N.R.A. LOBBYISTS ON CAPITOL HILL....

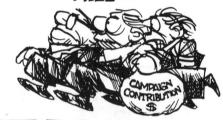

CAMPAIGN CONTRIBUTION $

ANOTHER GUN CONTROL BILL KILLED.

ANOTHER SICKO BUYS SOME ASSAULT WEAPONS...

54

September 17, 1989

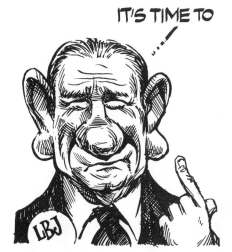

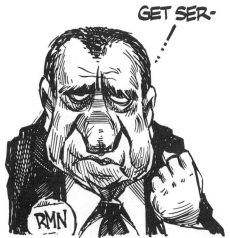

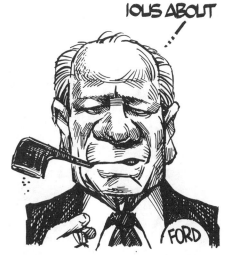

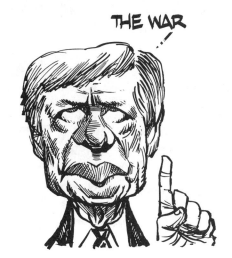

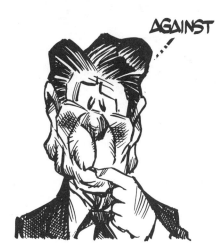

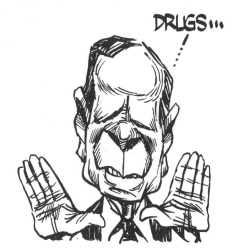

September 7, 1989

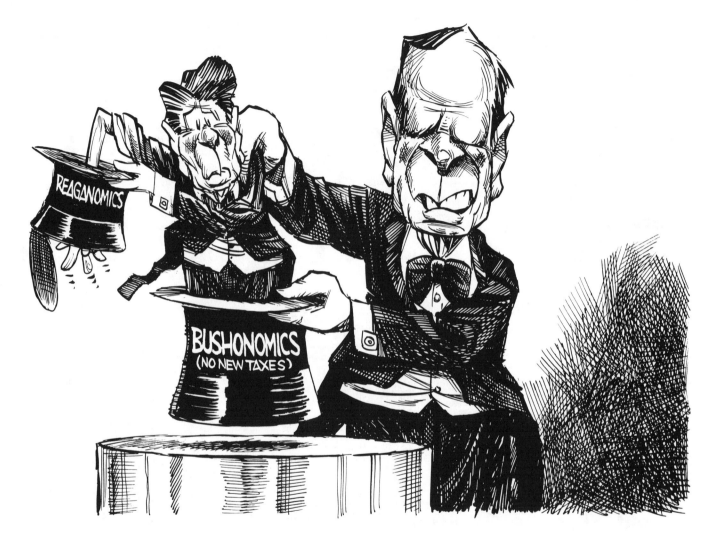

November 28, 1989

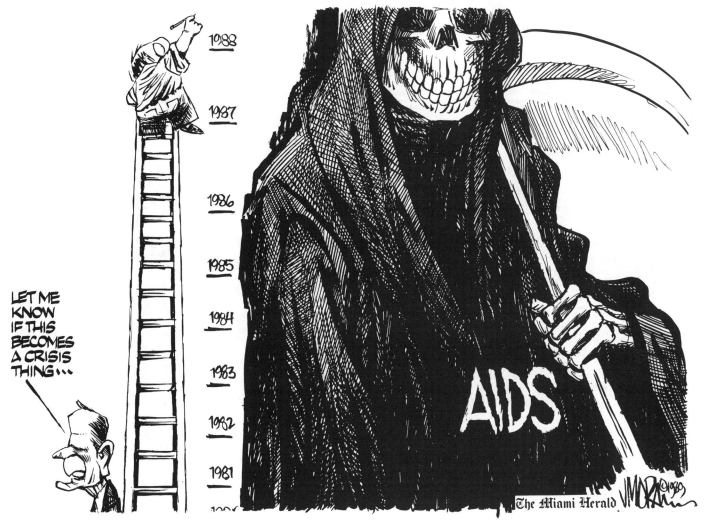

November 29, 1989

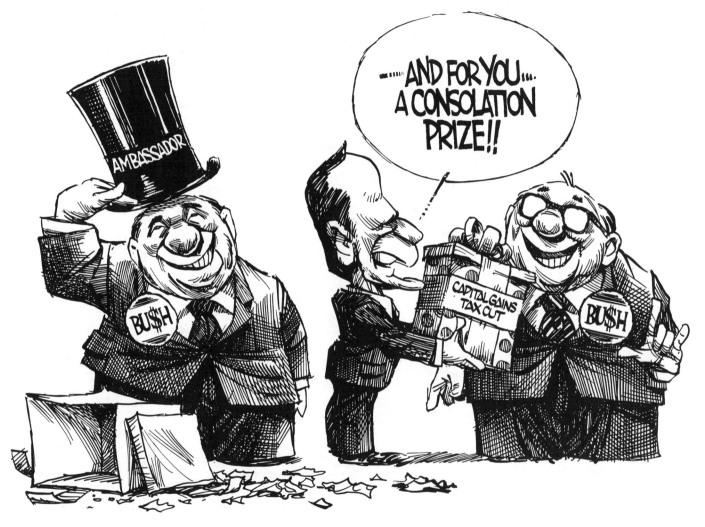

October 3, 1989

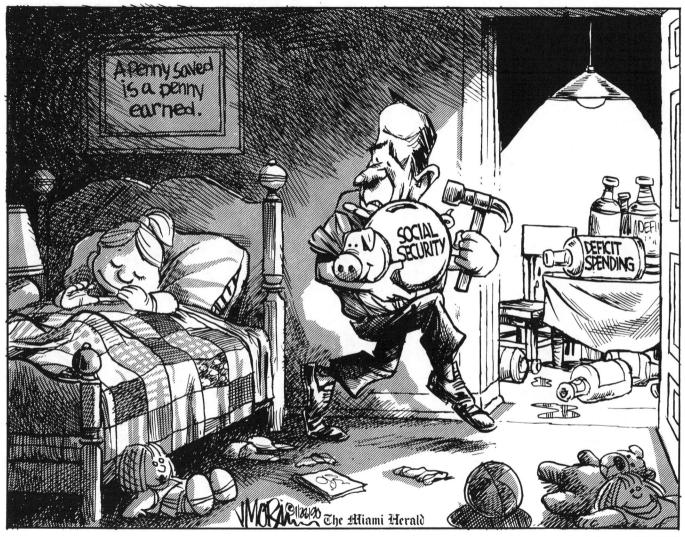

January 28, 1990

The White House and the Congress use Social Security surpluses to lessen the massive budget deficit.

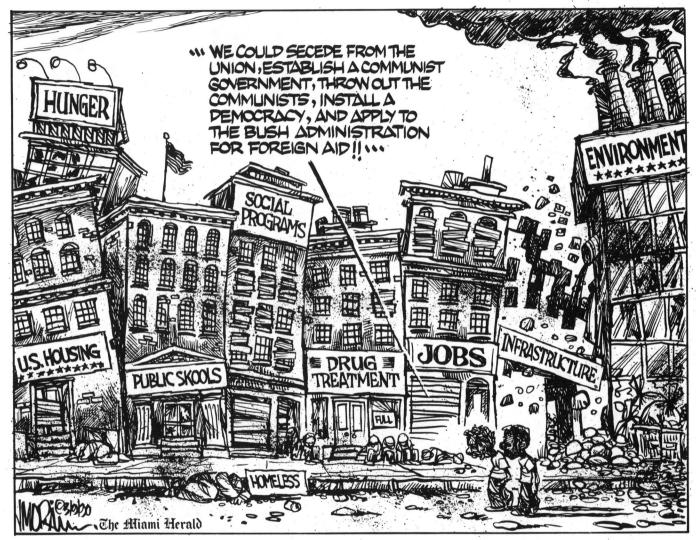

March 9, 1990

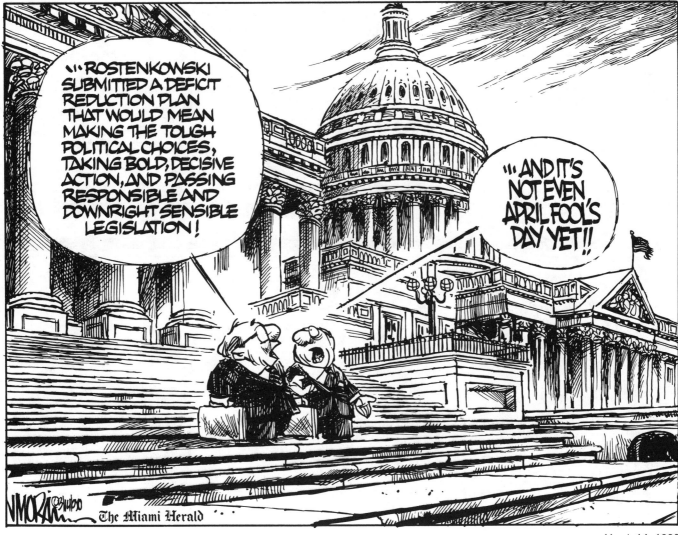

March 14, 1990

62

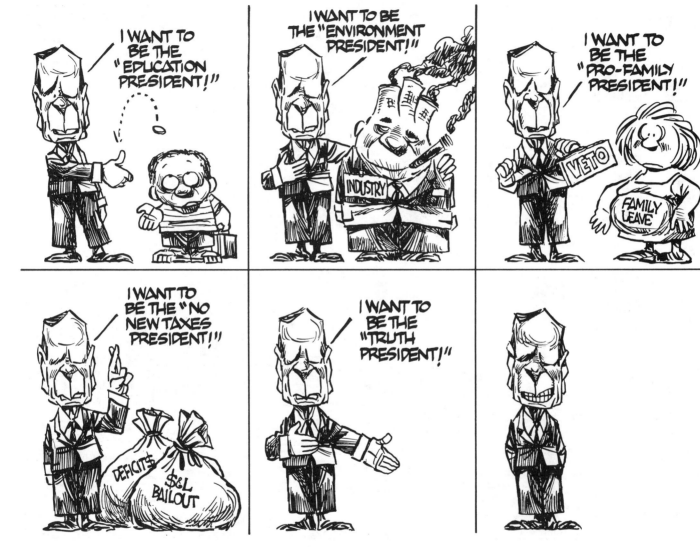

June 28, 1990

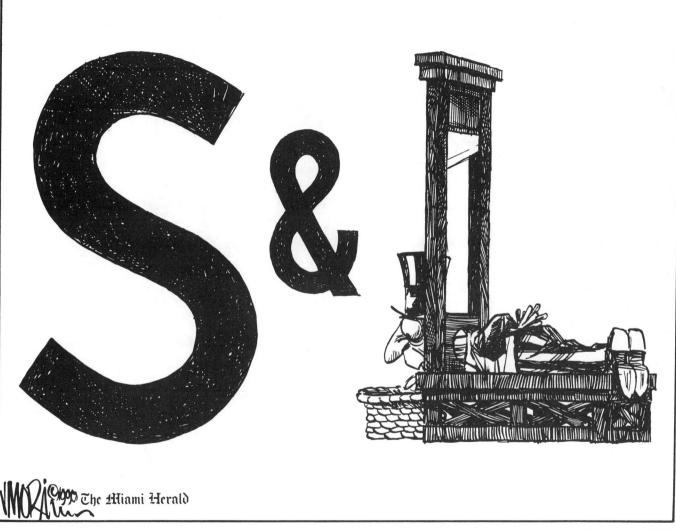

September 9, 1990

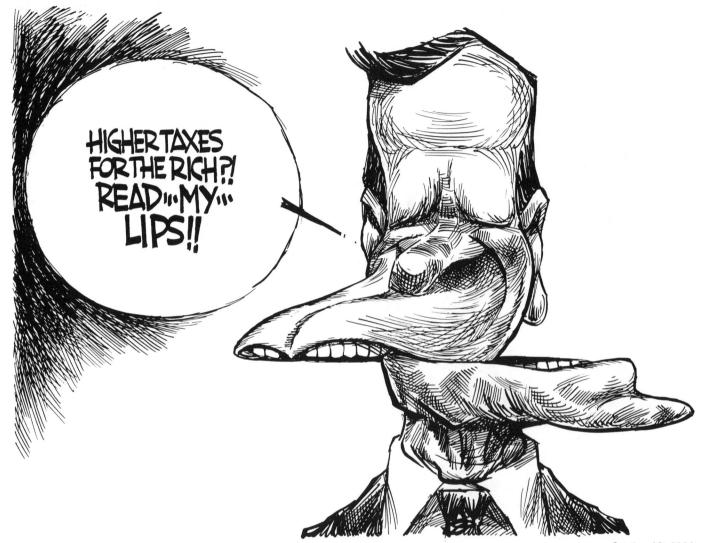

October 12, 1990

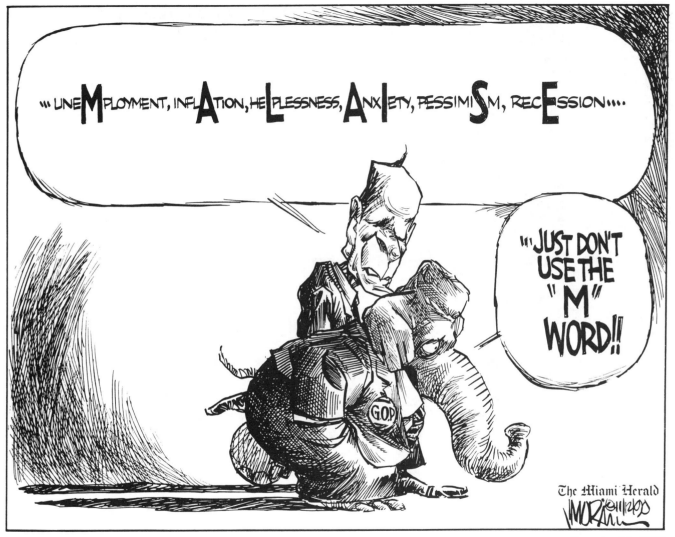

November 12, 1990

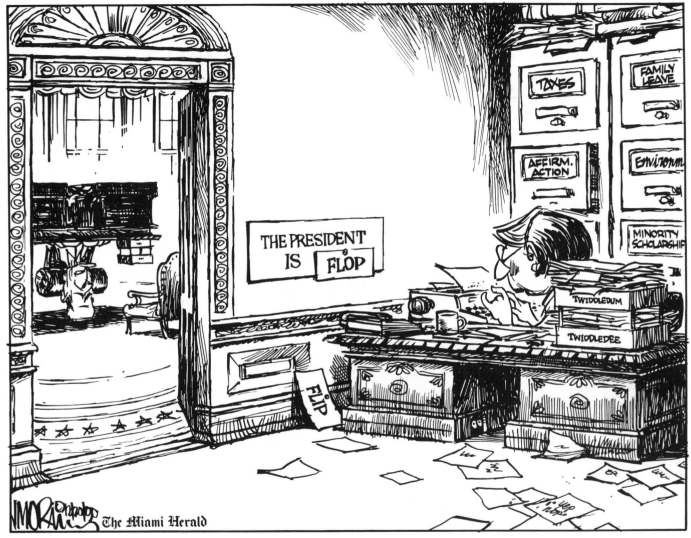

December 20, 1990

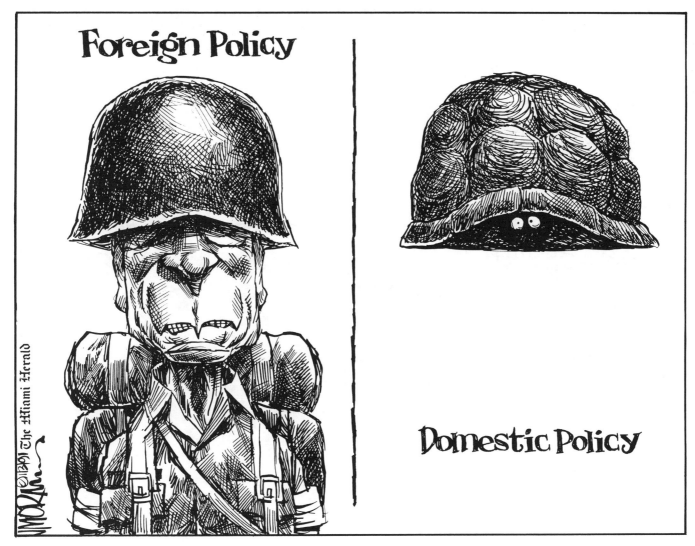

January 3, 1991

The Persian Gulf war overshadows mounting problems at home.

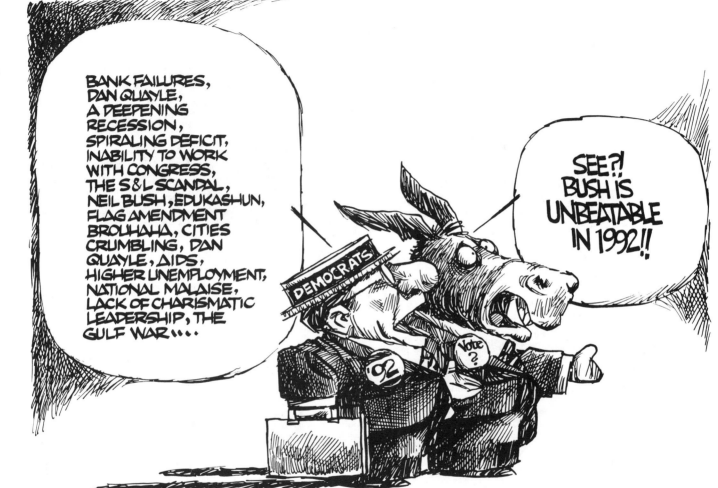

February 3, 1991

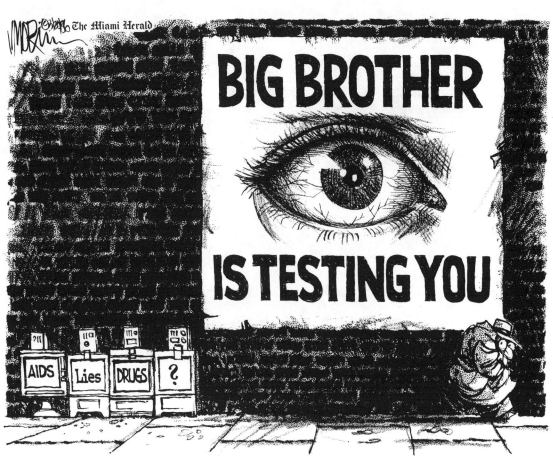

March 20, 1986

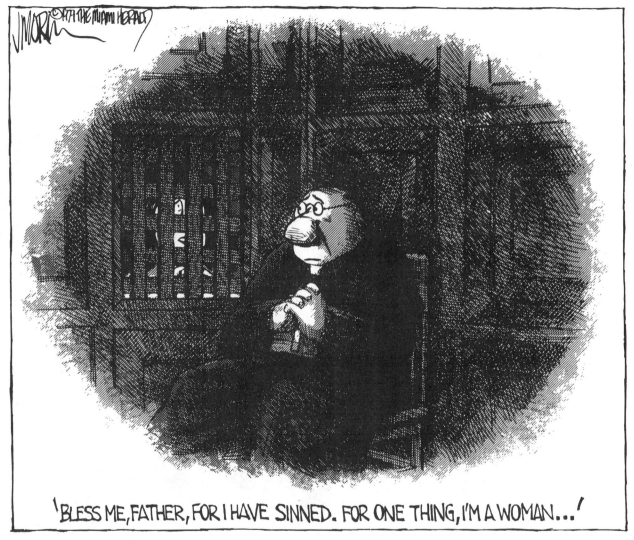

'BLESS ME, FATHER, FOR I HAVE SINNED. FOR ONE THING, I'M A WOMAN...'

October 9, 1979

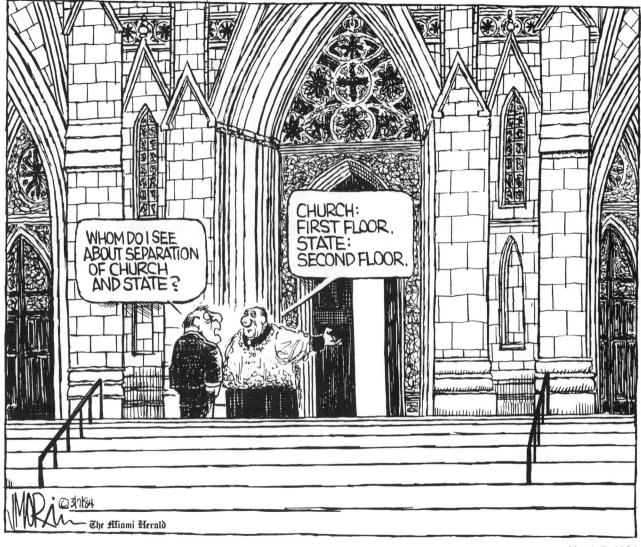

March 7, 1984

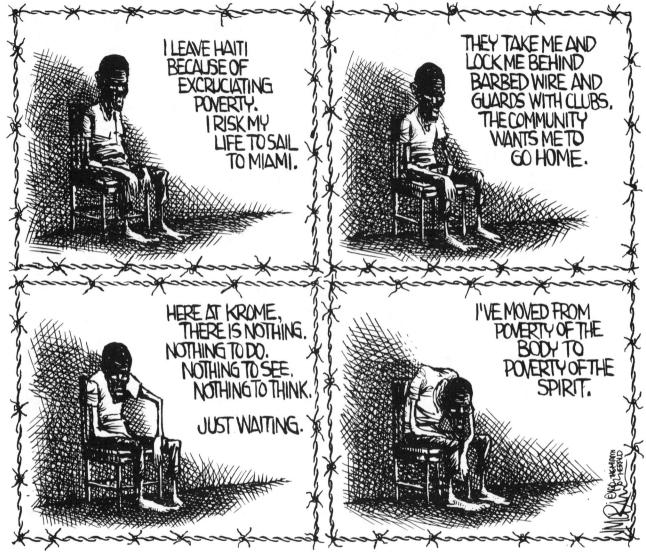

June 1, 1982

Haitian refugees looking to the United States for a better way of life are locked up
in Miami's Krome Avenue Refugee Detention Center.

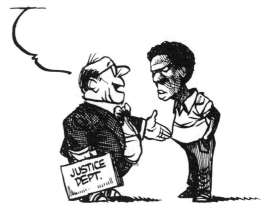

June 30, 1985

74

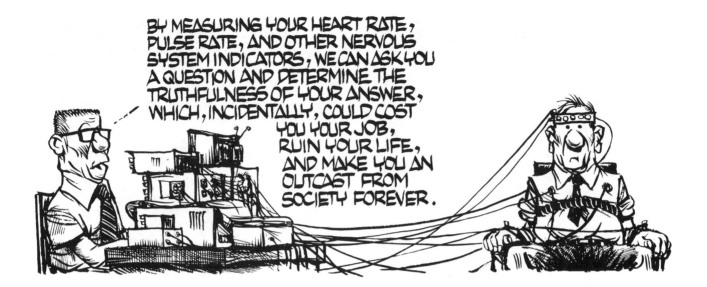

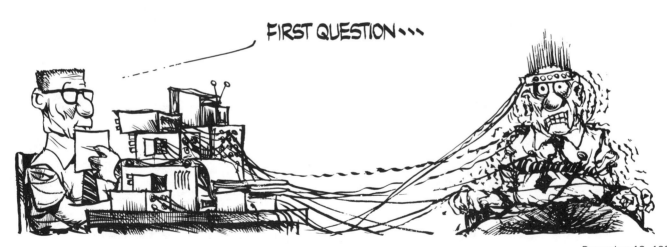

December 13, 1985

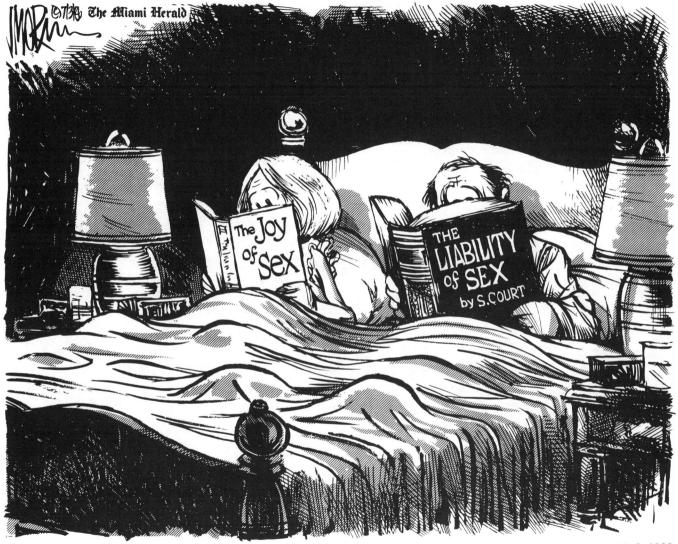

July 3, 1986

The Supreme Court upholds Georgia's sodomy law, thus denying citizens the right,
as dissenting Justice Blackmun put it, "to be left alone."

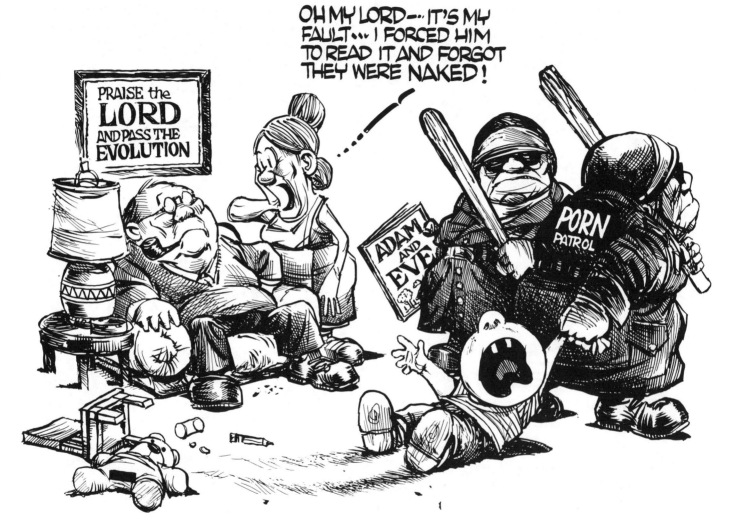

July 16, 1986

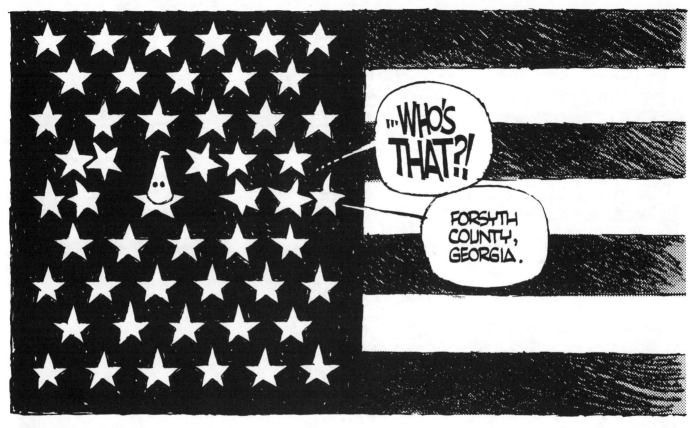

Twenty-five thousand civil-rights activists march on all-white Forsyth County, Georgia.

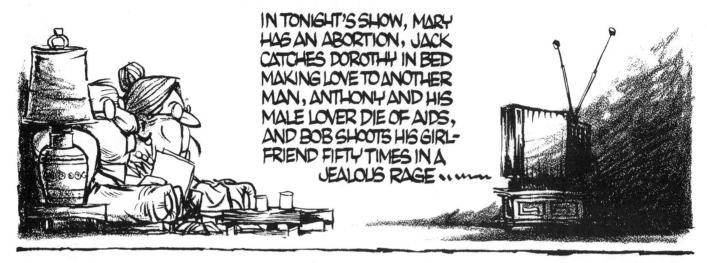

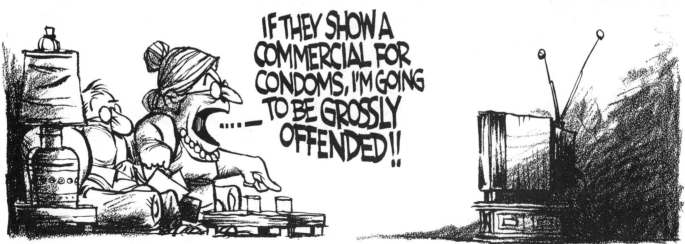

February 1, 1987

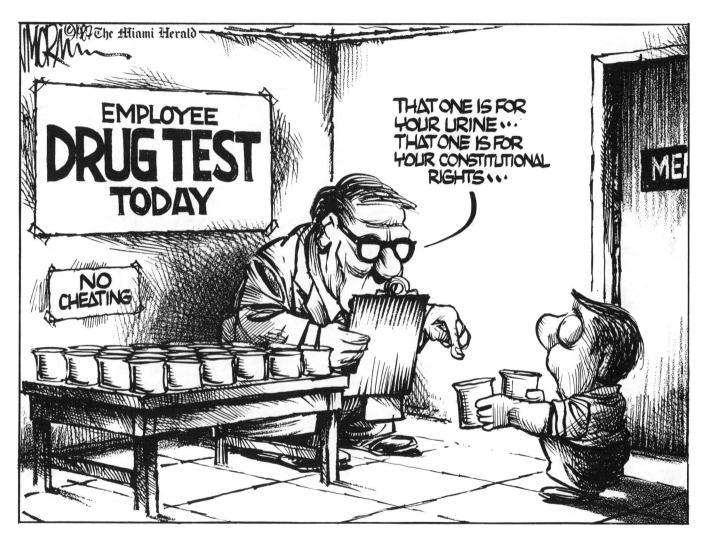

June 5, 1987

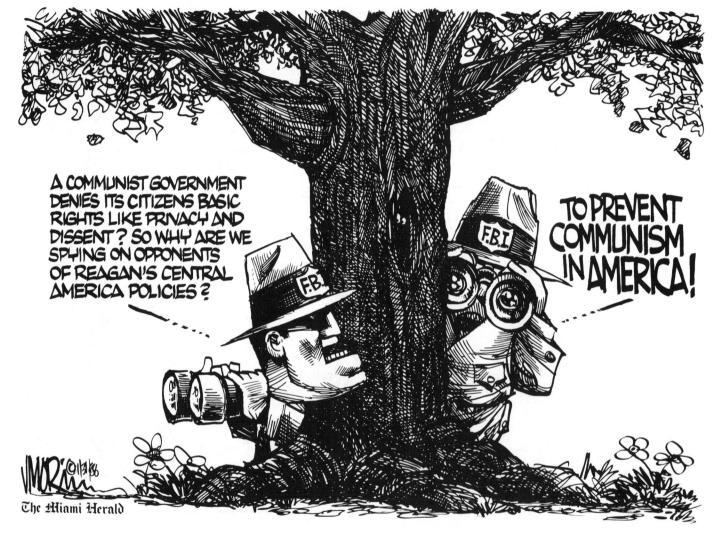

January 31, 1988

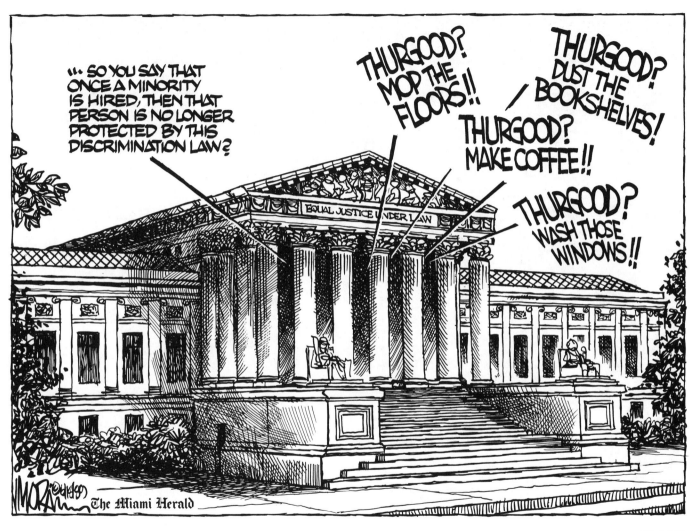

June 18, 1989

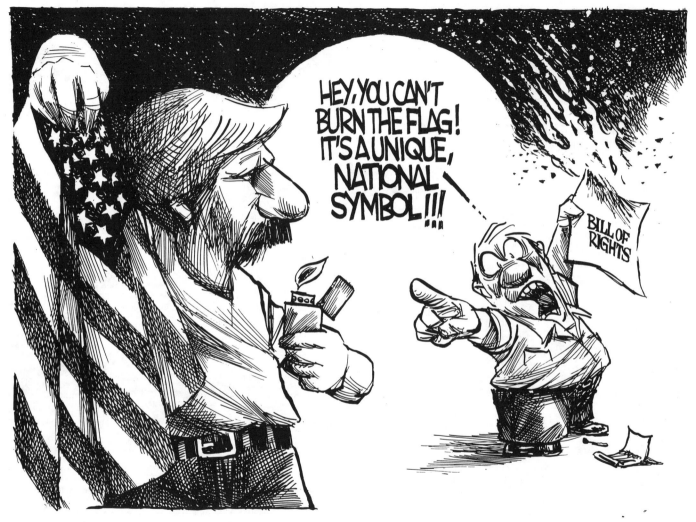

July 4, 1989

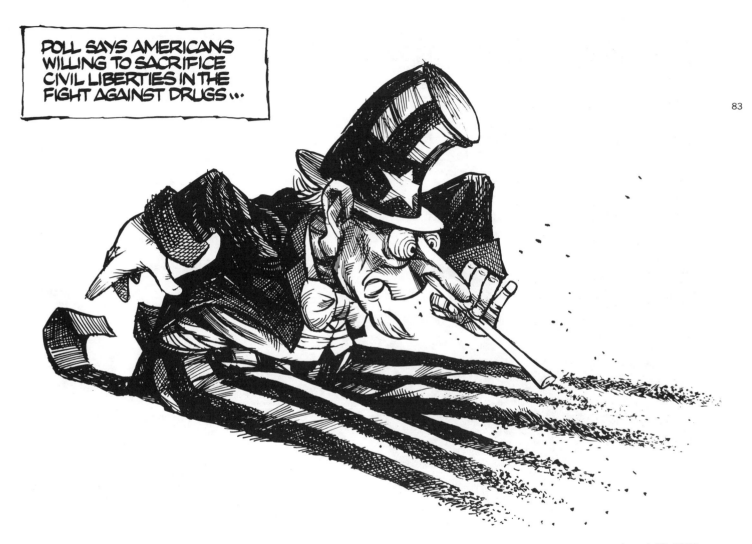

August 16, 1989

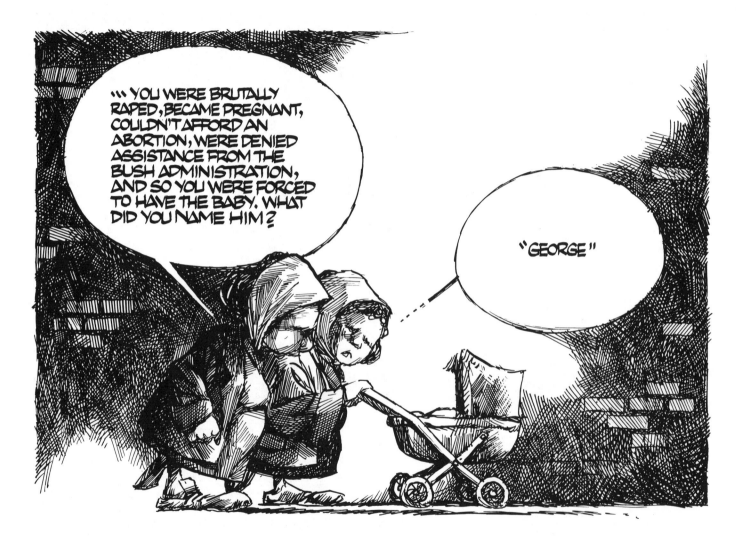

84

October 22, 1989

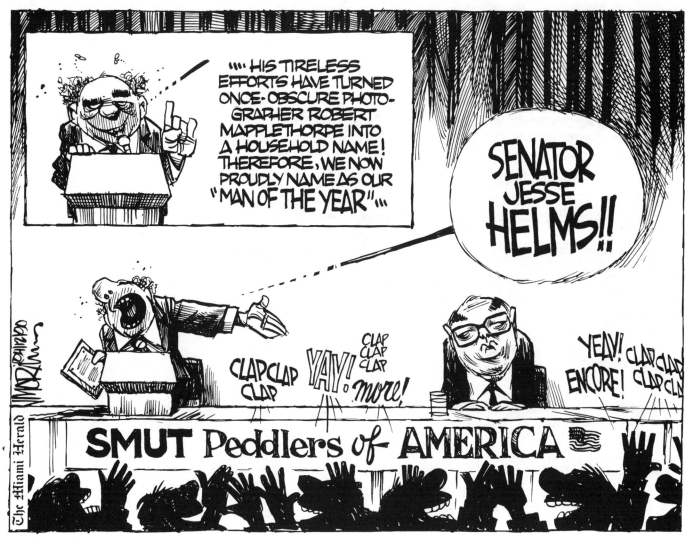

April 12, 1990

When politicians attempt to censor artistic expression of controversial tastes, they inevitably succeed only in popularizing the work of the artist. Such was the case with Senator Jesse Helms . . .

THE POOR IN TH' GHETTOS,
HOMELESS WALK TH' STREETS,
CHILDREN GOIN' HUNGRY, WHILE
THE RICH GROW OBESE!

THE OLD GETTIN' SICK,
CAN'T AFFORD TO STAY ALIVE,
NO MONEY FOR THE DOCTORS,
CONDEMNED TO DIE!

TOXIC WASTE DUMPS, MORE
GARBAGE AN' SLEAZE,
CARS SPEWIN' FUMES -
GETTIN' HARD TO BREATHE!

CRACK BABIES CRYIN',
CRACK MOMMA-FED, AN
ENTIRE GENERATION
OF WALKIN' DEAD!

CROOKED POLITICIANS
PAYOFFS AN' KICKBACKS,
BLOATED BUREAUCRACIES,
INCOMPETENT HACKS!

PSCHOS, RAPISTS, KILLERS,
ROBBERS, NEARLY EVERYONE,
IN THE STATE OF FLORIDA,
THEY ALL GOT GUNS!

THE SEAMS ARE BURSTIN', YO!,
THE STATE IS GOIN' NUTS,
TALLAHASSEE'S DOIN' NOTHIN'
'CAUSE THEY HAVEN'T GOT TH' GUTS!

"...SOUNDS CLEAN TO ME!"

MORALITY POLICE

VOTE BOB

86

March 4, 1990

. . . and Florida's Governor Bob Martinez's diatribe against Miami rap group 2 Live Crew.

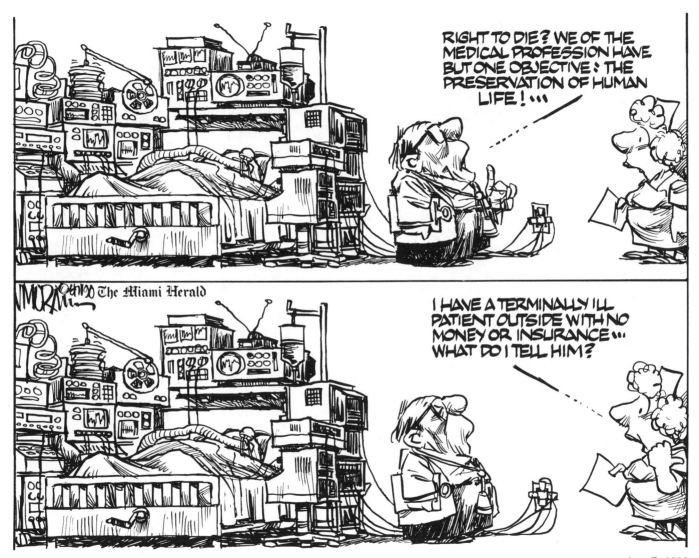

June 7, 1990

88

 RAP MUSICIANS ARE ARRESTED FOR UTTERING "OBJECTIONABLE" LANGUAGE TO CONSENTING ADULTS...

 A CONSTITUTIONAL AMENDMENT IS PROPOSED TO MAKE FLAG DESECRATION A CRIME...

 RELIGIOUS FUNDAMENTALISTS BANNING BOOKS IN THE PUBLIC SCHOOLS...

 A MUSEUM DIRECTOR IS ARRESTED FOR DISPLAYING "OBSCENE" ART. GOVERNMENT ATTEMPTS TO IMPOSE MORAL GUIDELINES ON ART IT FUNDS...

 SUPREME COURT OKAYS RANDOM ROADSIDE CHECKPOINTS TO SEARCH FOR DRUNK DRIVERS...

 ...AND THE EASTERN BLOC ASKS FOR OUR ADVICE IN BUILDING A FREE SOCIETY!

June 17, 1990

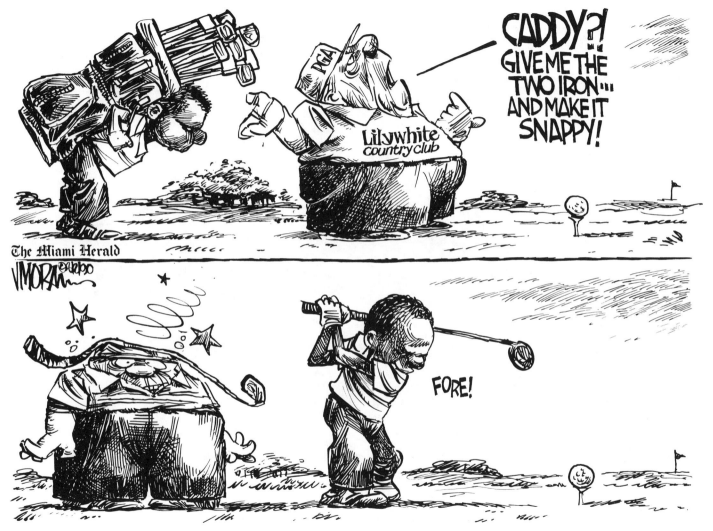

August 2, 1990

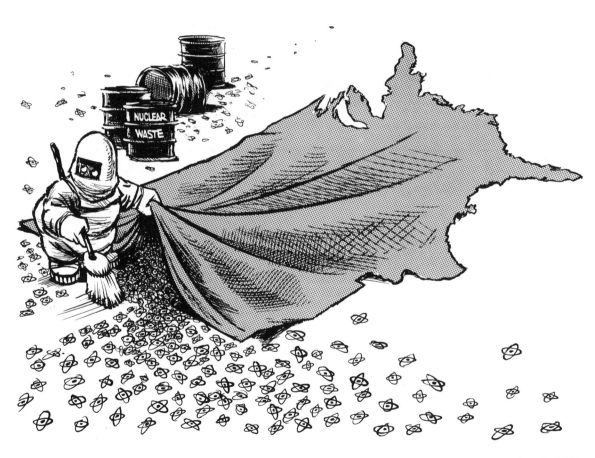

June 1, 1986

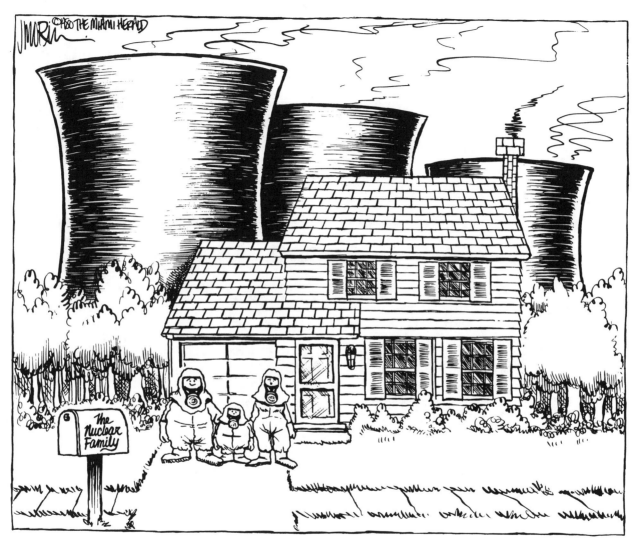

February 17, 1980

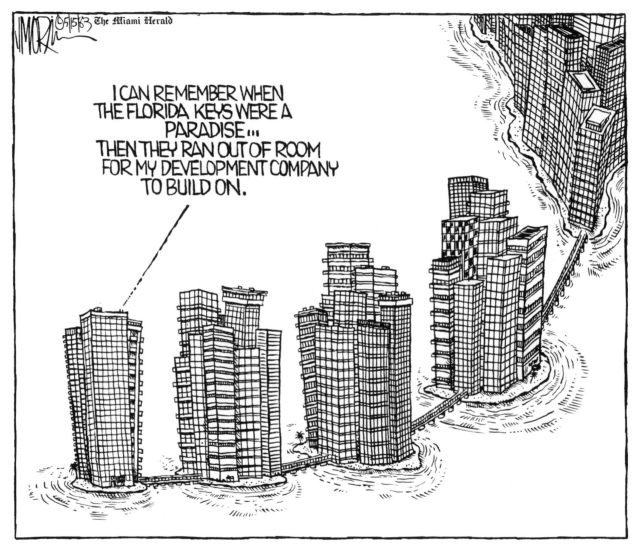

May 15, 1983

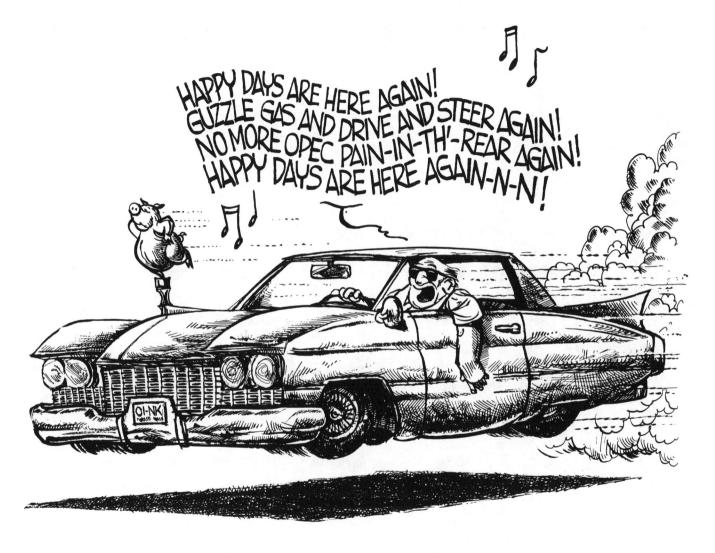

July 7, 1985

**Gasoline prices recede from the crisis level of the 1970s and Americans go back to buying
big, gas-guzzling cars again, ignoring ever-present environmental dangers as well as political instability in the Middle East.**

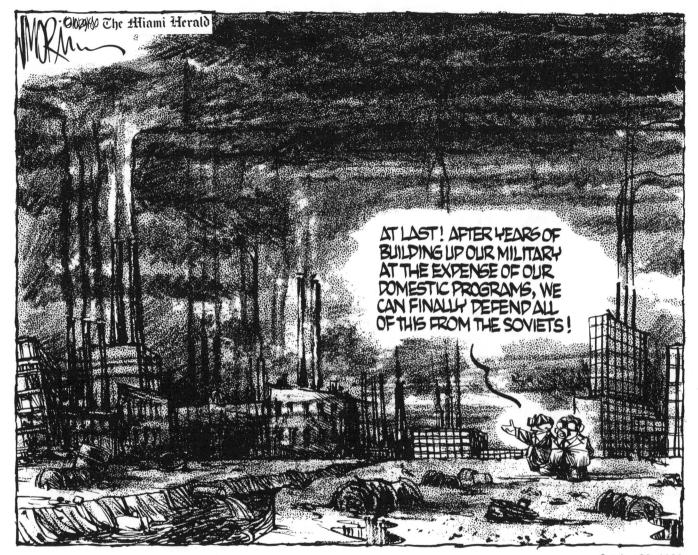

94

October 29, 1986

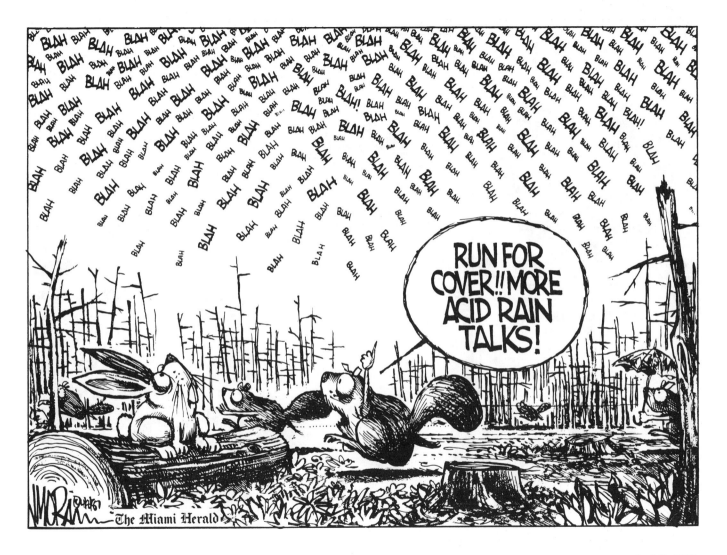

April 8, 1987

96

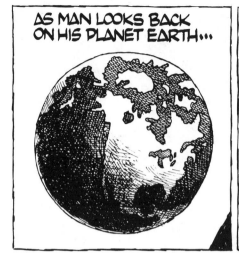

AS MAN LOOKS BACK ON HIS PLANET EARTH...

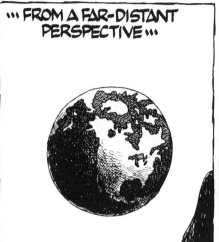

...FROM A FAR-DISTANT PERSPECTIVE...

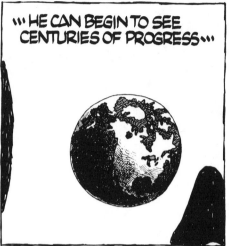

..."HE CAN BEGIN TO SEE CENTURIES OF PROGRESS...

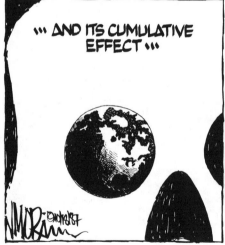

... AND ITS CUMULATIVE EFFECT ...

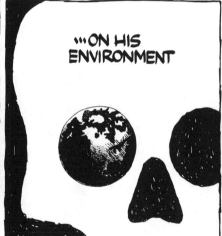

..."ON HIS ENVIRONMENT

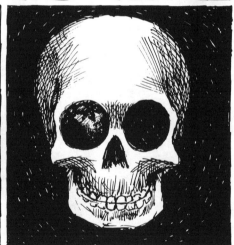

October 18, 1987

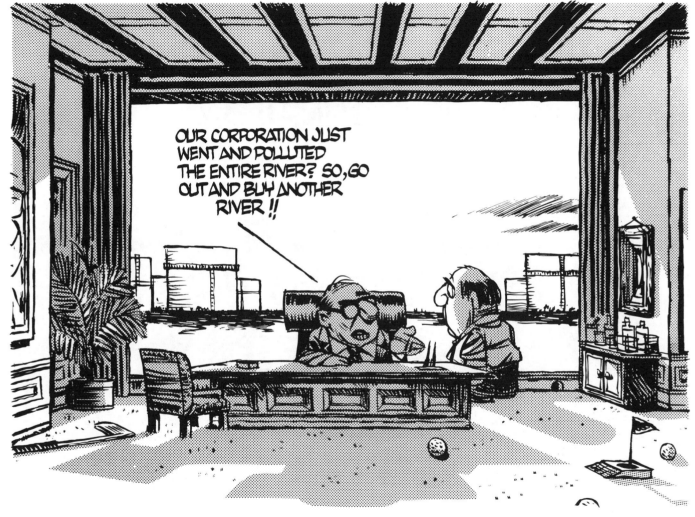

January 7, 1988

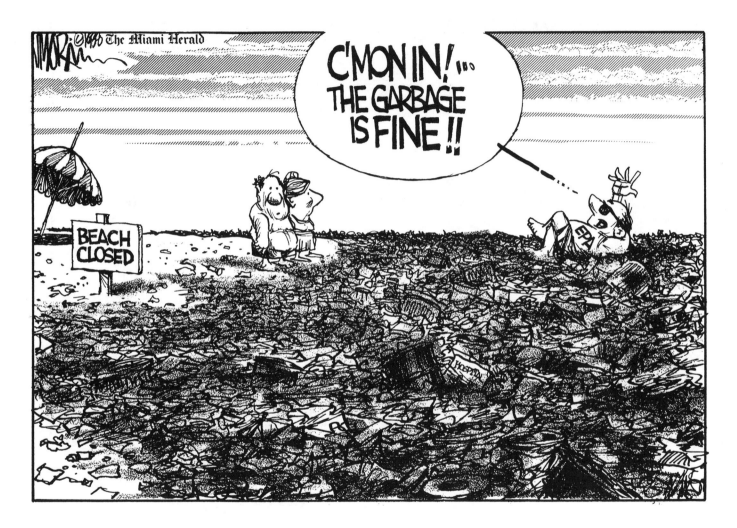

September 6, 1988

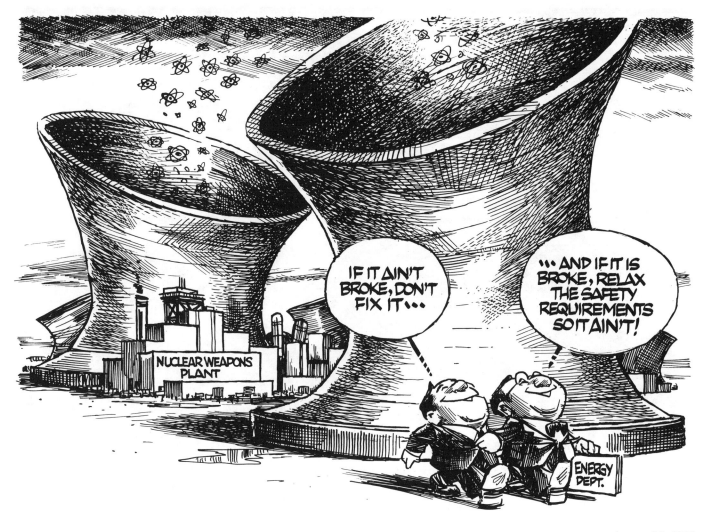

January 29, 1989

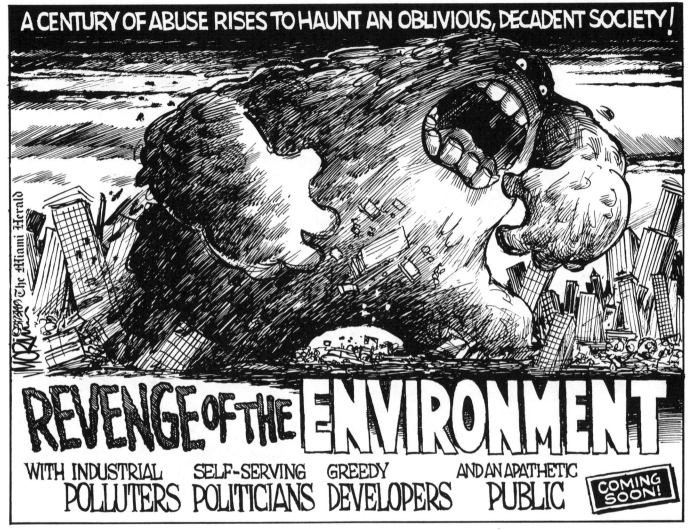

March 23, 1989

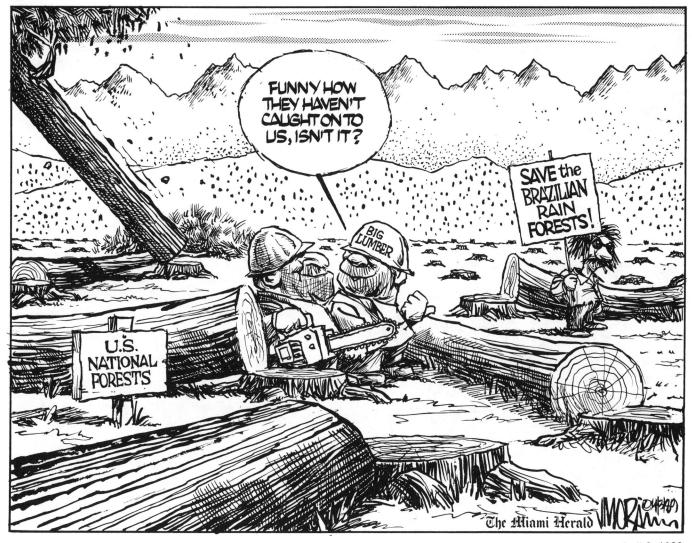

April 3, 1989

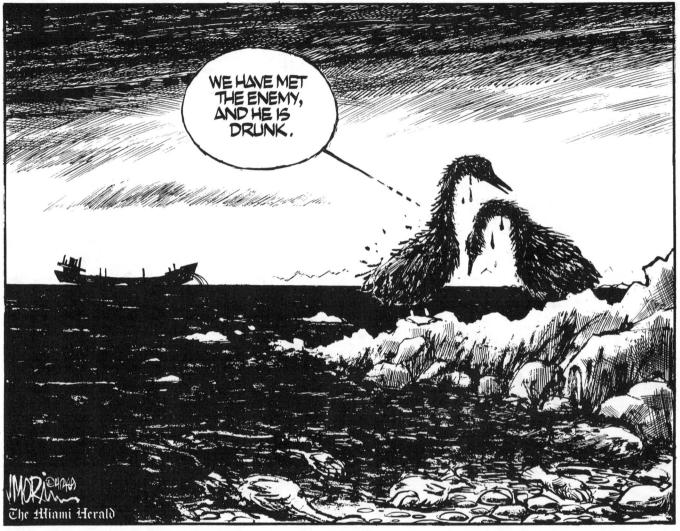

April 2, 1989

Oil tanker *Exxon Valdez* runs aground off Alaska's coast, spilling 240,000 barrels of oil, the worst spill in U.S. history. The tanker's captain, Joseph Hazelwood, was reportedly intoxicated at the time.

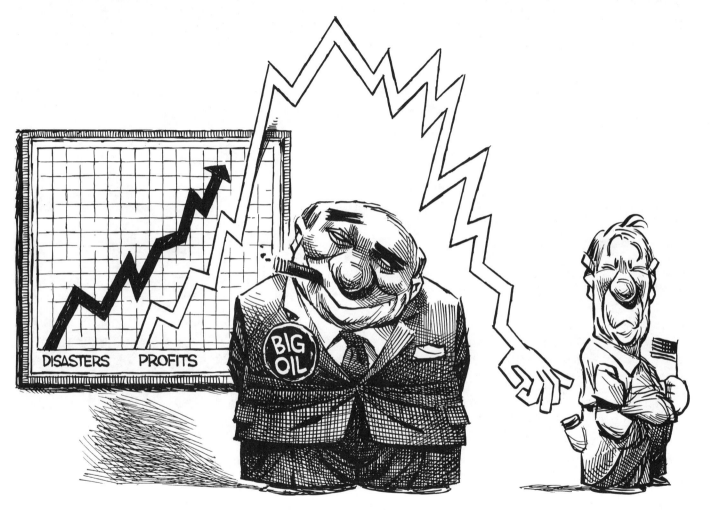

April 23, 1989

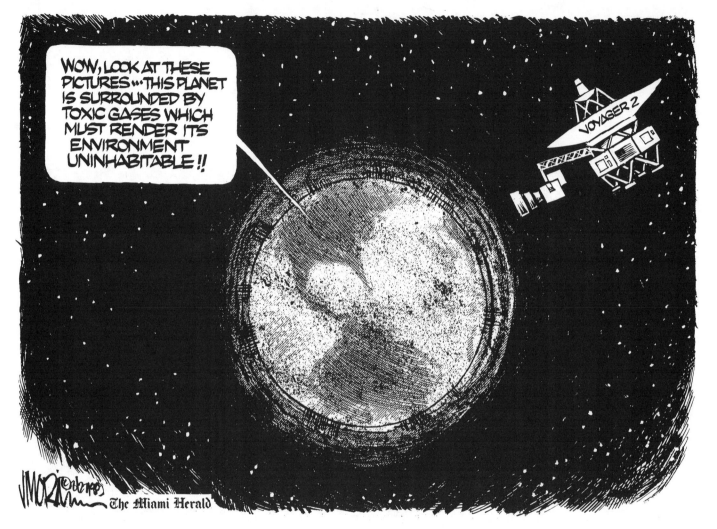

August 27, 1989

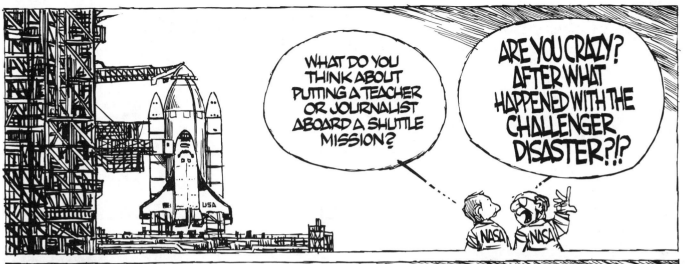

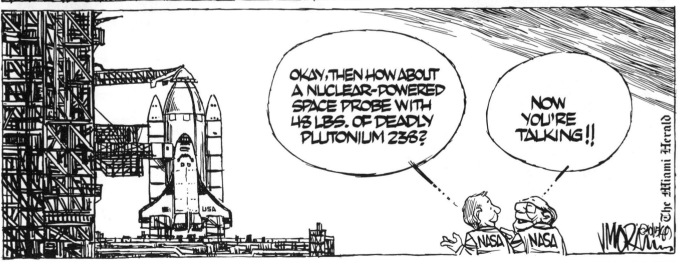

October 15, 1989

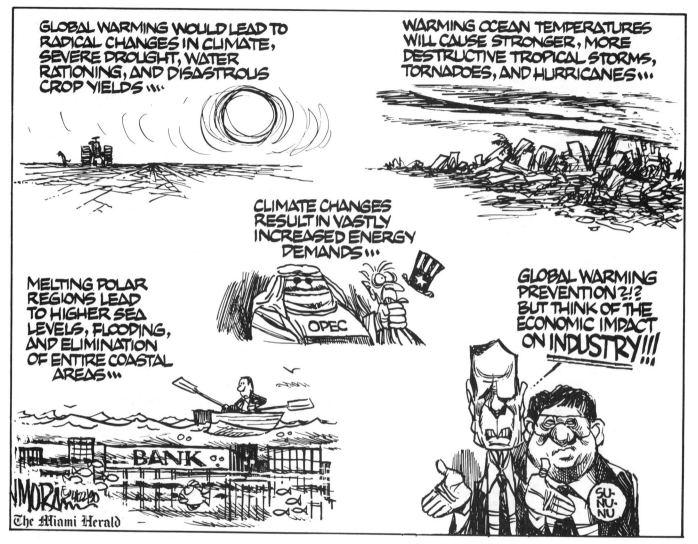

April 22, 1990

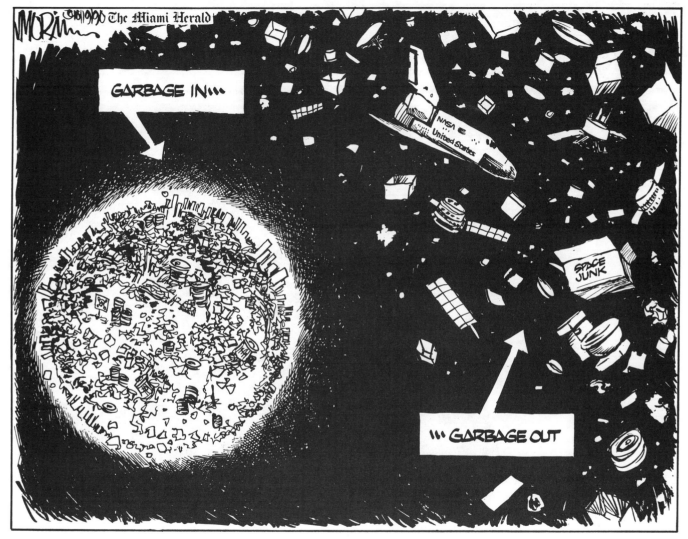

October 9, 1990

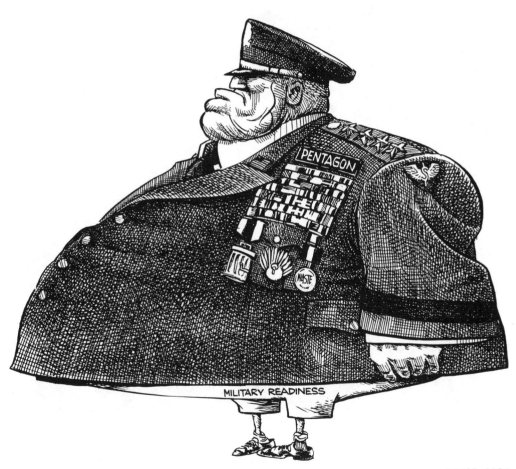

July 25, 1984

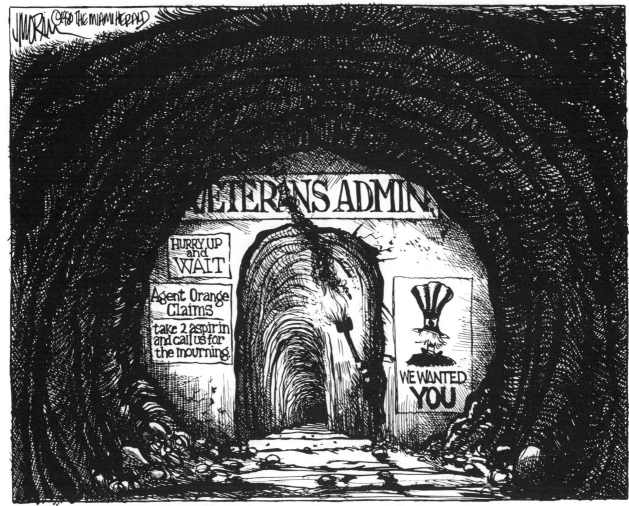

THE TUNNEL AT THE END OF THE TUNNEL.

February 5, 1980

Vietnam veterans suffering the effects of Agent Orange are given the cold shoulder.

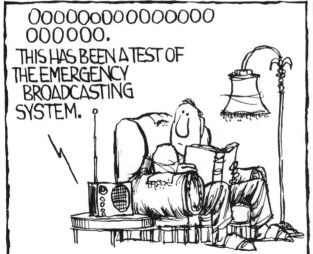

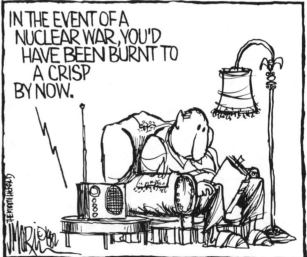

April 20, 1982

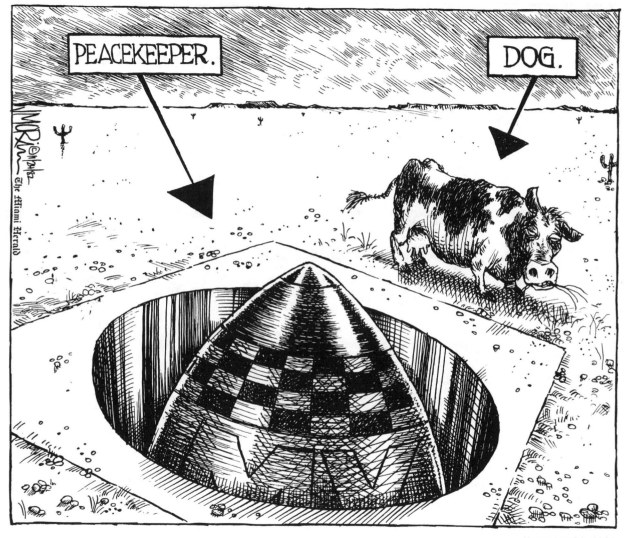

November 24, 1982

The MX missile is dubbed the "Peacekeeper."

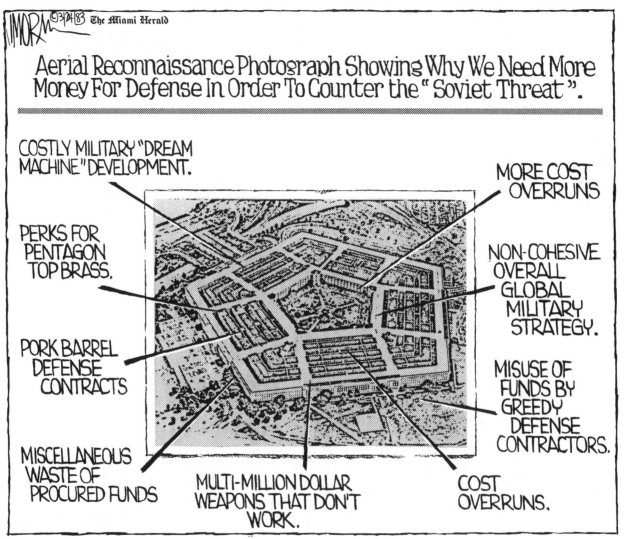

Signature: MORIN ©3/24/83 The Miami Herald

Aerial Reconnaissance Photograph Showing Why We Need More Money For Defense In Order To Counter the "Soviet Threat".

COSTLY MILITARY "DREAM MACHINE" DEVELOPMENT.

MORE COST OVERRUNS

PERKS FOR PENTAGON TOP BRASS.

NON-COHESIVE OVERALL GLOBAL MILITARY STRATEGY.

PORK BARREL DEFENSE CONTRACTS

MISUSE OF FUNDS BY GREEDY DEFENSE CONTRACTORS.

MISCELLANEOUS WASTE OF PROCURED FUNDS

MULTI-MILLION DOLLAR WEAPONS THAT DON'T WORK.

COST OVERRUNS.

March 24, 1983

A SPACE SHUTTLE EXPLODES

A NUCLEAR REACTOR EXPLODES

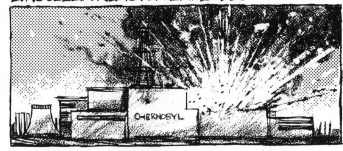

A TITAN ROCKET EXPLODES

A JET FIGHTER EXPLODES

A NUCLEAR SUB EXPLODES

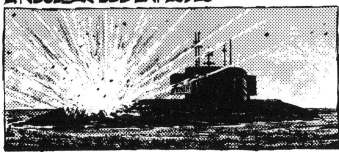

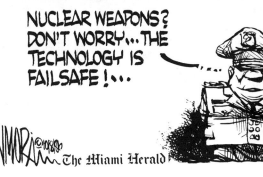

October 8, 1986

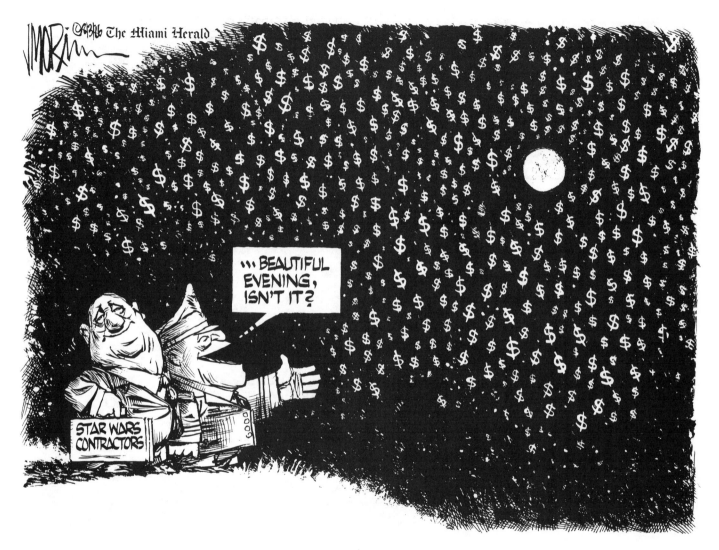

August 3, 1986

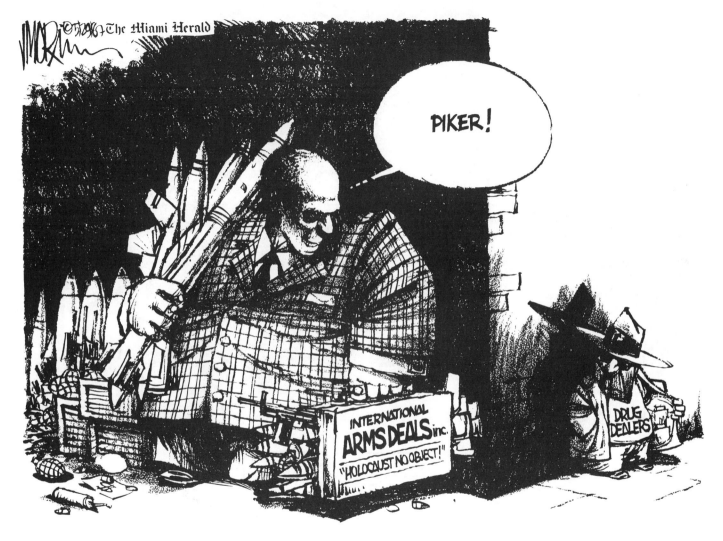

May 29, 1987

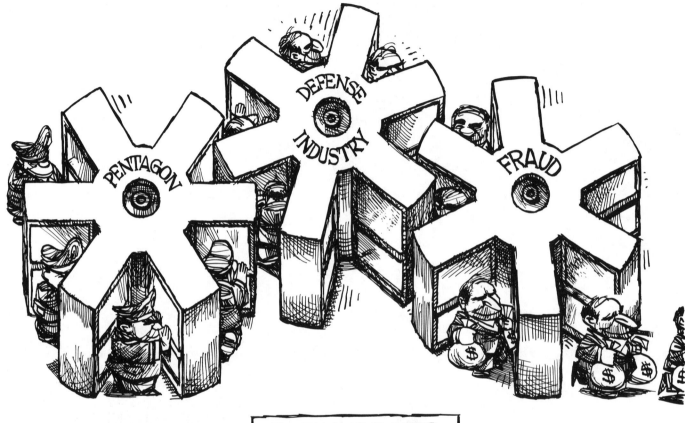

REVOLVING DOORS

June 21, 1988

The Pentagon procurement scandals.

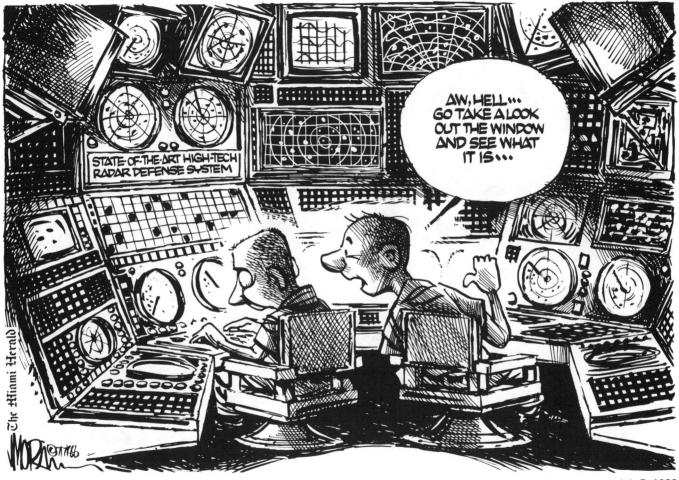

July 7, 1988

Despite being equipped with the most advanced radar technology available, Navy cruiser USS *Vincennes* accidentally shoots down Iran Air's Flight 655 in the Persian Gulf, killing all 290 passengers.

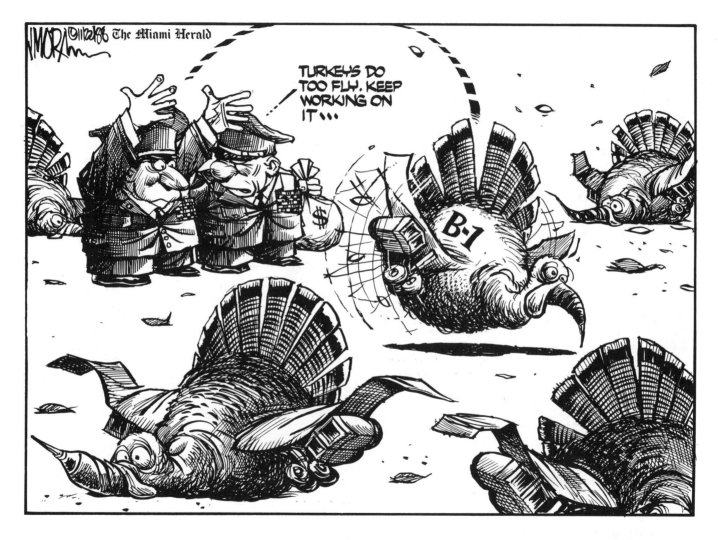

November 22, 1988

The B-1 bomber's cost-effectiveness comes under tough questioning . . .

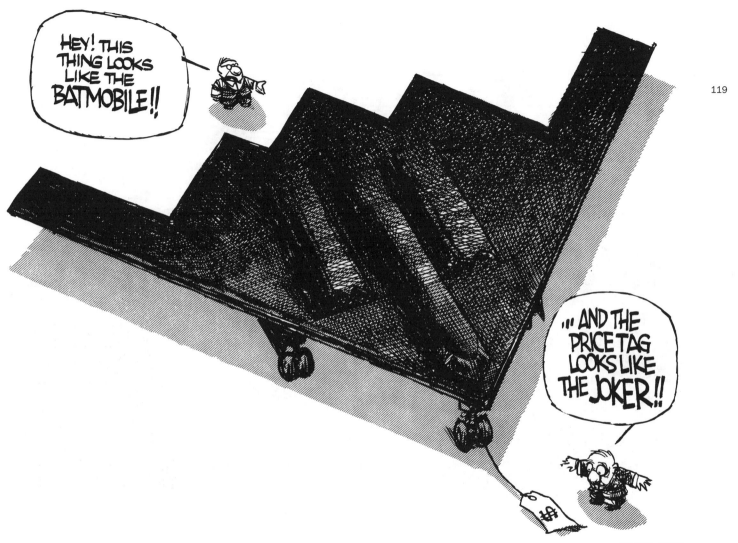

July 22, 1989

. . . as does the B-2 Stealth Bomber.

120

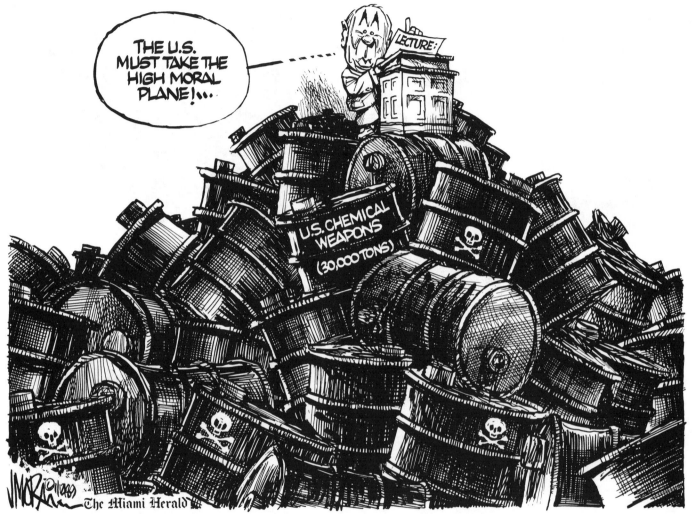

January 12, 1989

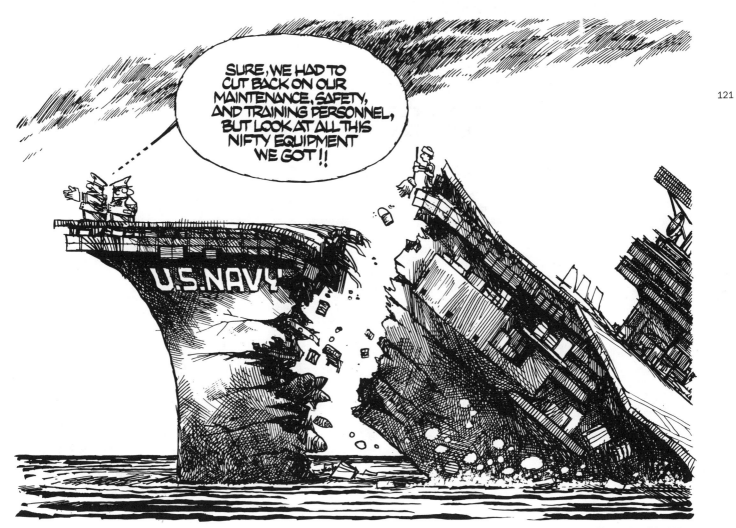

November 16, 1989

HALF-BILLION DOLLAR, TAXPAYER FUNDED U.S. STEALTH BOMBER PENETRATING ENEMY AIR SPACE, SURPRISING THEIR DEFENSES BY ELUDING SOPHISTICATED RADAR SO THAT IT MAY VALIANTLY RETALIATE AGAINST THE ''·

''' STEALTH SOVIET THREAT

March 6, 1990

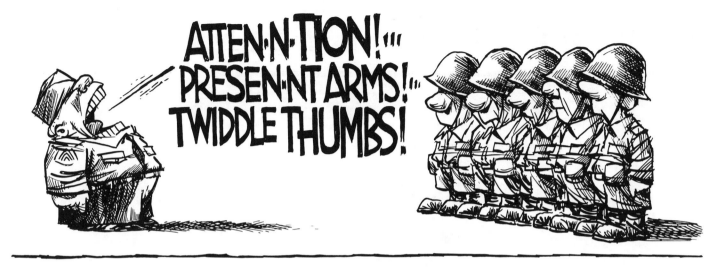

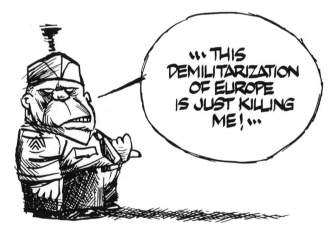

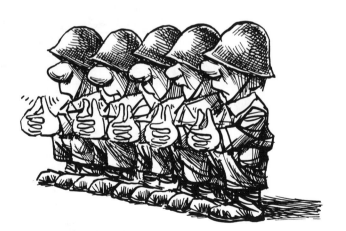

December 27, 1989

The Berlin Wall crumbles, and Pentagon brass worry about likely defense-budget cutting.

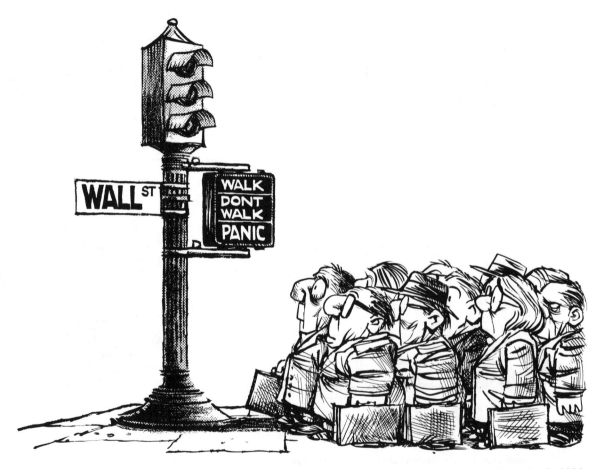

December 2, 1986

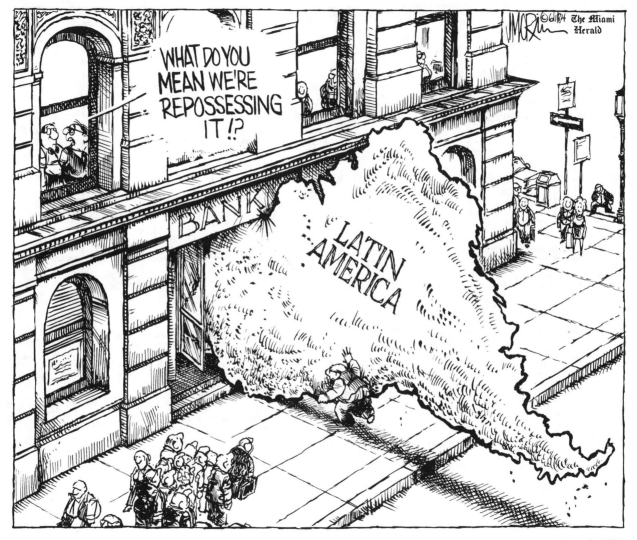

June 1, 1984

The Latin American debt crisis.

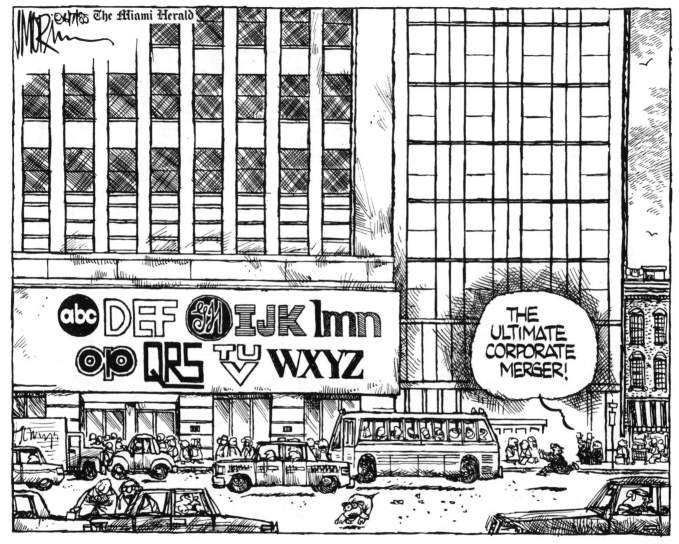

June 7, 1985

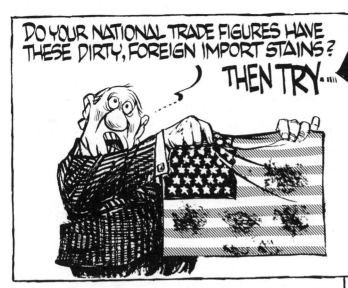

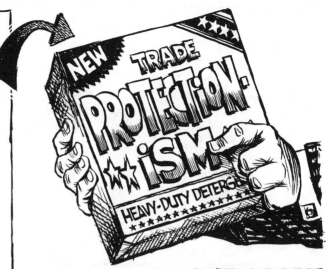

127

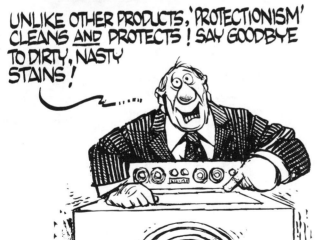

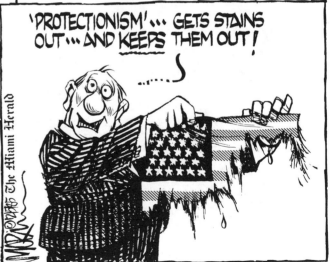

December 5, 1985

128

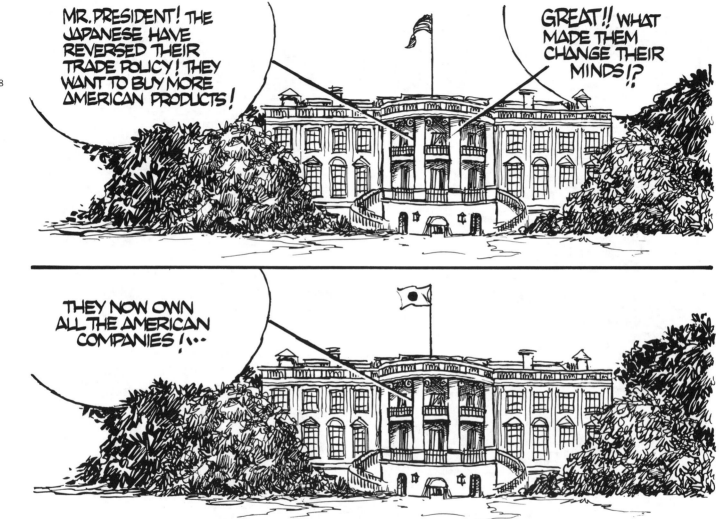

May 8, 1989

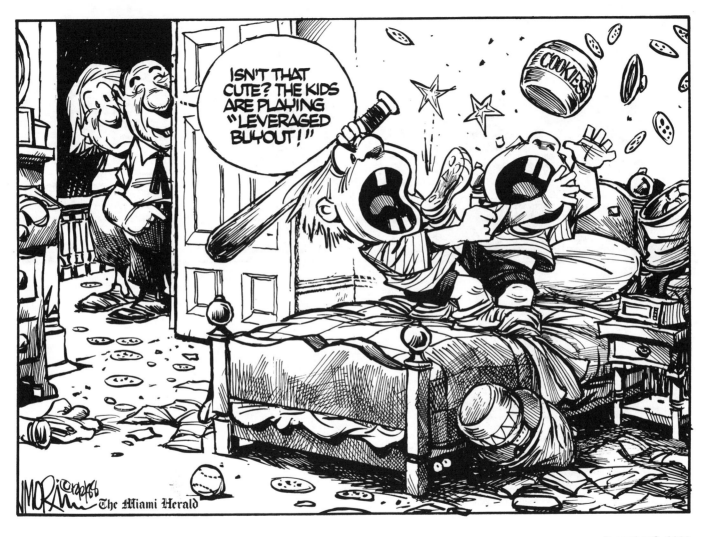

December 2, 1988

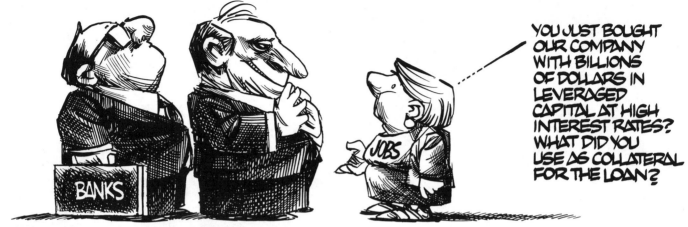

YOU JUST BOUGHT OUR COMPANY WITH BILLIONS OF DOLLARS IN LEVERAGED CAPITAL AT HIGH INTEREST RATES? WHAT DID YOU USE AS COLLATERAL FOR THE LOAN?

The Miami Herald

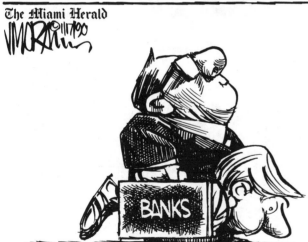

January 17, 1990

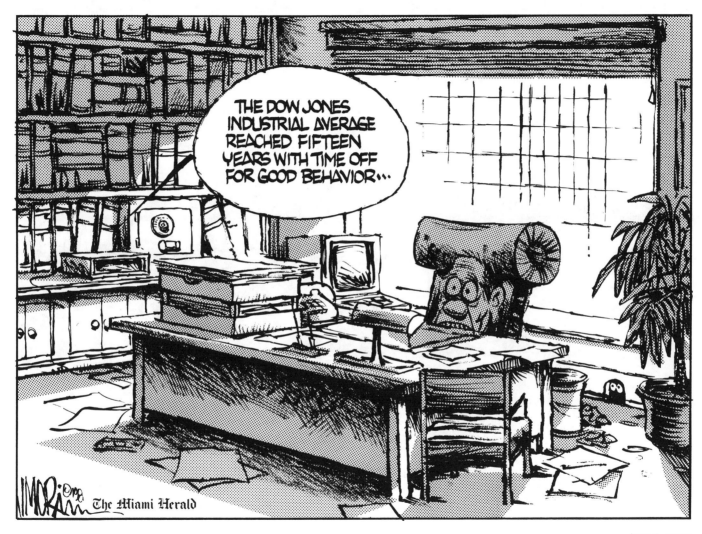

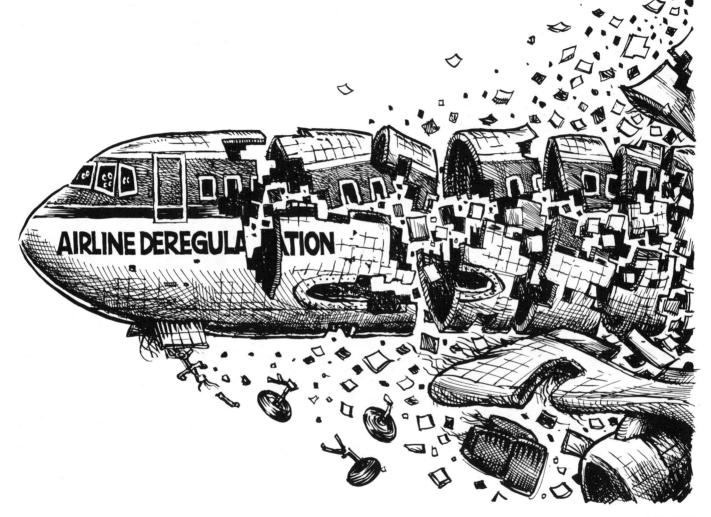

August 25, 1987

Airline deregulation results in financial uncertainty, crowded skies, deteriorating safety and service standards, and a record number of customer complaints.

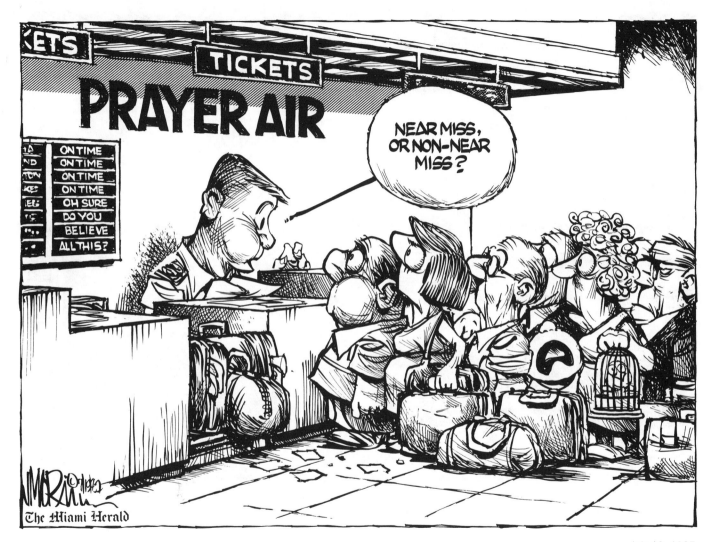

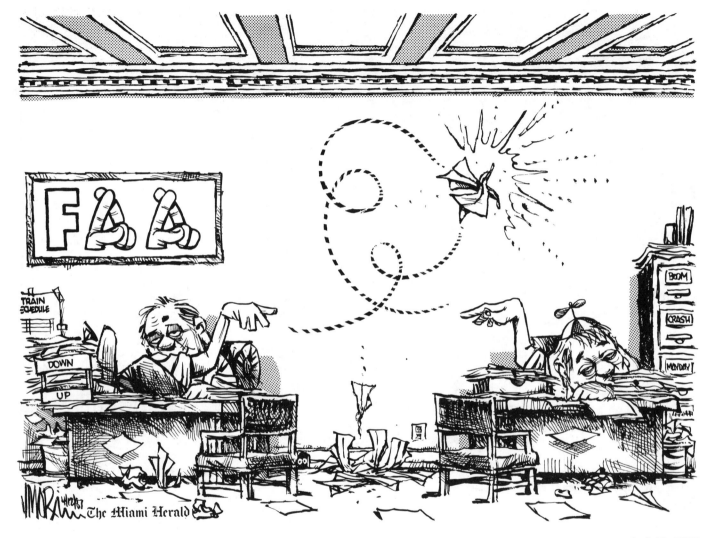

April 12, 1987

Federal Aviation Administration overseeing of airline safety comes under fire.

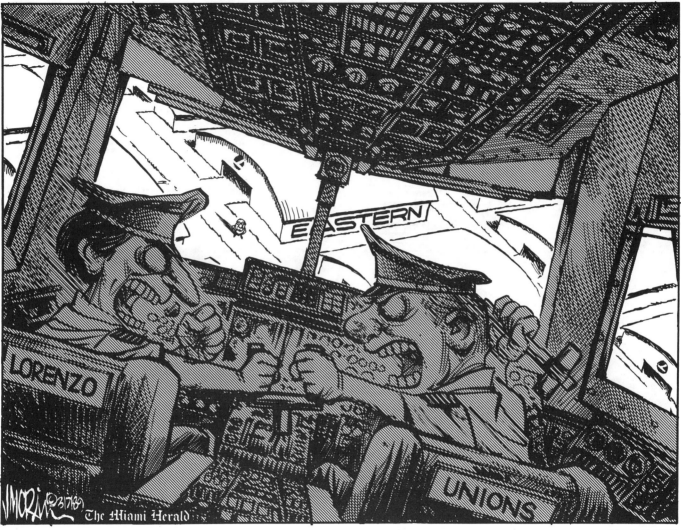

March 7, 1989

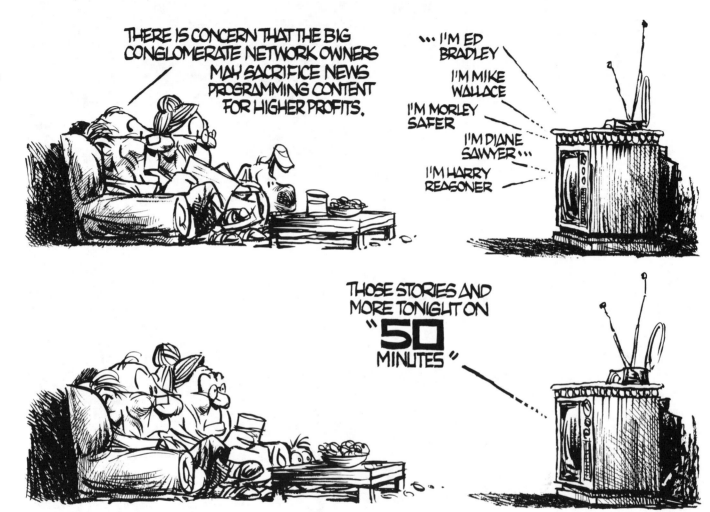

May 10, 1987

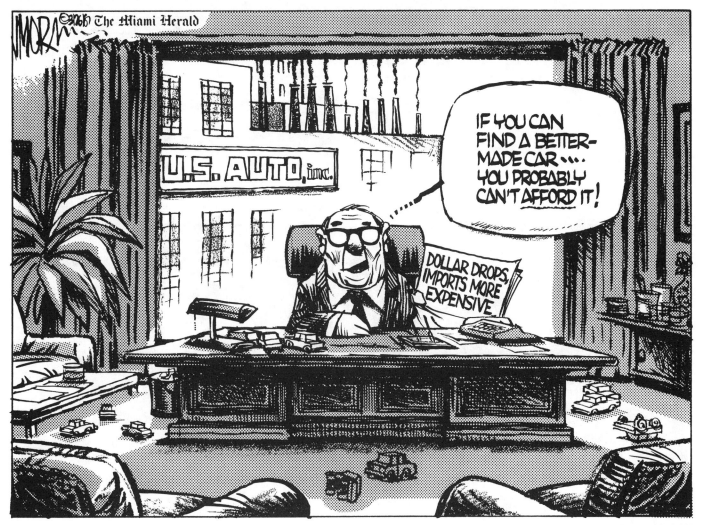

March 26, 1987

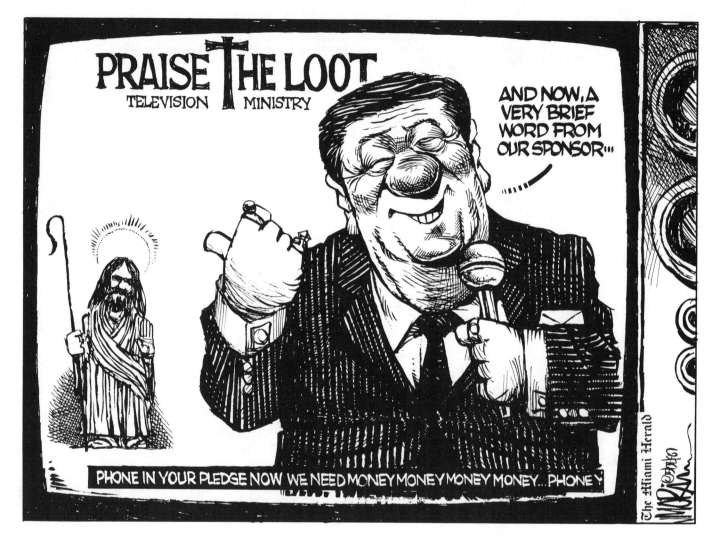

138

May 28, 1987

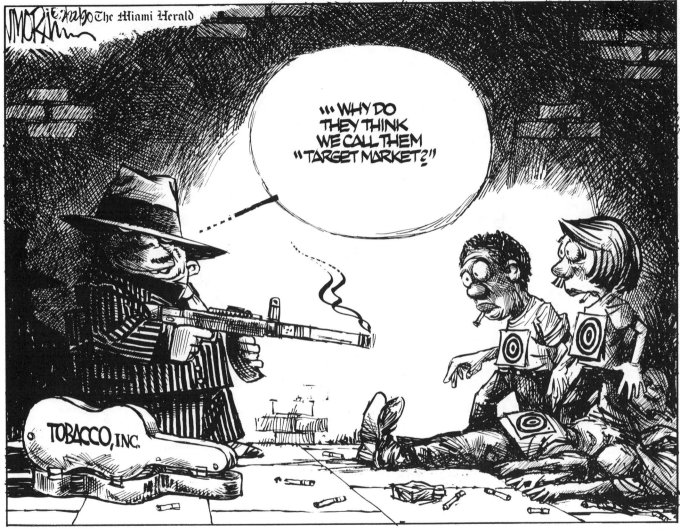

February 22, 1990

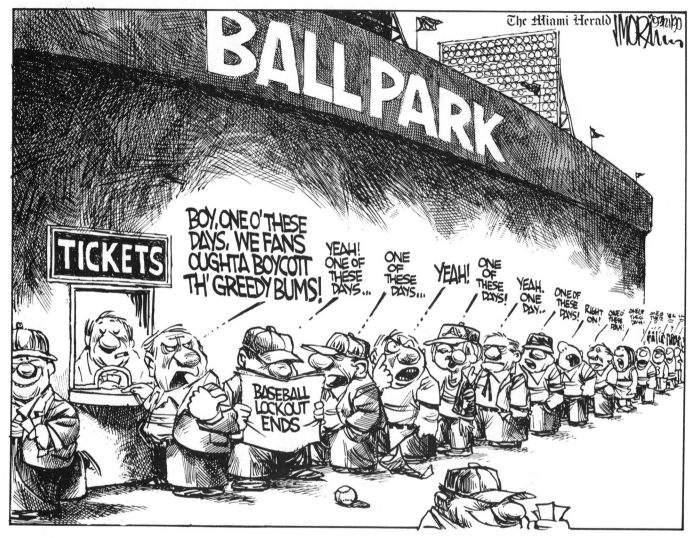

March 21, 1990

WHAT TO DO DURING THE N.F.L. STRIKE...

READ A BOOK...

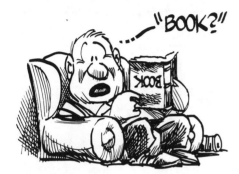

TALK WITH THE WIFE...

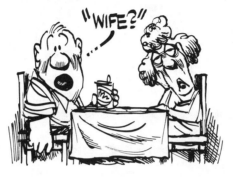

PLAY WITH YOUR KIDS...

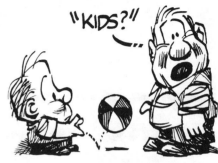

WRITE A LETTER...

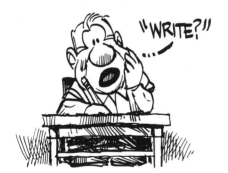

THINK...

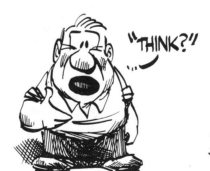

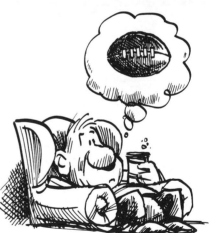

September 30, 1987

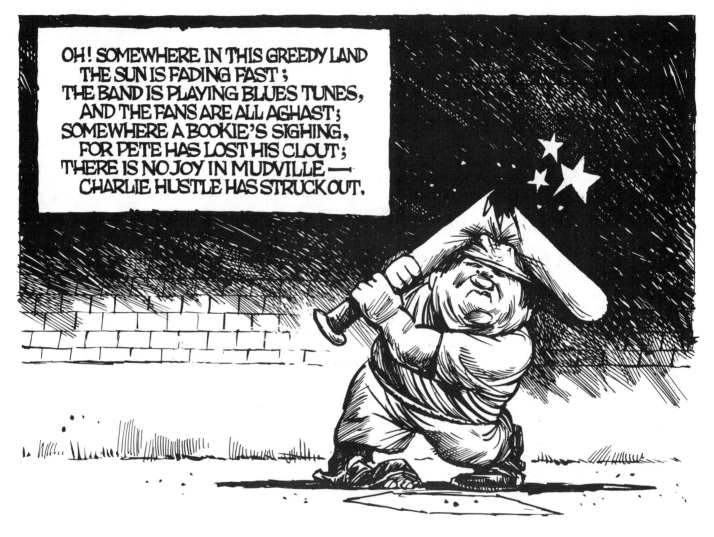

142

August 25, 1989

Baseball superstar Pete Rose is caught gambling on sports events.

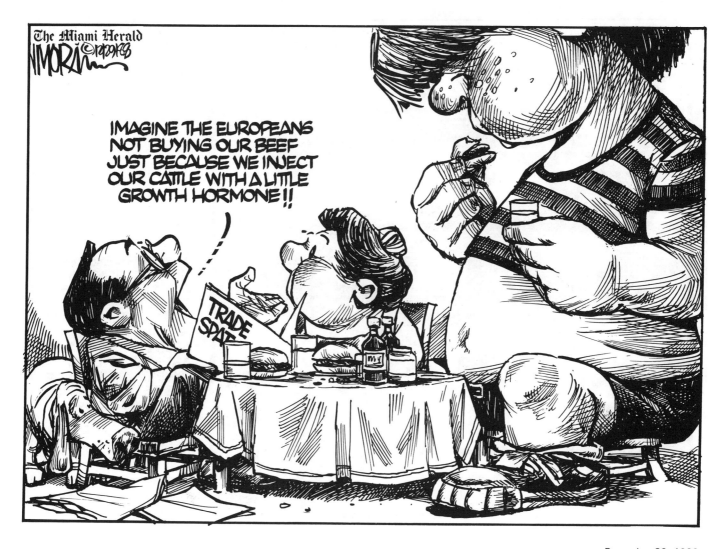

December 29, 1988

144

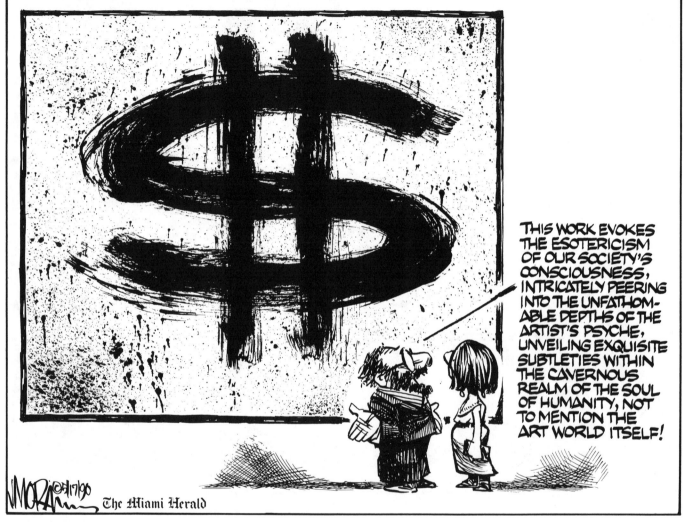

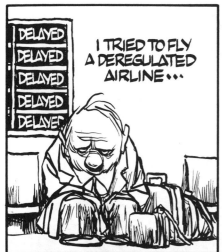

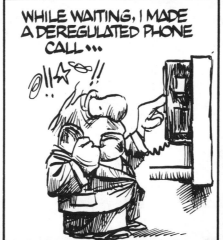

145

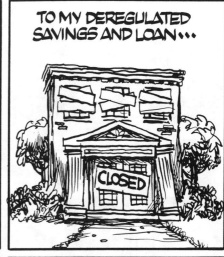

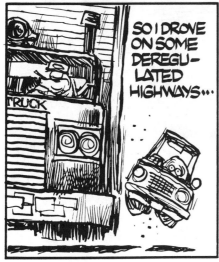

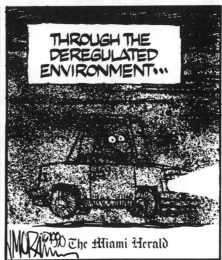

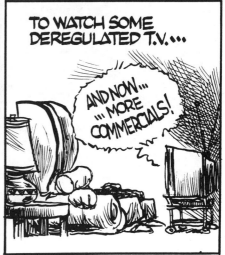

September 6, 1990

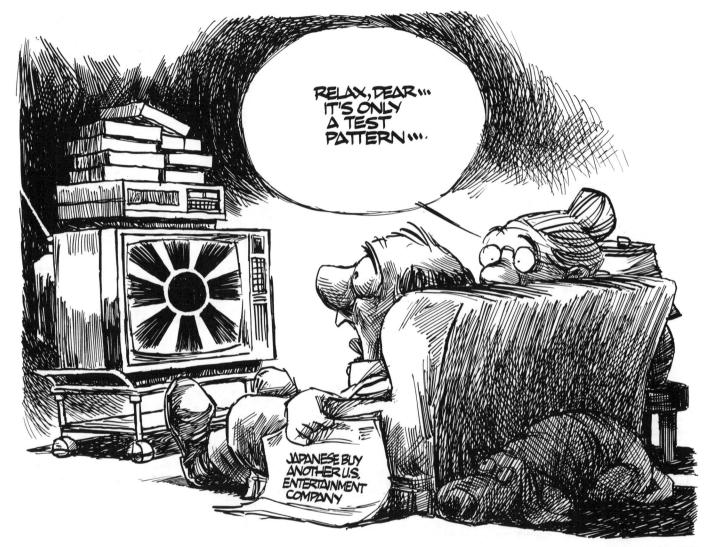

146

November 29, 1990

147

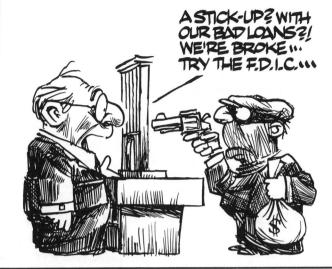
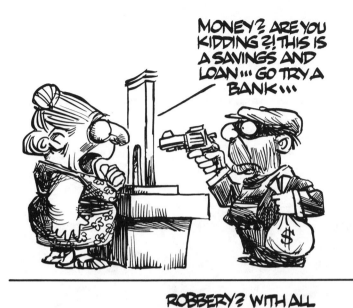
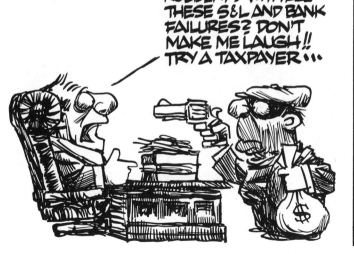
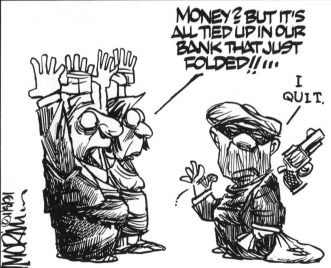

January 8, 1991

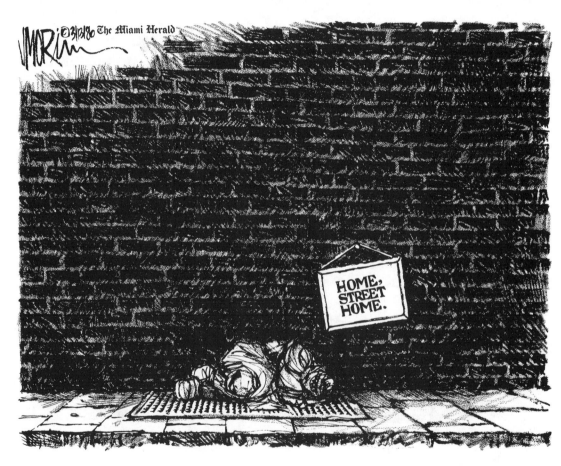

March 13, 1986

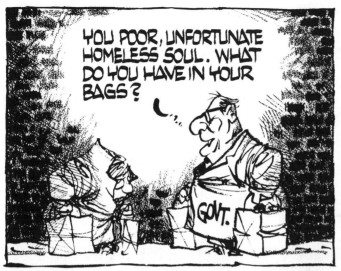

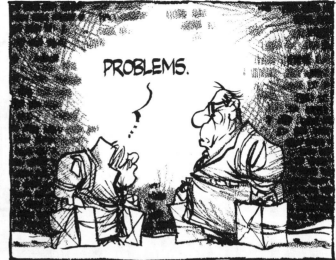

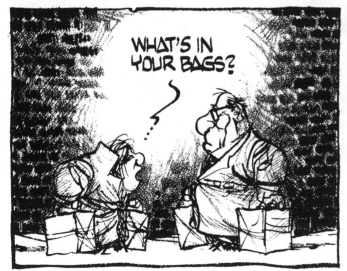

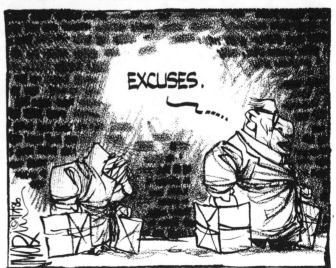

January 7, 1986

150

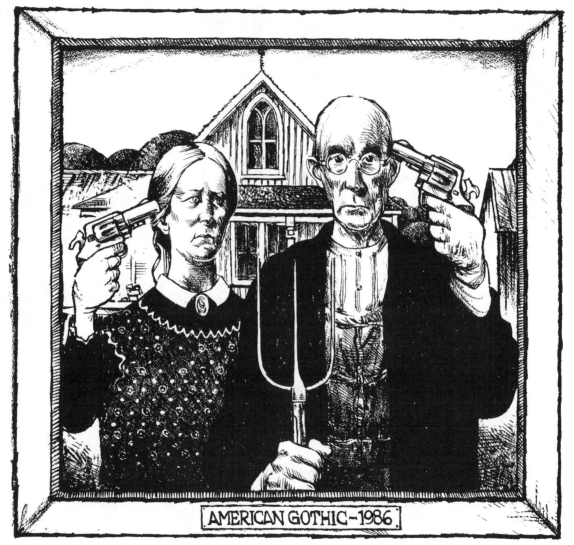

AMERICAN GOTHIC–1986

January 12, 1986

Foreclosures of family farms reach alarming numbers.

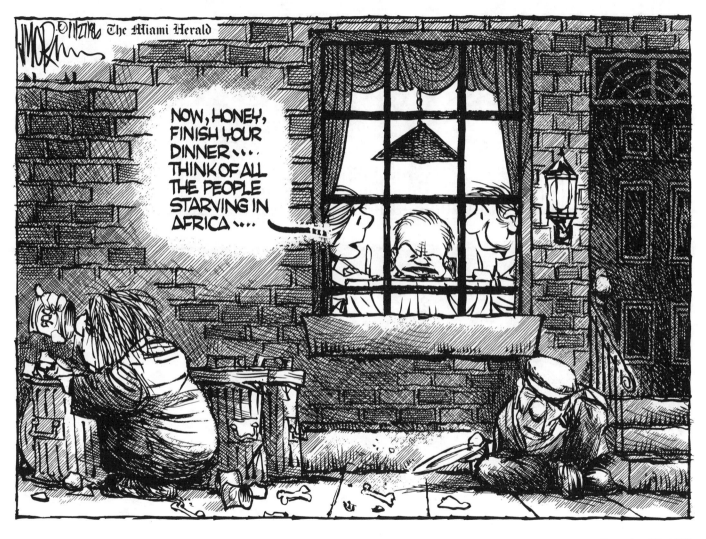

November 27, 1986

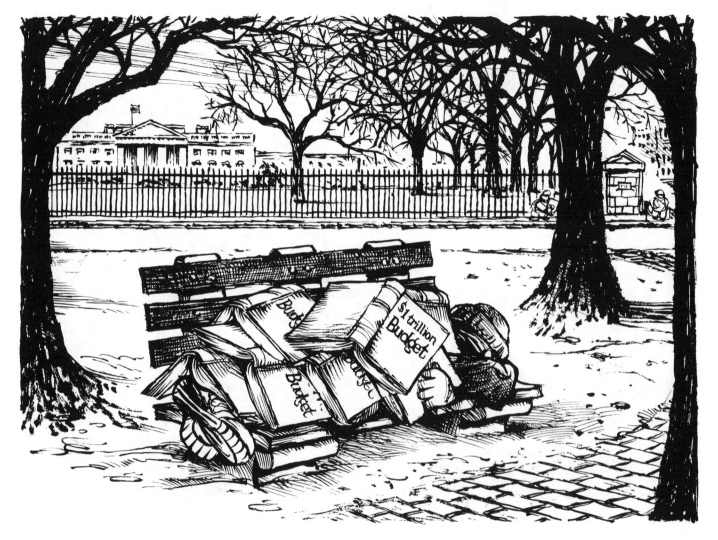

January 7, 1987

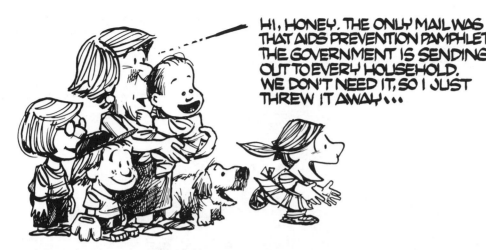

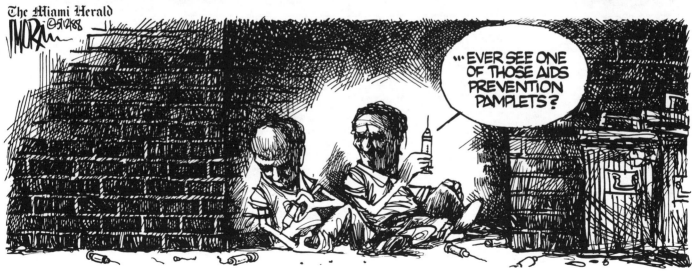

May 12, 1988

154

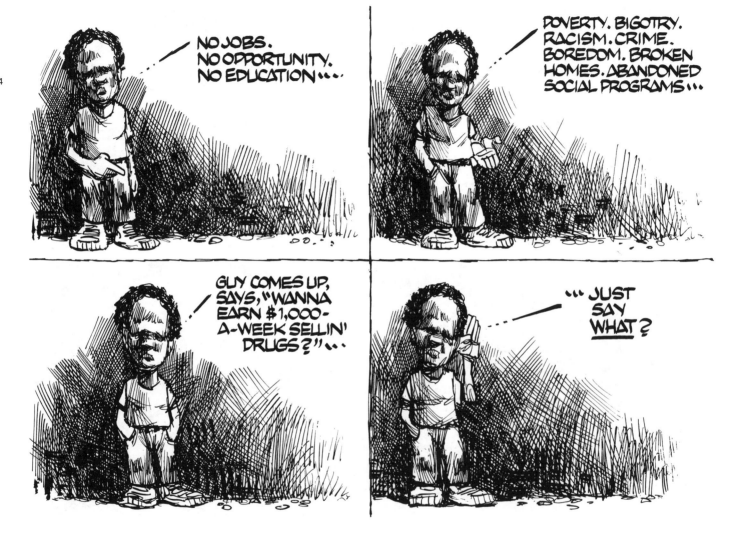

September 6, 1989

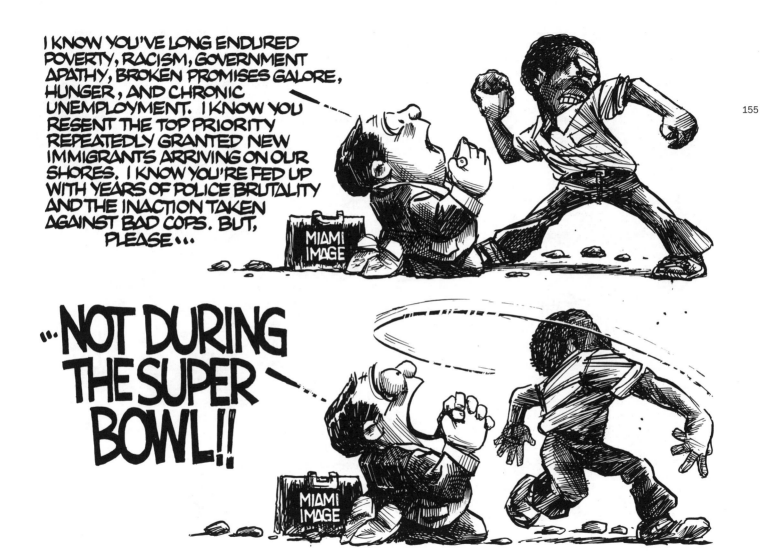

January 18, 1989

As Miami hosts the Super Bowl, police officer William Lozano shoots and kills two black men fleeing on a motorcycle, resulting in yet another mini-riot in Miami's Overtown district.

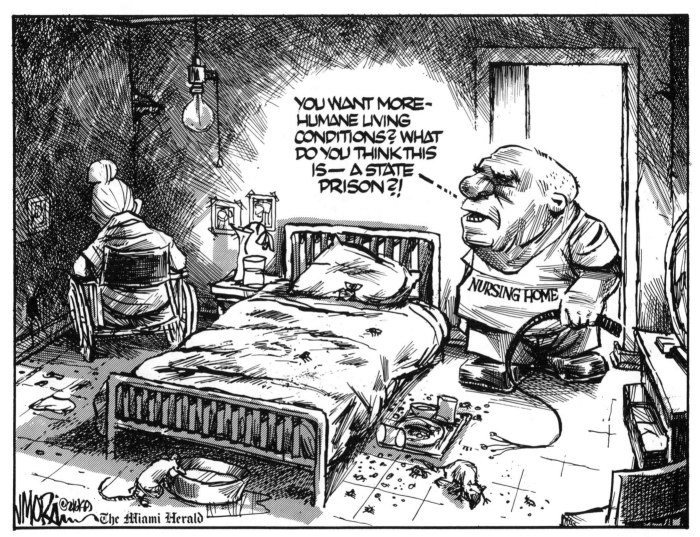

February 6, 1989

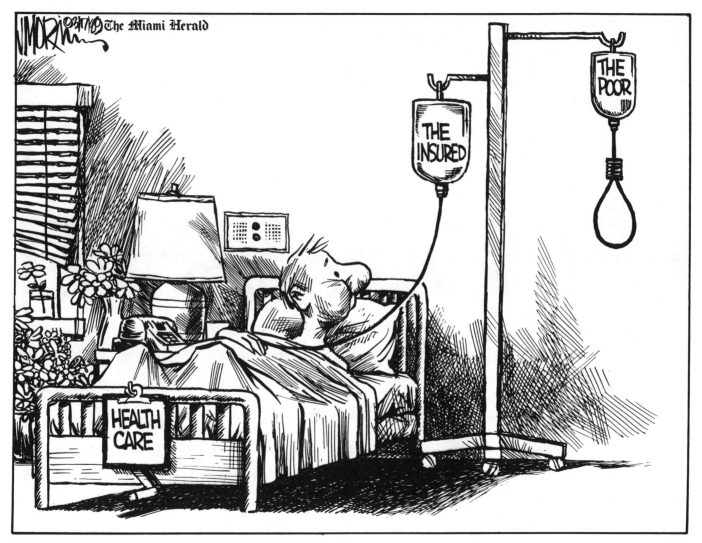

March 17, 1989

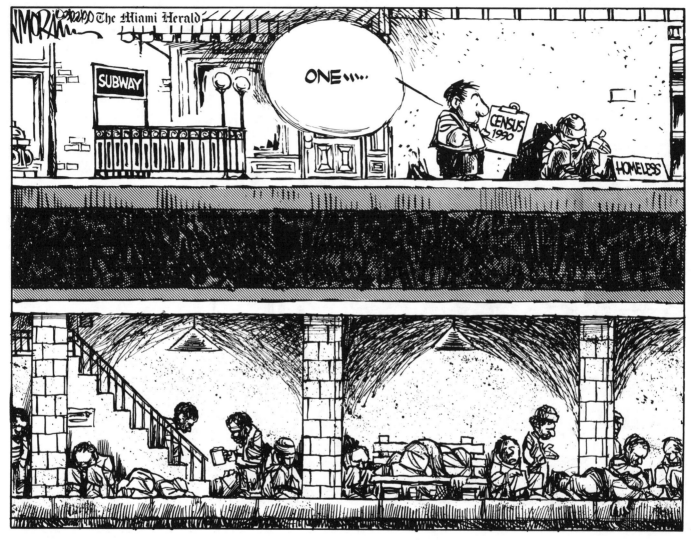

March 22, 1990

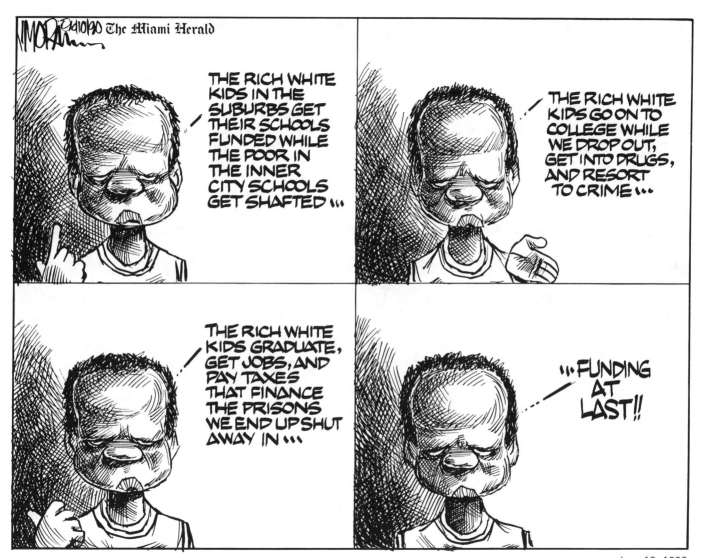

June 10, 1990

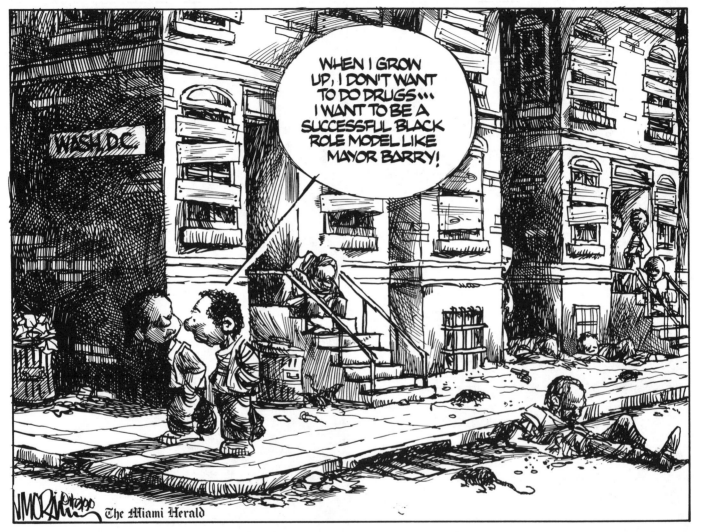

January 23, 1990

Washington D.C.'s Mayor Marion Barry is arrested after being caught smoking crack cocaine.

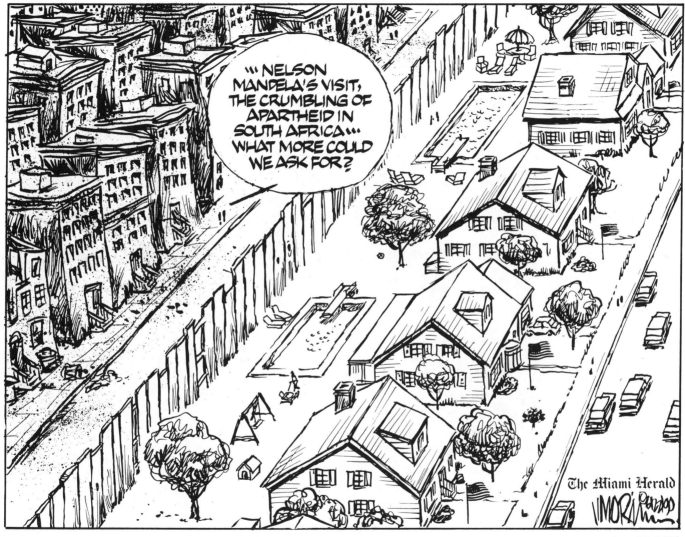

June 22, 1990

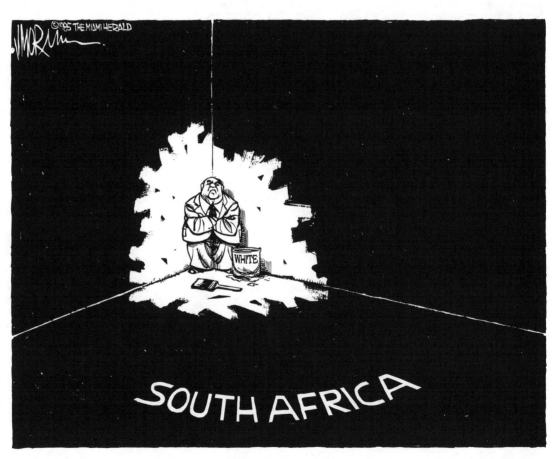

SOUTH AFRICA

April 23, 1985

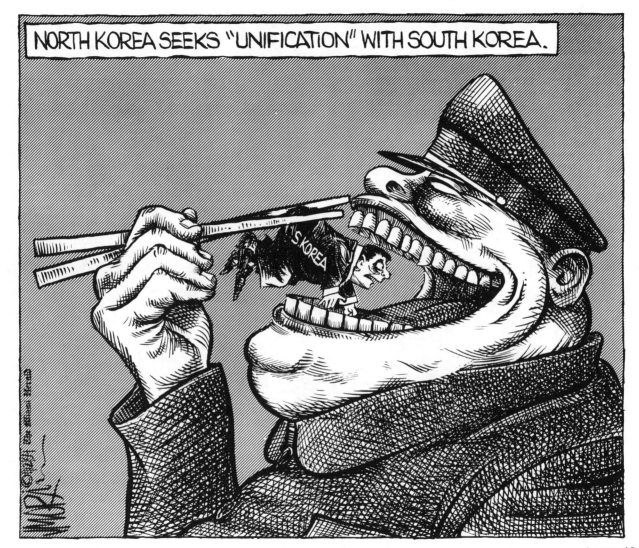

NORTH KOREA SEEKS "UNIFICATION" WITH SOUTH KOREA.

January 12, 1984

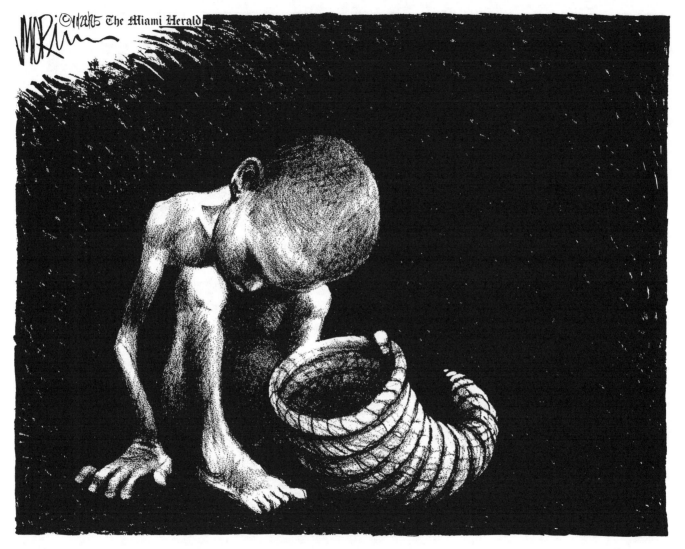

The Miami Herald

November 28, 1985

Famine in Africa.

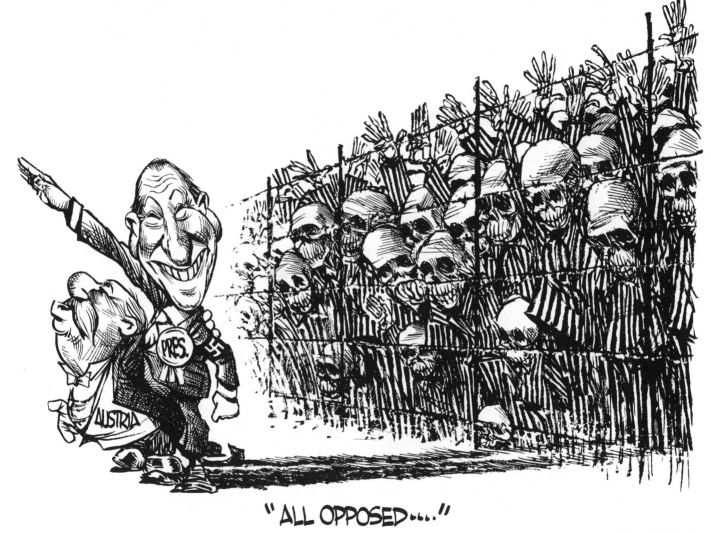

"ALL OPPOSED....."

June 10, 1986

Kurt Waldheim's Nazi past comes back to haunt him.

166

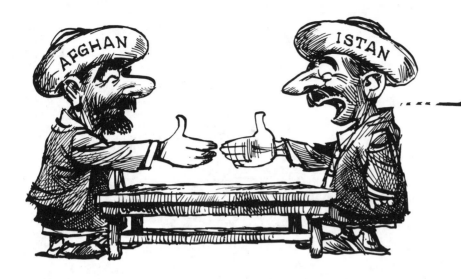

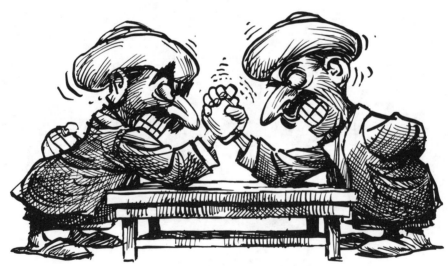

May 18, 1988

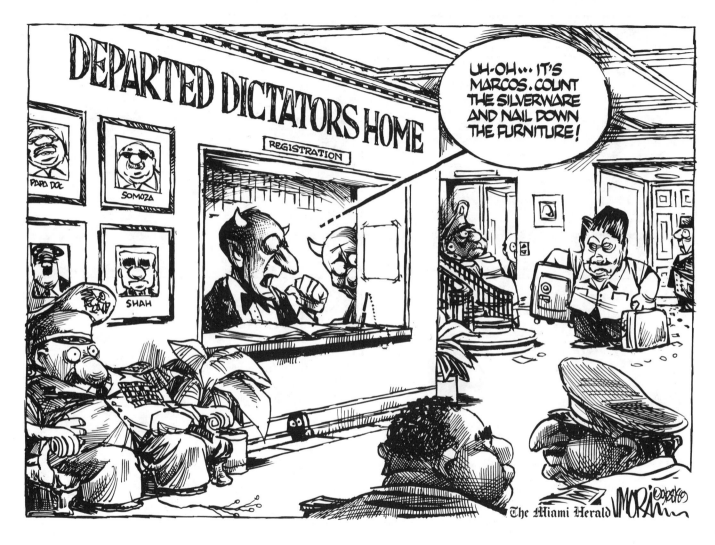

September 28, 1989

Ferdinand Marcos dies.

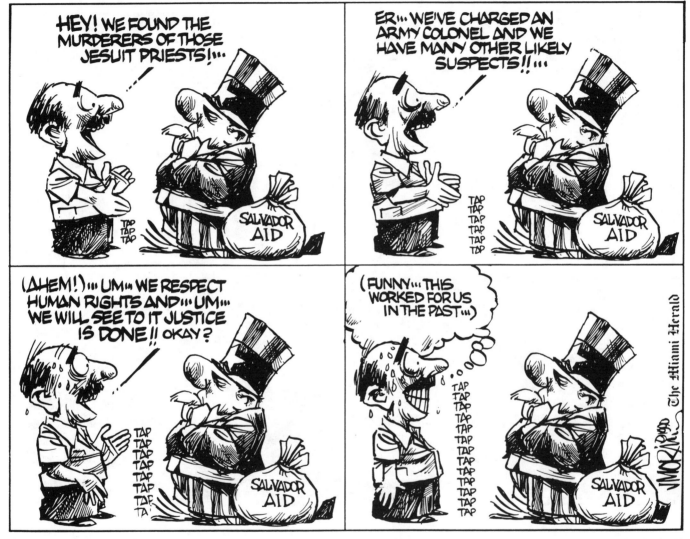

168

May 11, 1990

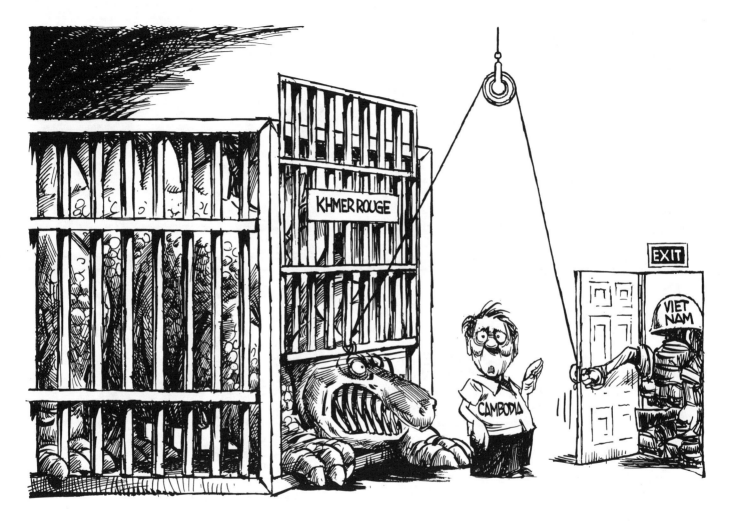

October 1, 1989

As Vietnam withdraws from Cambodia, the genocidal Khmer Rouge are poised to retake the Killing Fields.

170

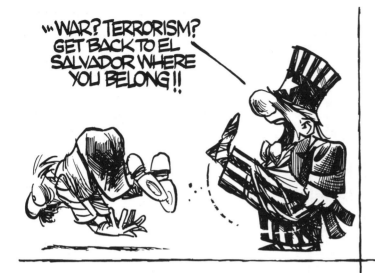

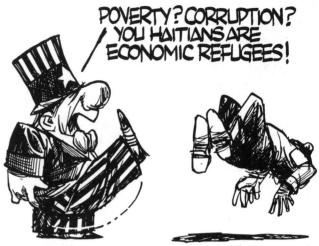

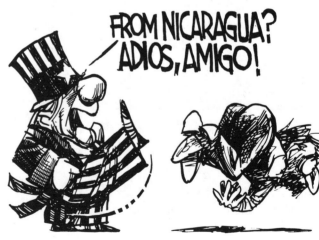

December 15, 1989

U.S. immigration policy.

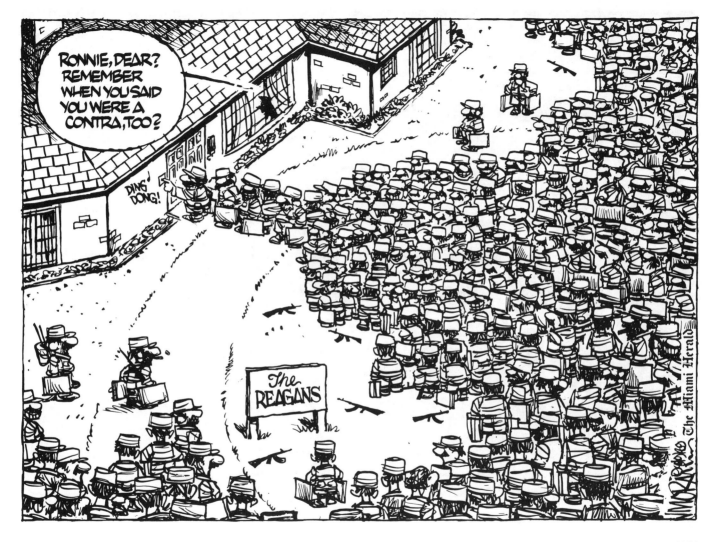

August 9, 1989

As the peace process moved forward, the Contras found themselves with little to do.

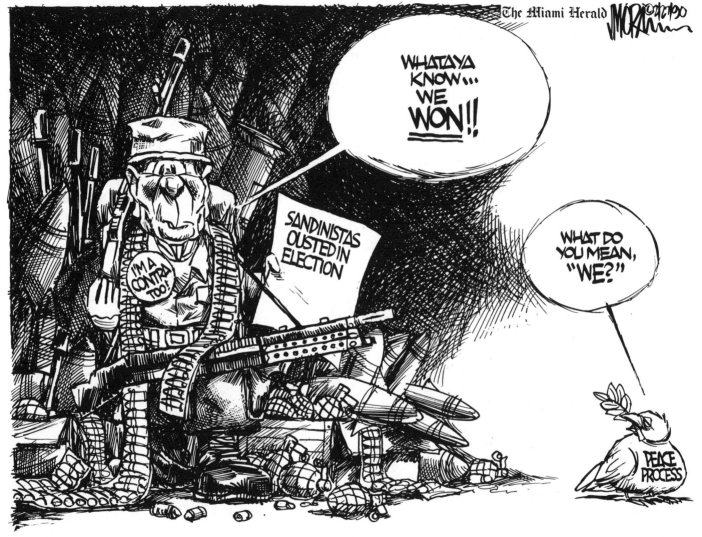

February 27, 1990

Violeta Chamorro wins a free election in Nicaragua.

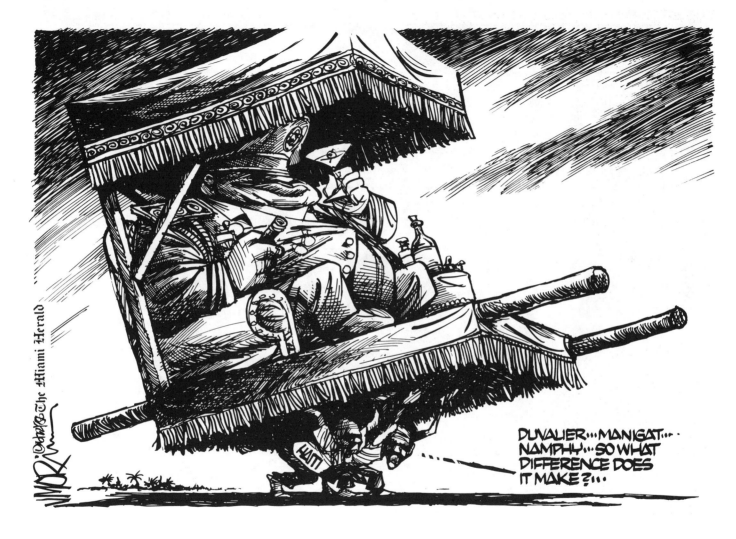

DUVALIER····MANIGAT····
NAMPHY····SO WHAT
DIFFERENCE DOES
IT MAKE?····

June 22, 1986

The poorest nation in the Western Hemisphere is burdened by one corrupt regime after another.

174

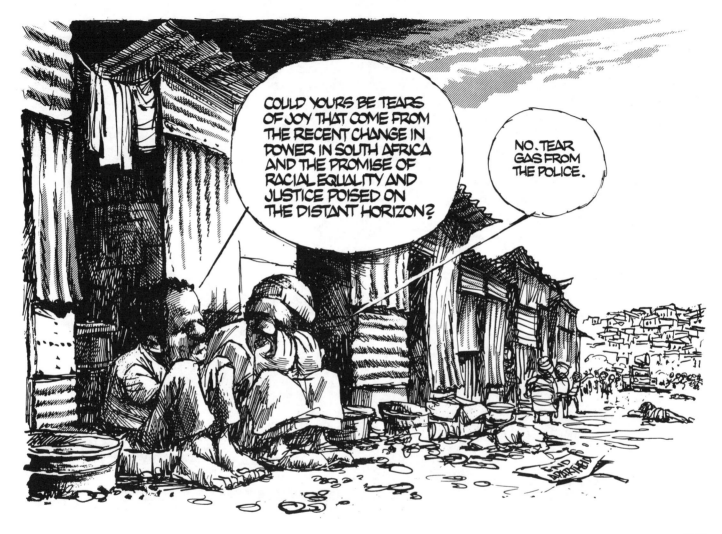

September 10, 1989

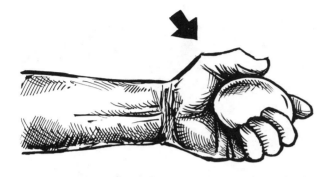
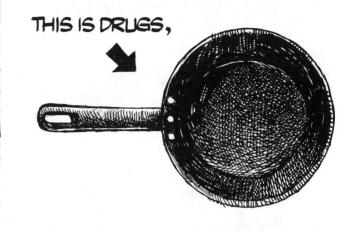

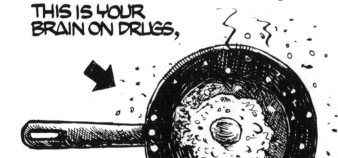
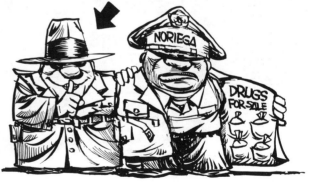

February 11, 1988

Panamanian dictator Manuel Noriega's alliance with Colombian drug dealers is overlooked by U.S. government officials in favor of his assistance to U.S. intelligence agencies.

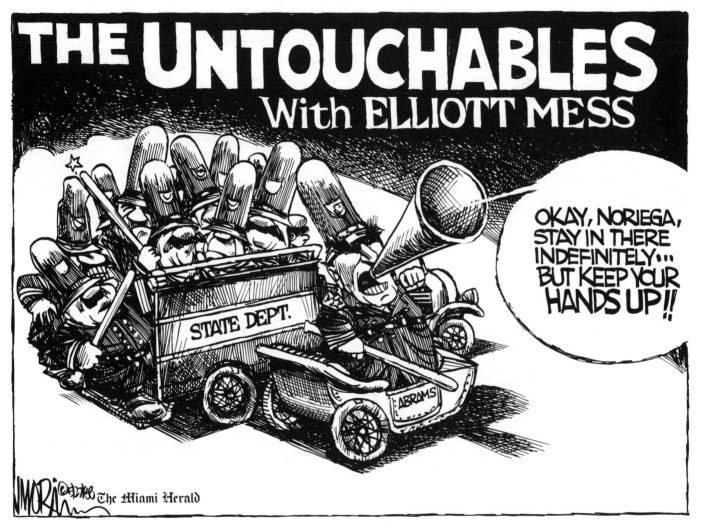

May 27, 1988

U.S. efforts to oust Noriega are repeatedly frustrated.

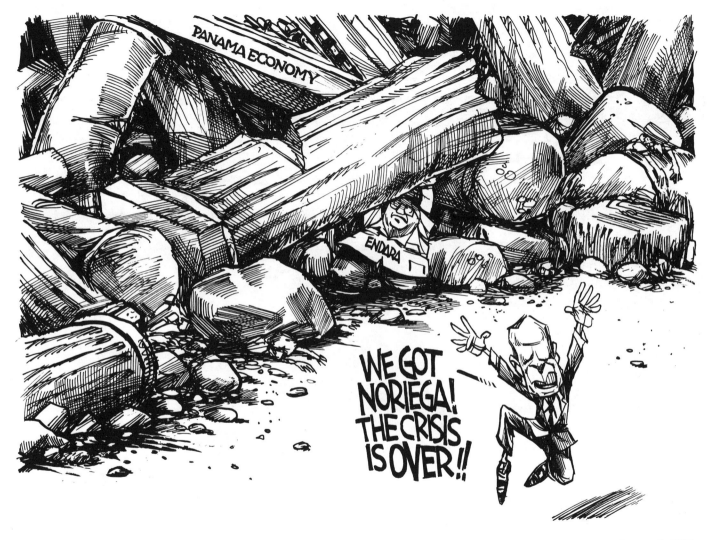

January 5, 1990

The United States invades Panama, captures and arrests Noriega, and extradites him to Miami to stand trial for drug trafficking.

178

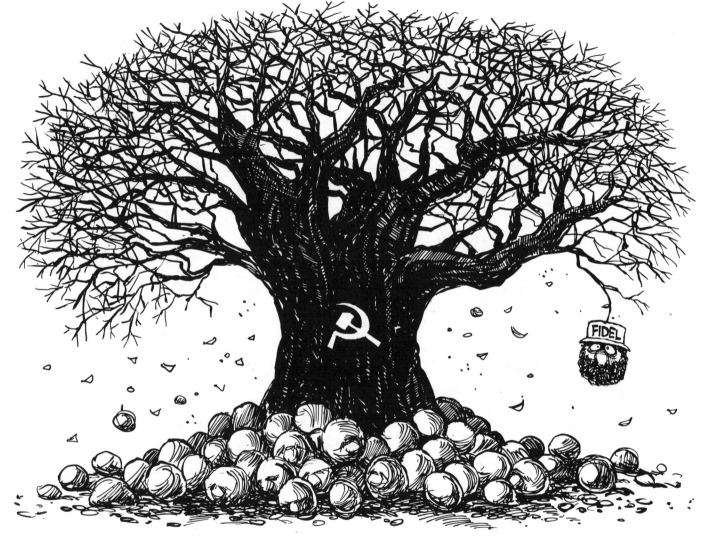

February 28, 1990

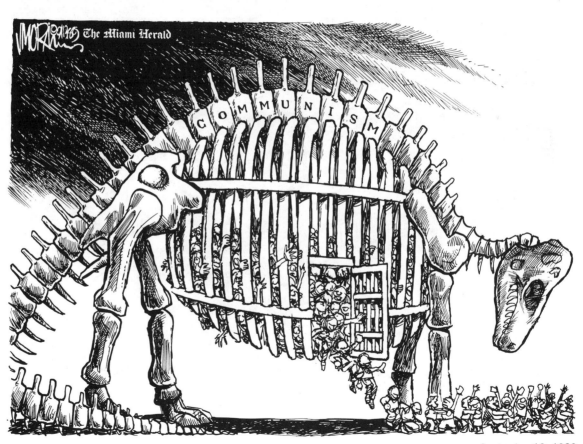

September 13, 1989

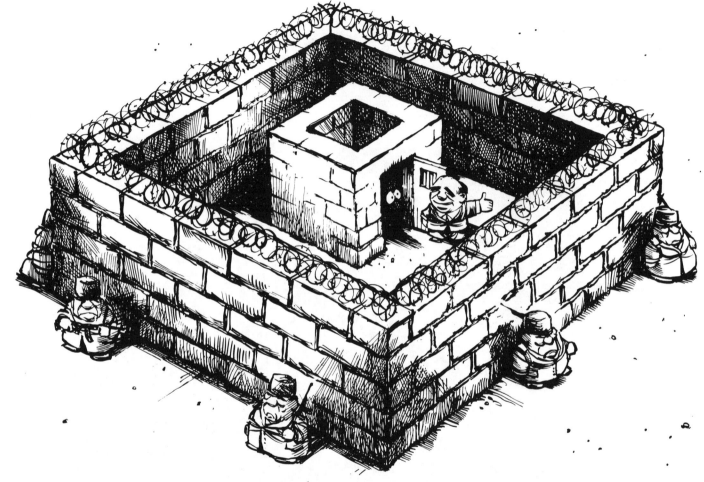

GLASNOST (the new soviet openness)

November 5, 1987

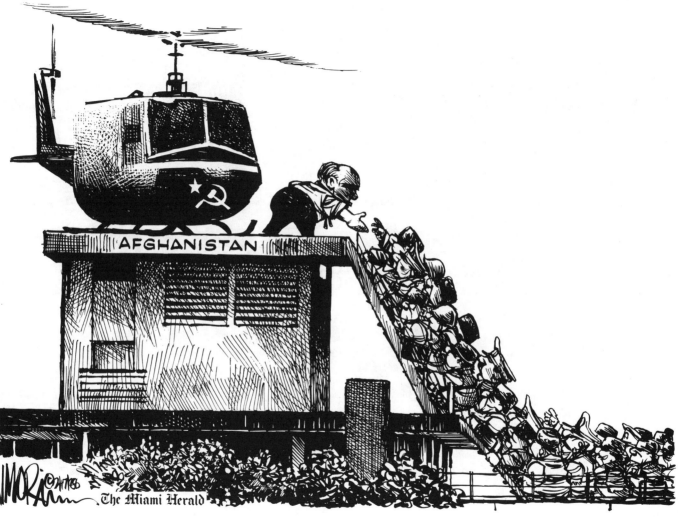

February 17, 1988

The Soviets withdraw from "their Vietnam."

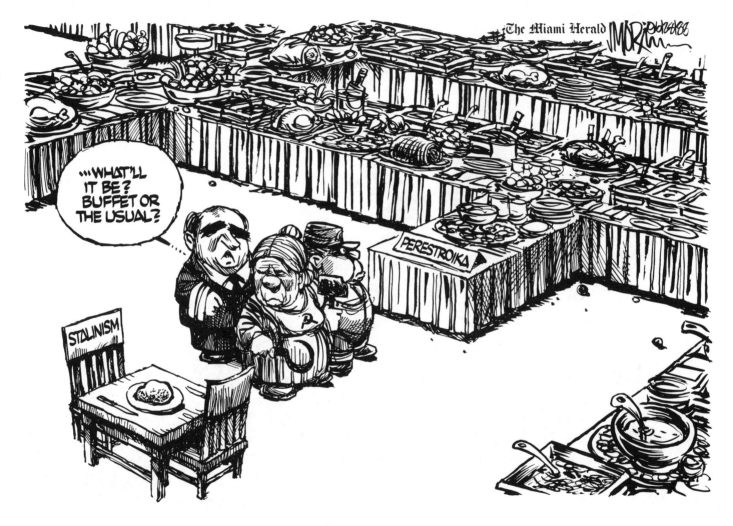

June 28, 1988

Gorbachev attempts a complete overhaul of the disastrous Soviet economy.

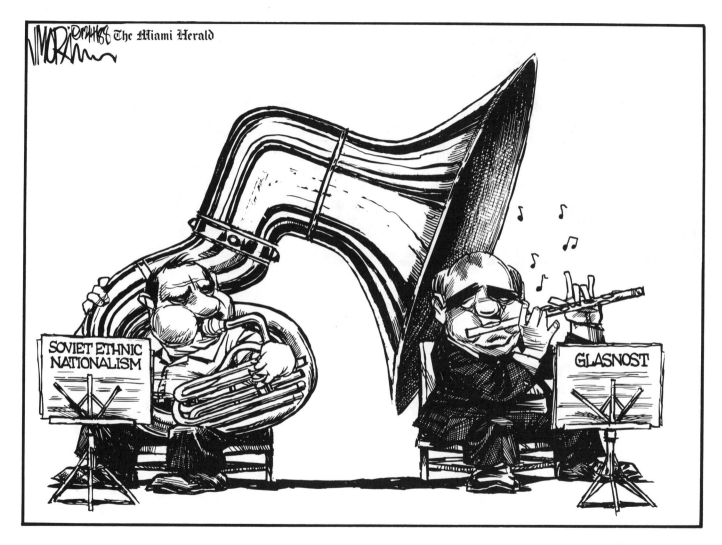

The Miami Herald

December 4, 1988

Gorbachev's "openness" policy has unexpected repercussions.

184

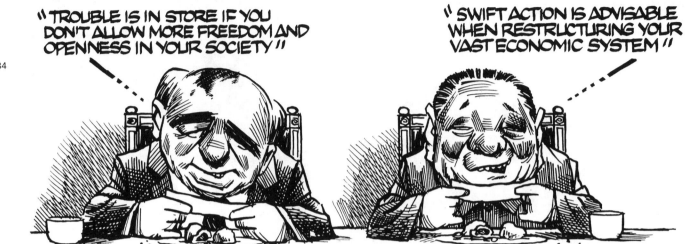

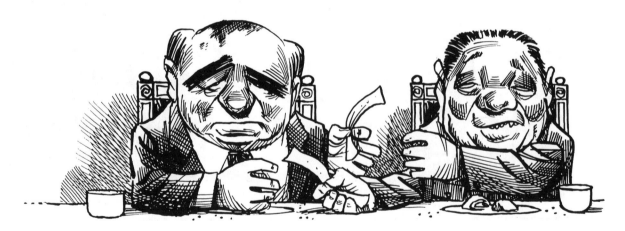

May 19, 1989

Gorbachev meets with Chinese leaders . . .

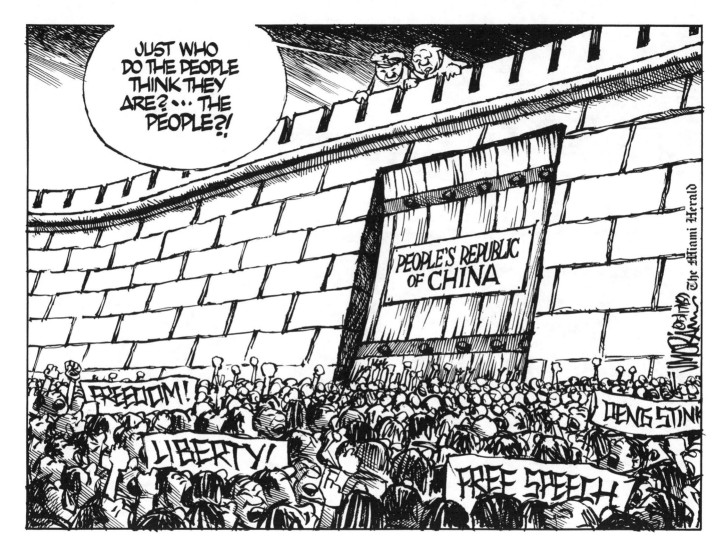

May 17, 1989

. . . **sparking massive demonstrations by freedom-starved Chinese citizens.**

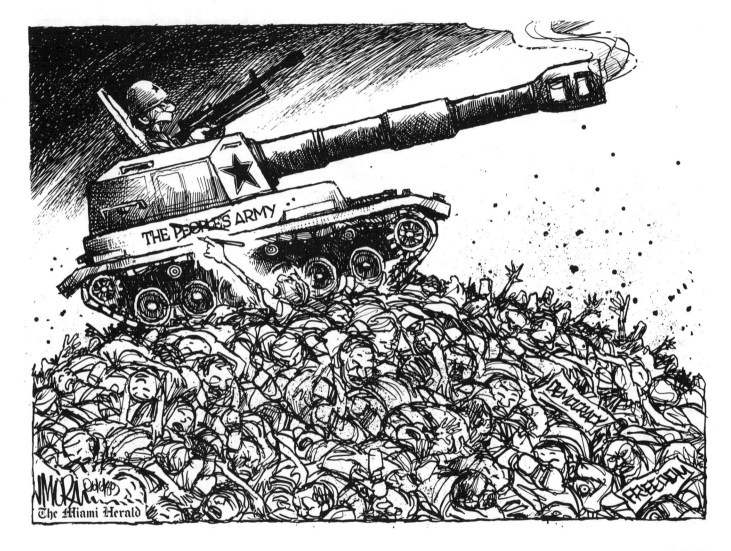

June 6, 1989

The Tiananmen Square massacre . . .

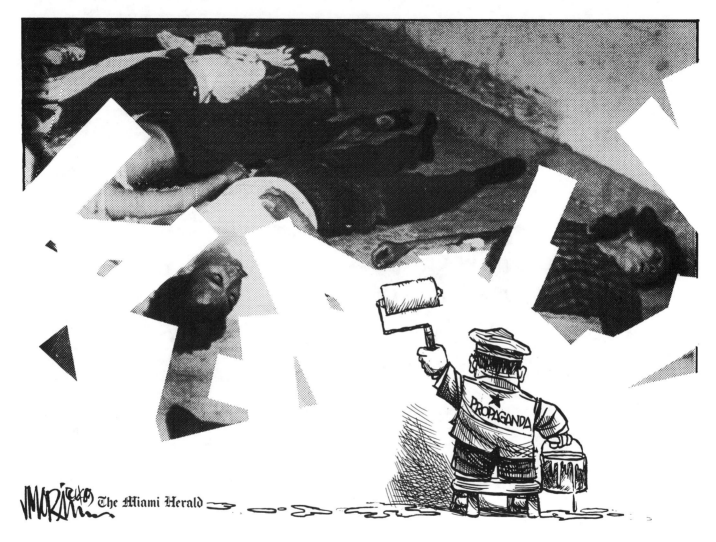

The Miami Herald

June 17, 1989

. . . and the cover-up.

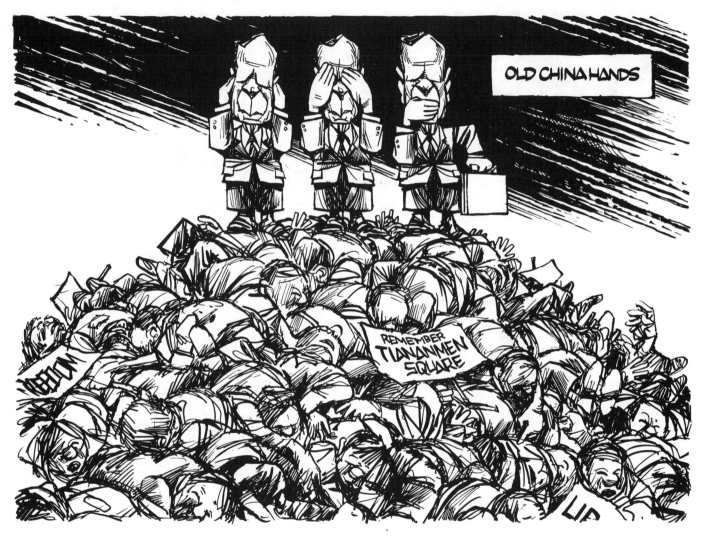

188

OLD CHINA HANDS

REMEMBER TIANANMEN SQUARE

December 12, 1989

The world condemns China's brutality. President Bush, former ambassador to China—mindful of substantial U.S. business interests—is strangely silent.

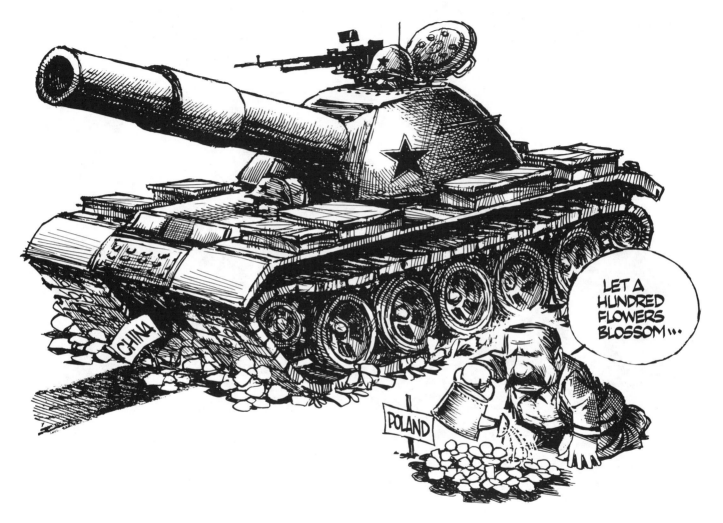

June 8, 1989

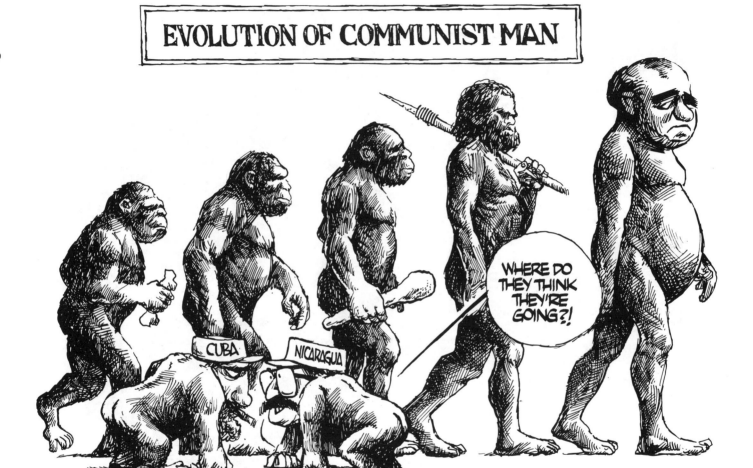

October 27, 1989

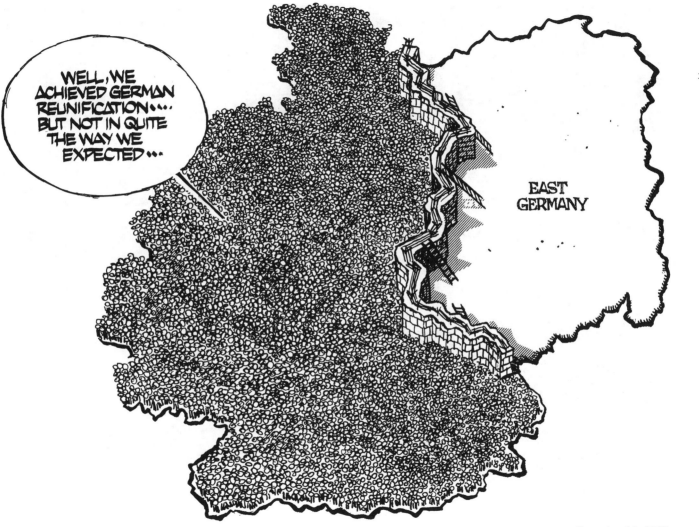

November 14, 1989

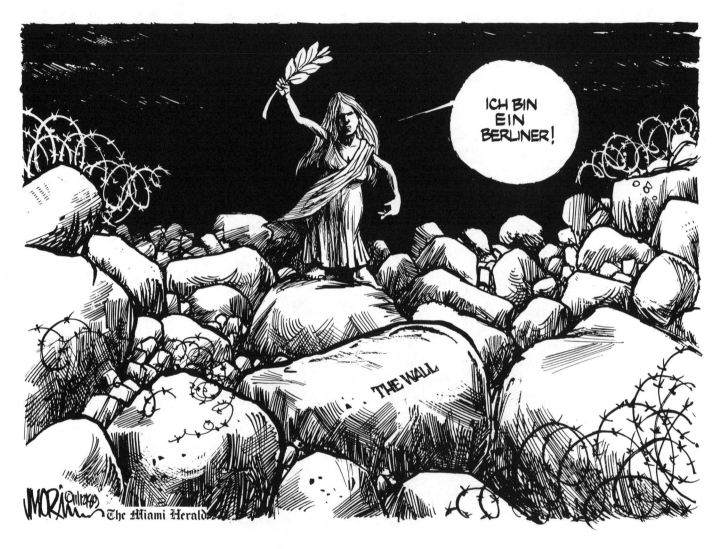

November 10, 1989

The Berlin Wall, towering symbol of division between Western democracies and Eastern communist dictatorships . . .

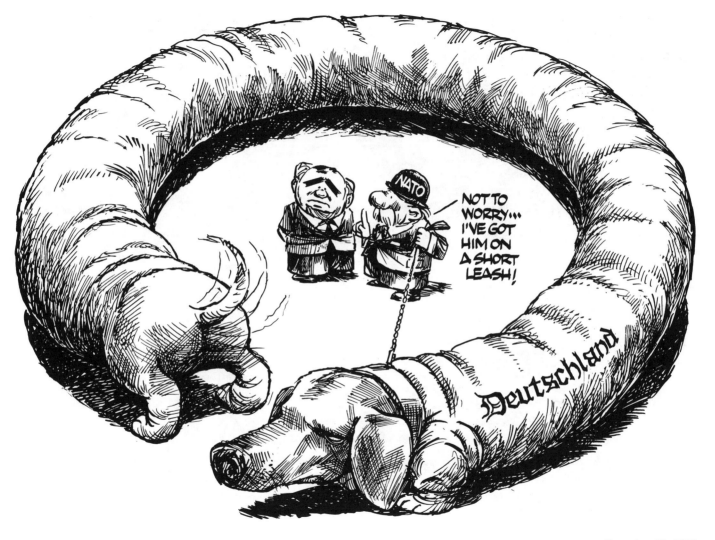

November 12, 1989

. . . comes tumbling down.

194

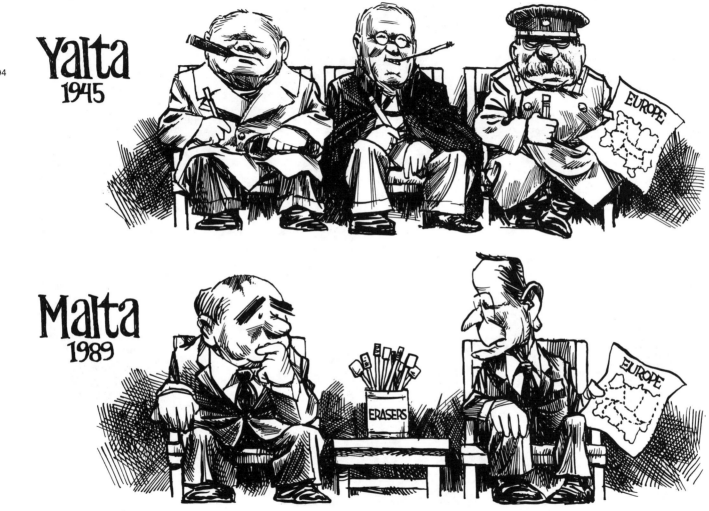

July 18, 1990

Gorbachev agrees, somewhat reluctantly, to allow a reunified Germany into the NATO alliance.

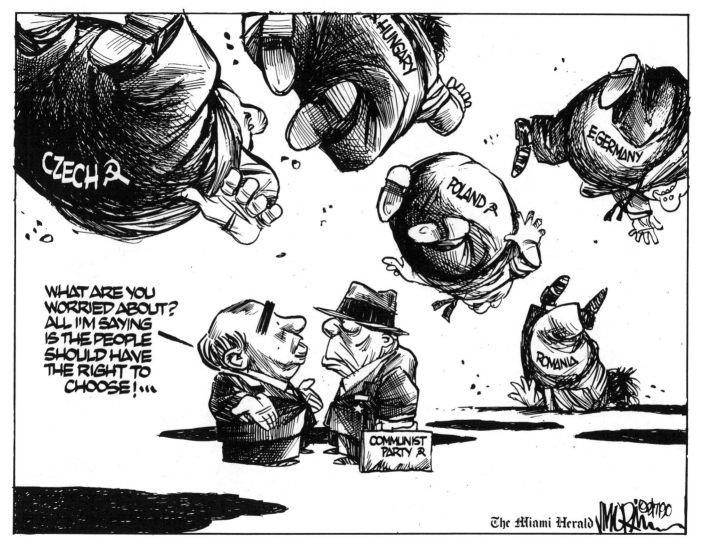

February 7, 1990

Voters throughout Eastern Europe throw the bums out.

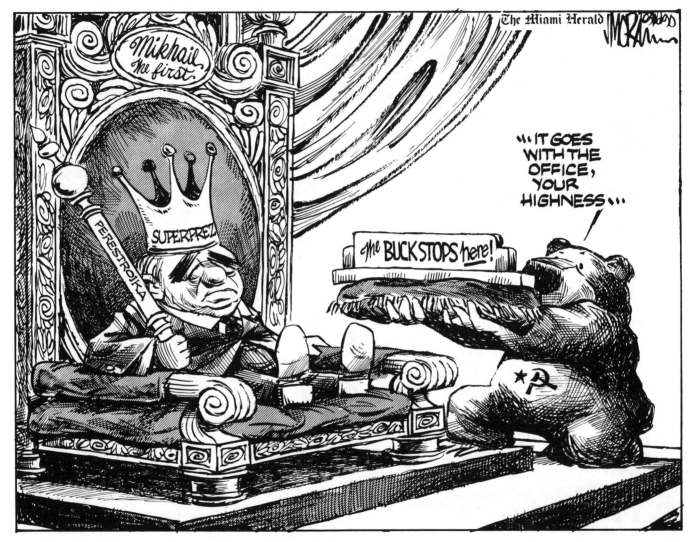

March 16, 1990

While Gorbachev gains more power, Soviet citizens voice their increasing anger over worsening economic conditions and ineffective reforms.

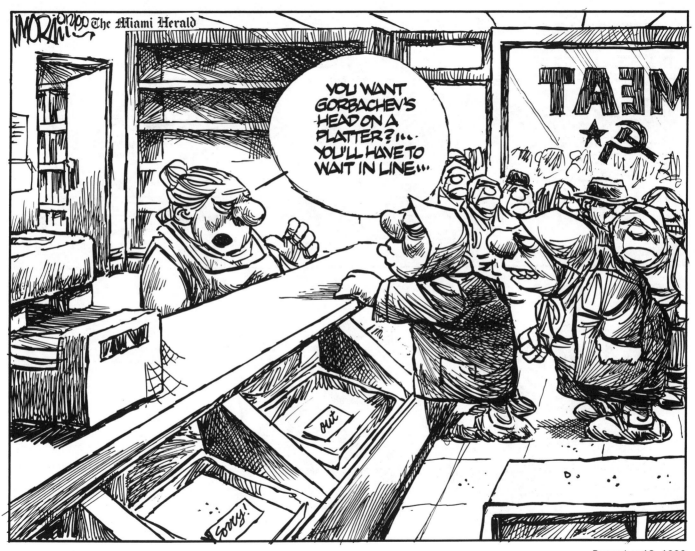

December 12, 1990

198

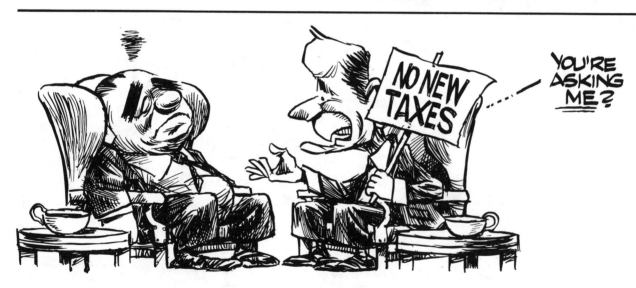

May 30, 1990

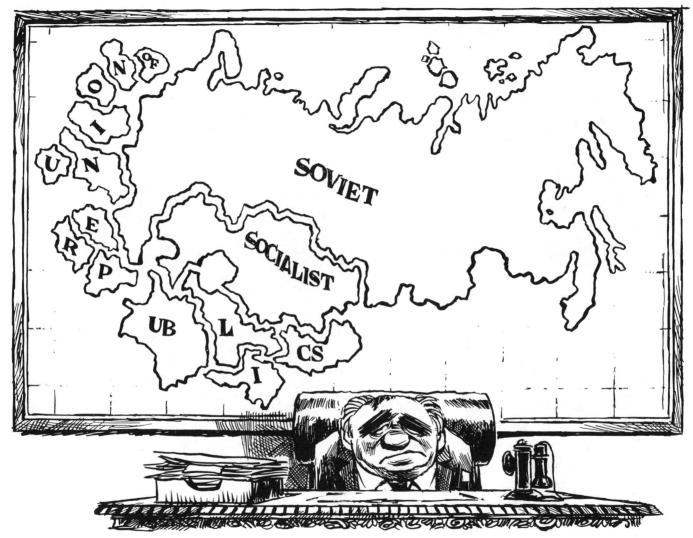

June 19, 1990

One after the other, Soviet republics call for independence.

WITH THE COLD WAR OVER, NATO BEGINS
A TRANSITION FROM A MILITARY TO A
TRADE-BASED ECONOMIC ALLIANCE...

200

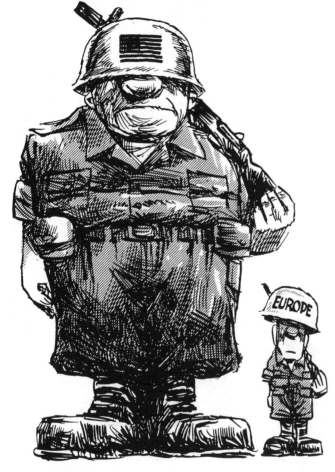

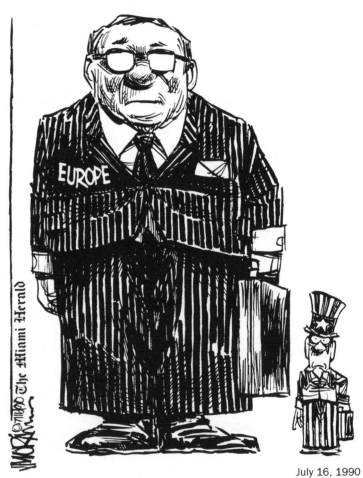

The post—cold war Europe.

July 16, 1990

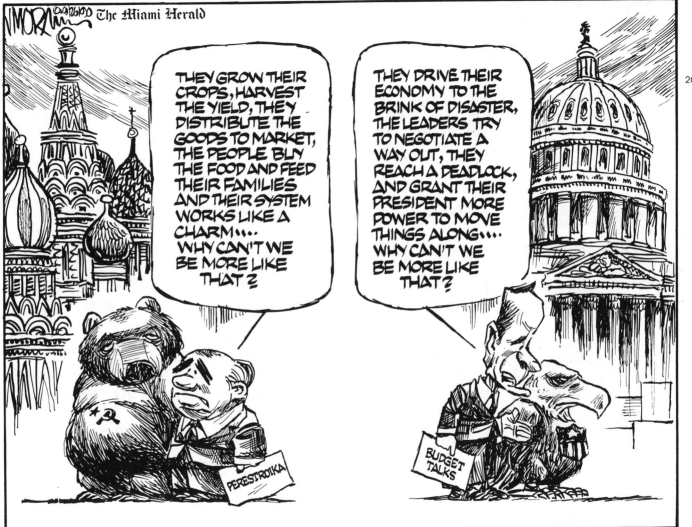
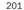

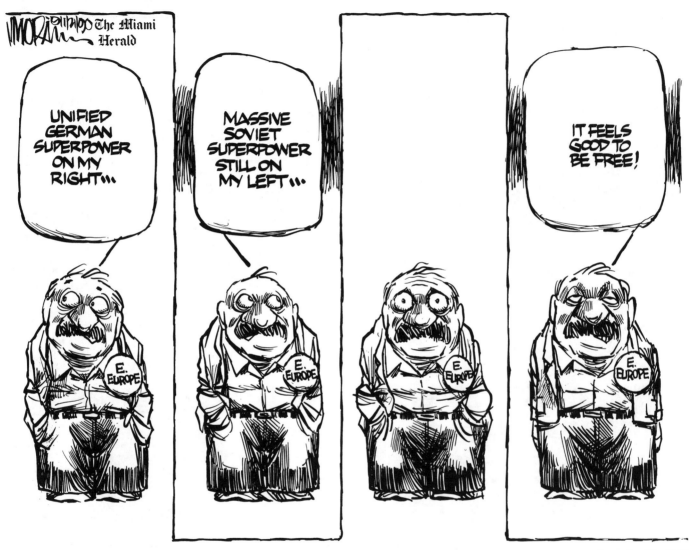

November 21, 1990

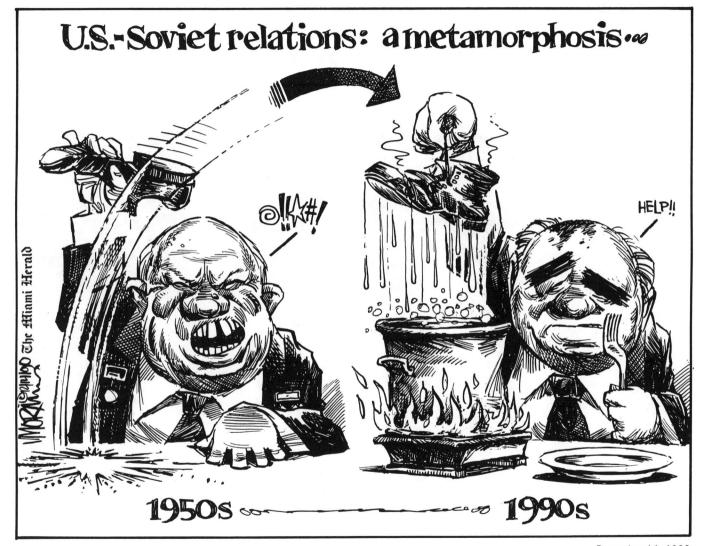

December 14, 1990

Winter brings the worst food shortages in the Soviet Union since World War II. The Soviets request emergency international aid.

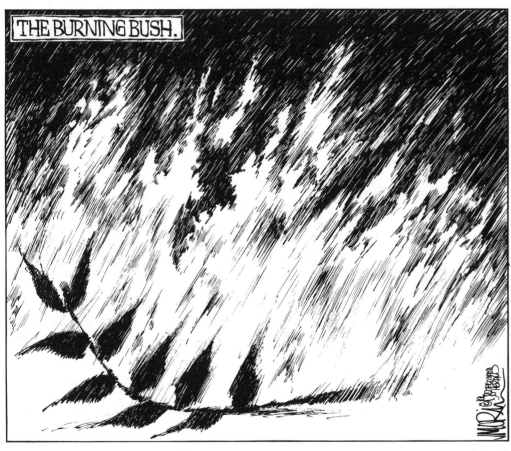

July 7, 1982

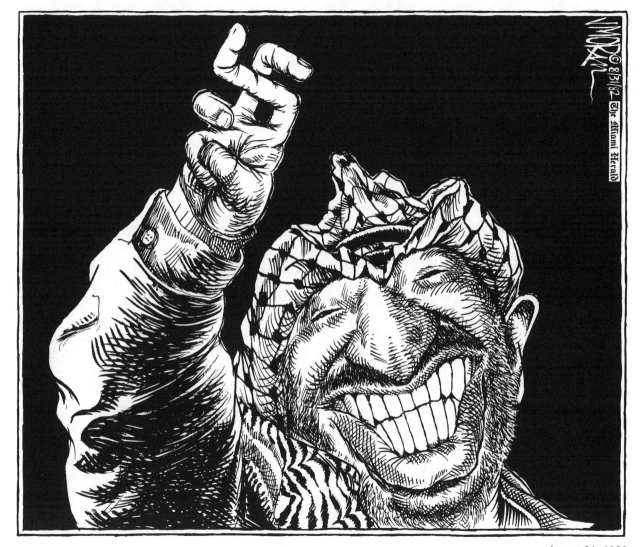

August 31, 1982

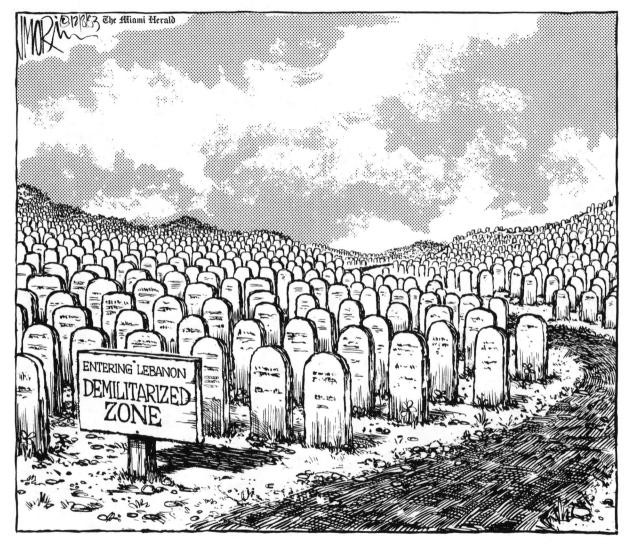

The Miami Herald

ENTERING LEBANON
DEMILITARIZED
ZONE

December 8, 1983

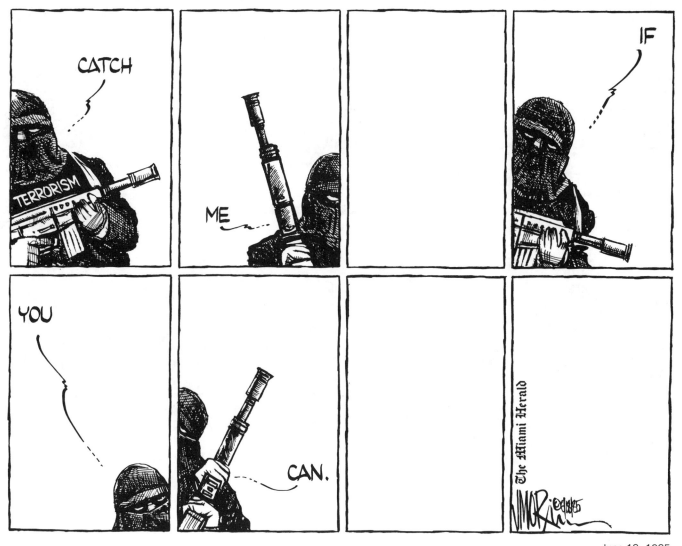

June 18, 1985

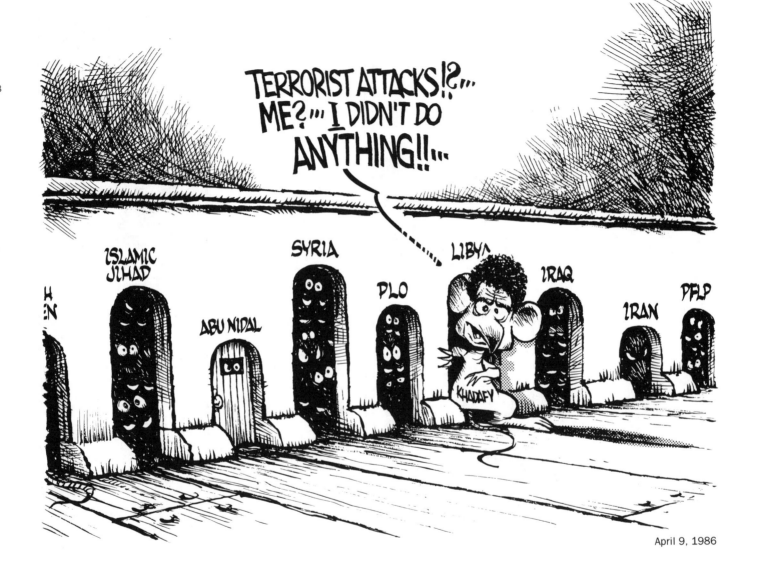

April 9, 1986

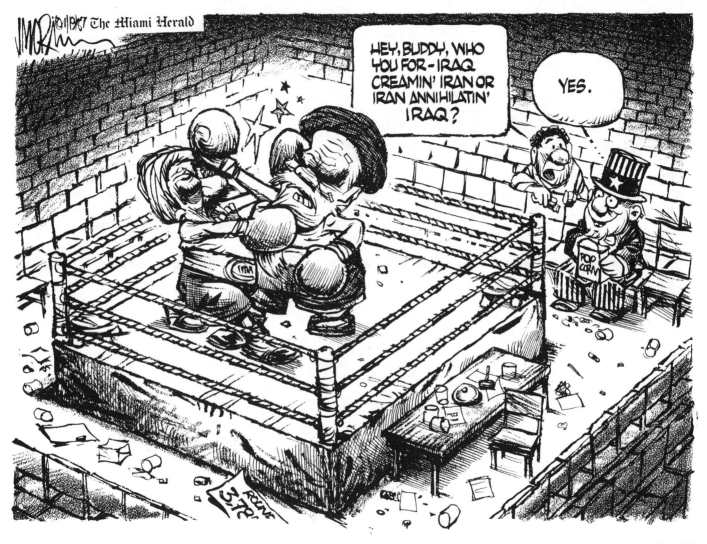

January 19, 1987

The Iran-Iraq war. The United States claims neutrality but supports Iraq with weapons and technology, a move we would soon come to regret.

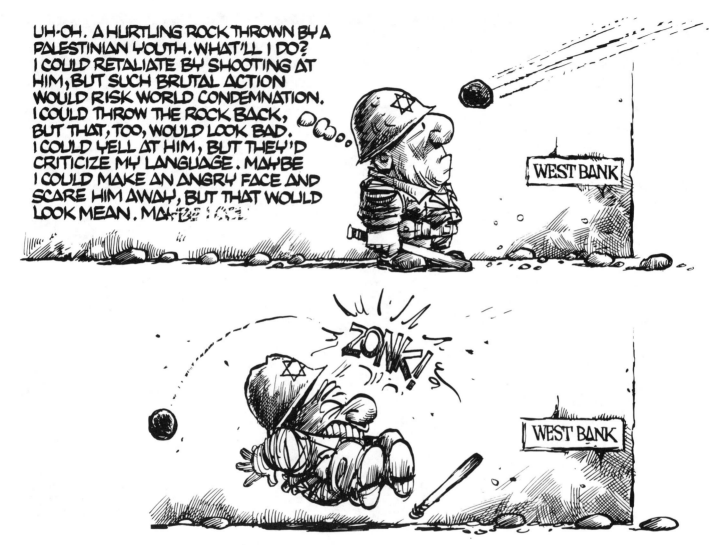

February 3, 1988

The Intifada erupts on the West Bank and Gaza Strip. As Palestinian youths toss rocks, the world watches for Israeli soldiers' reactions.

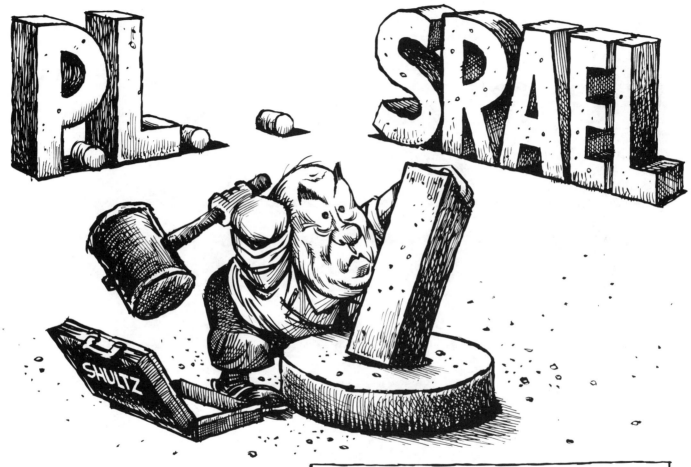

THE SQUARE PEG AND THE ROUND HOLE

March 2, 1988

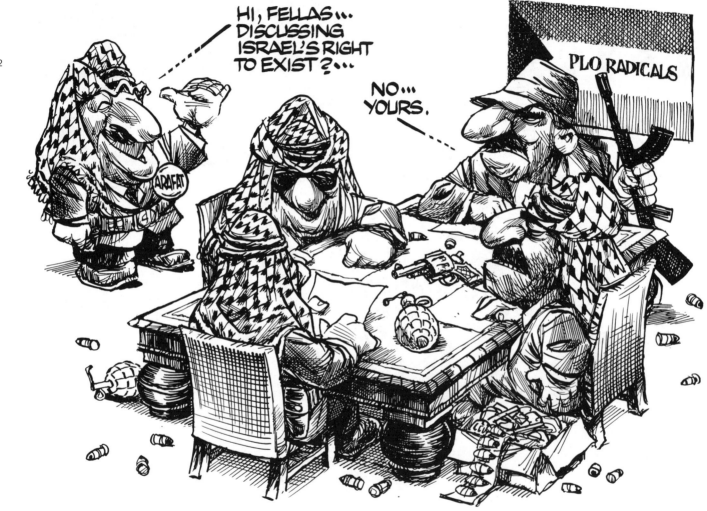

December 23, 1988

Yasir Arafat recognizes Israel's right to exist, but not everyone is happy.

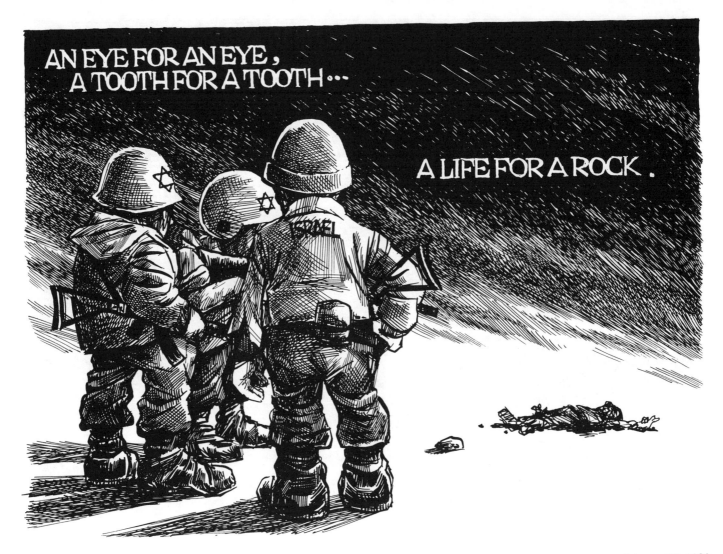

February 10, 1989

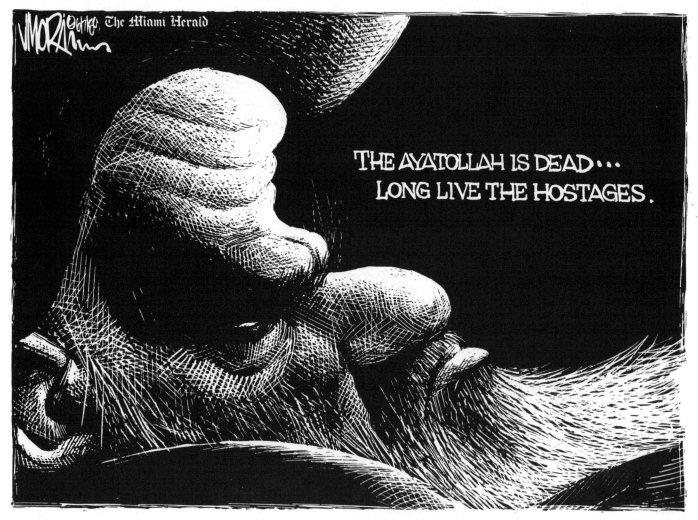

June 7, 1989

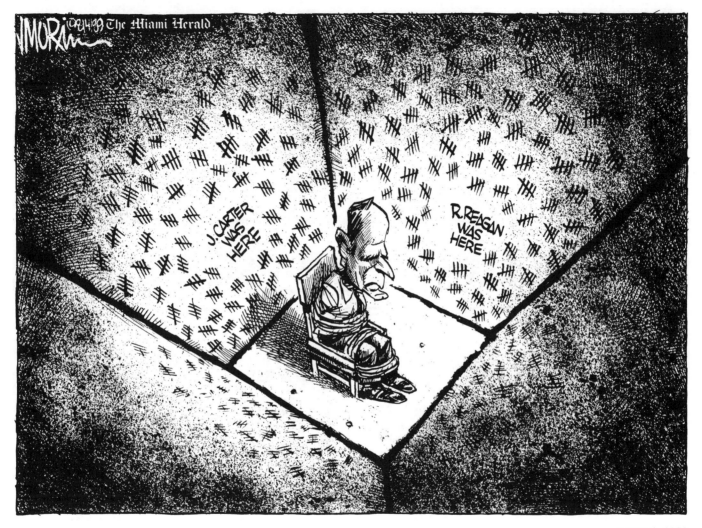

August 4, 1989

The Beirut hostage crisis and three U.S. presidents.

THE U.S.
DOLLAR...

THE BRITISH
POUND...

THE GERMAN
MARK...

THE SOVIET
RUBLE...

World Currencies

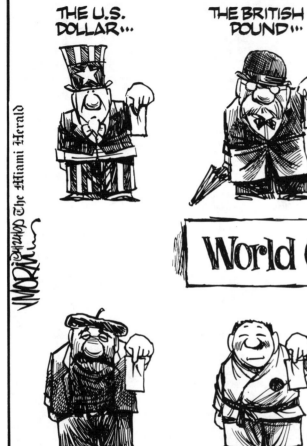

THE FRENCH
FRANC...

THE JAPANESE
YEN...

THE ITALIAN
LIRA...

THE IRANIAN
HOSTAGE

216

April 24, 1990

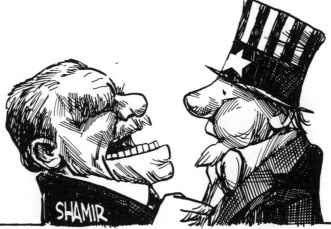

BUT WE CAN'T TALK TO ARAFAT! THAT WOULD BRING MORE WAR, MISERY, DEATH, AND DESTRUCTION!!

SHAMIR

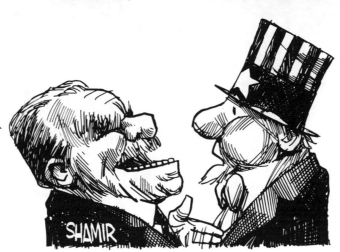

LET'S TALK ABOUT MORE U.S. MILITARY AID!

SHAMIR

January 4, 1990

218

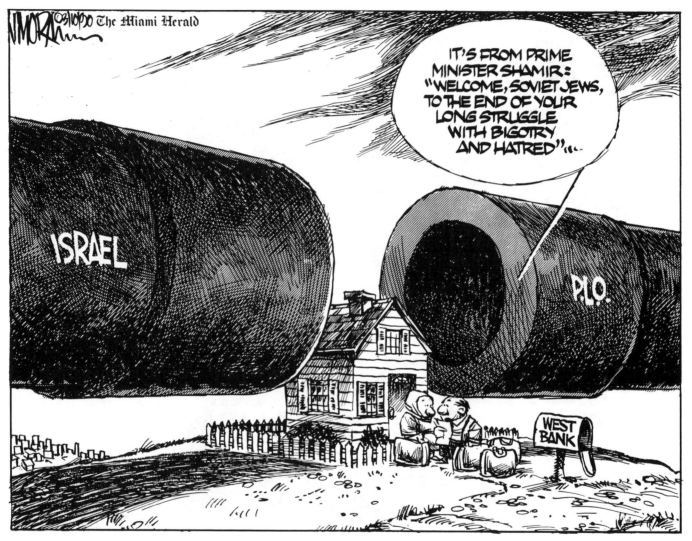

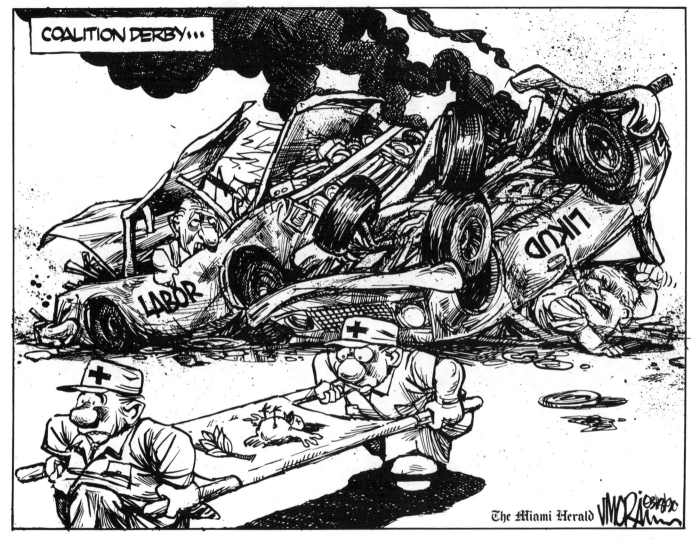

March 18, 1990

The Peres-Shamir coalition government: Israel at war with itself.

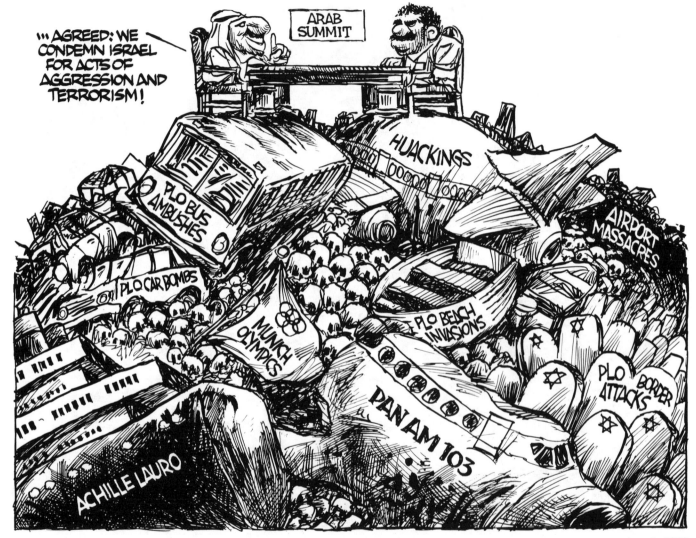

June 1, 1990

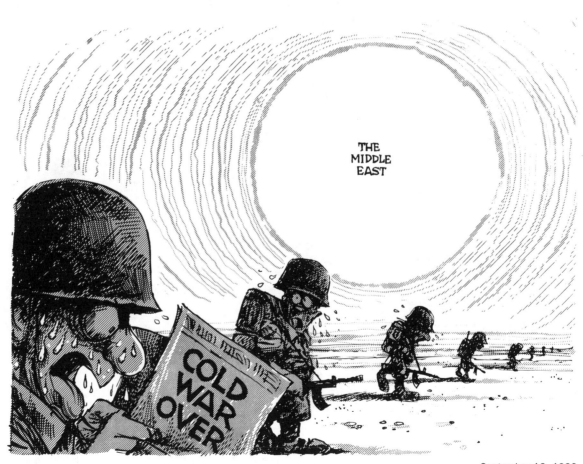

THE
MIDDLE
EAST

COLD
WAR
OVER

September 16, 1990

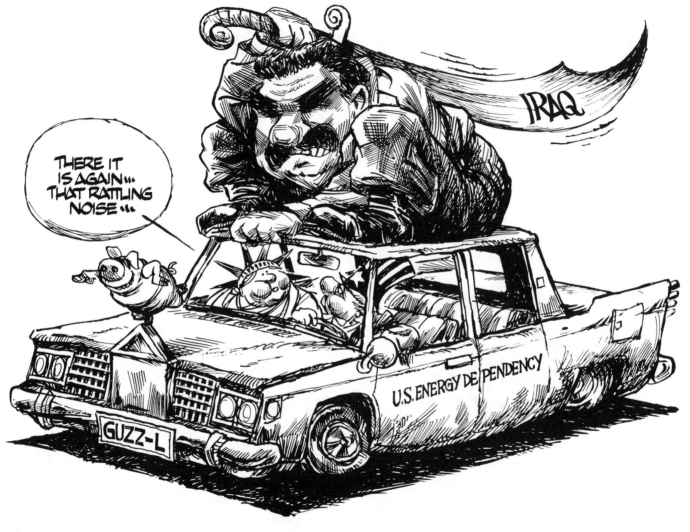

July 26, 1990

Iraqi dictator Saddam Hussein amasses 100,000 troops on Kuwait's northern border over an oil-pricing and land dispute . . .

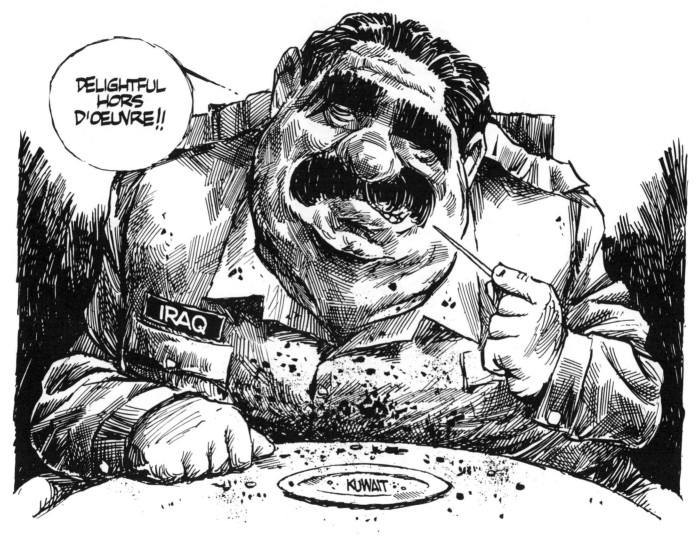

August 3, 1990

. . . and invades Kuwait.

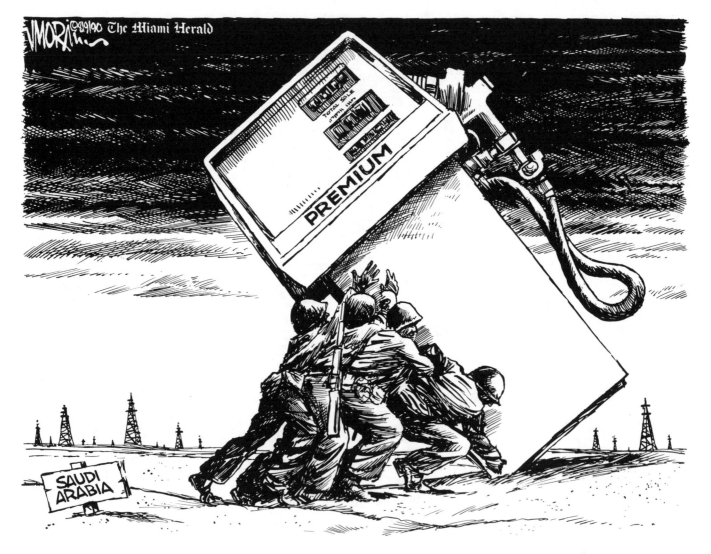

August 9, 1990

President Bush sends troops to Saudi Arabia.

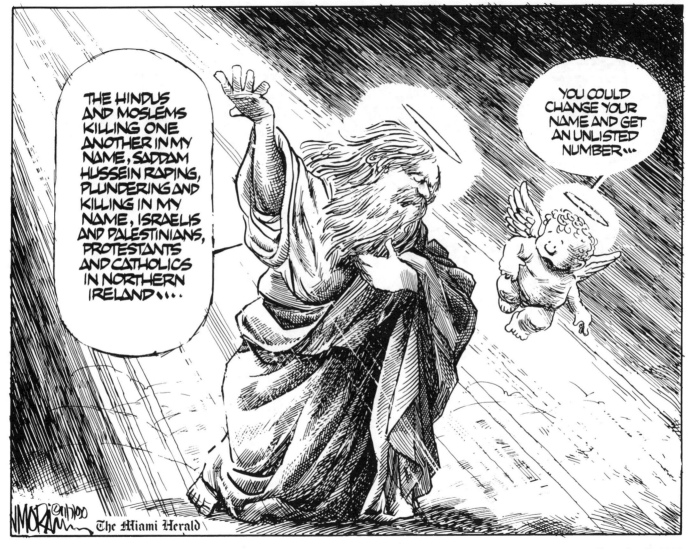

God—man's most popular pretext for waging war.

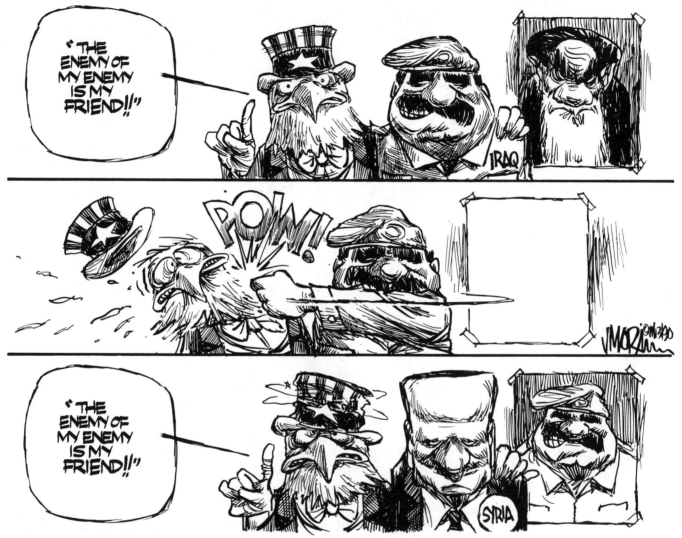

November 13, 1990

After backing Iraq in the Iran-Iraq war, the United States enlists Syria—another terrorist state—
in the allied coalition opposed to Iraq. Strange bedfellows, indeed.

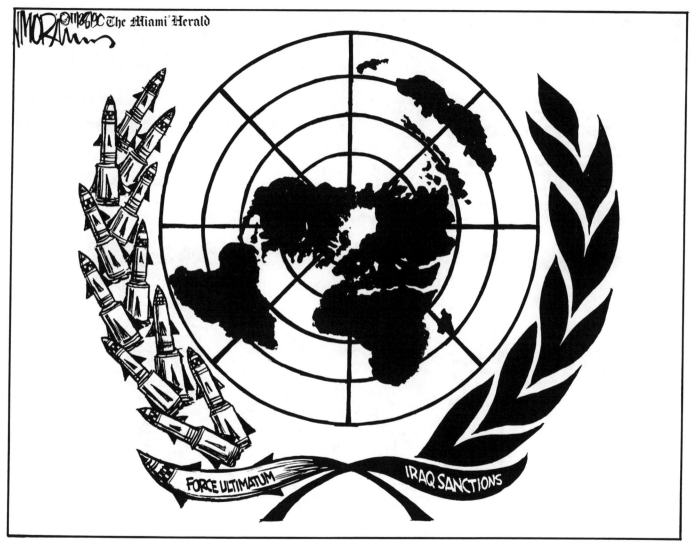

FORCE ULTIMATUM

IRAQ SANCTIONS

November 28, 1990

The United Nations gives Iraq until January 15 to withdraw from Kuwait . . . or else.

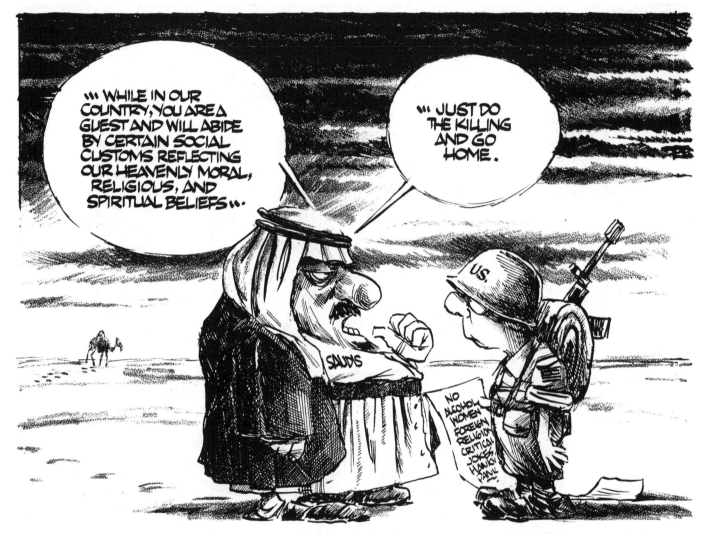

December 27, 1990

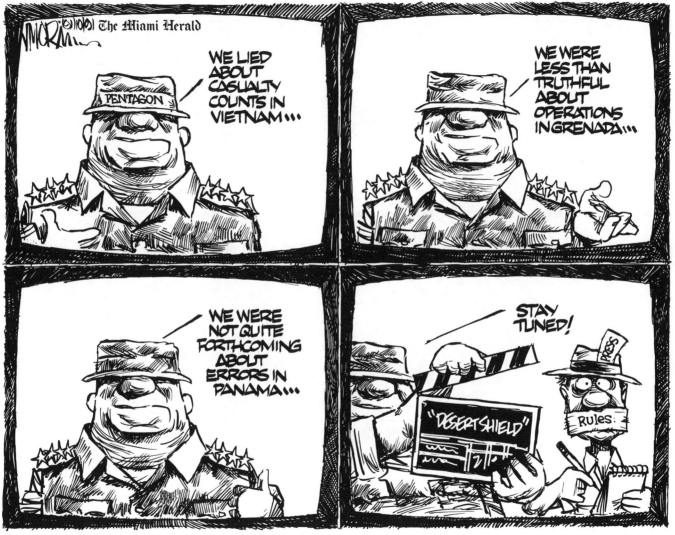

January 10, 1991

Unprecedented restrictions are imposed on the press coverage of a war fought in the name of freedom and democracy.

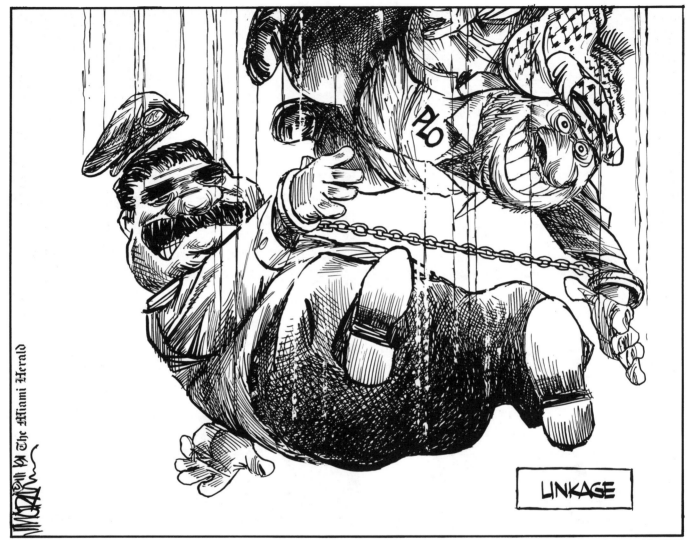

LINKAGE

January 14, 1991

The Palestinians support Saddam. Saddam links an Iraqi pullout from Kuwait to an Israeli withdrawal from the occupied territories.

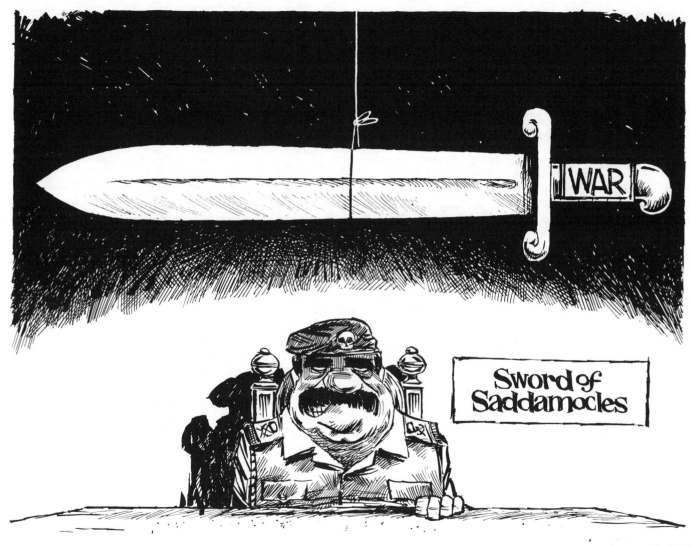

WAR

Sword of Saddamocles

January 16, 1991

The January 15 U.N. deadline passes . . .

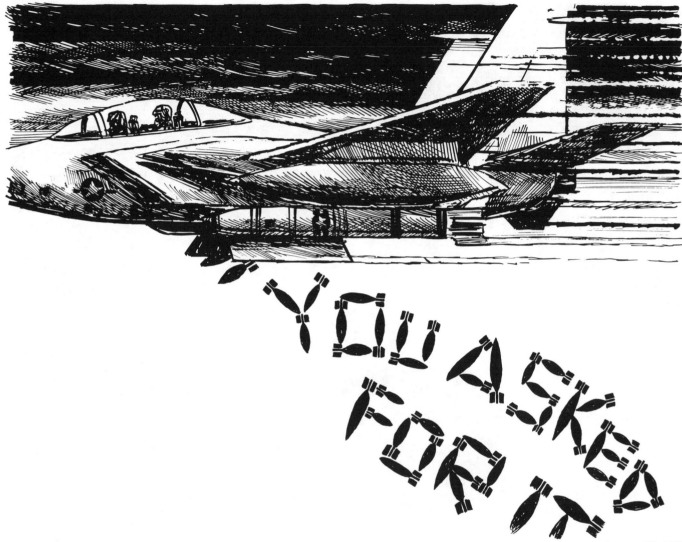

January 18, 1991

. . . **and Operation Desert Storm begins.**

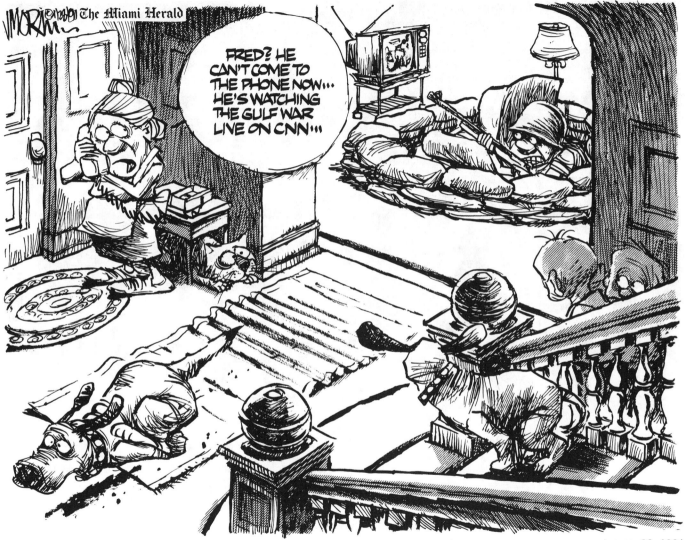

233

January 28, 1991

The nation is transfixed by the first war in history to be covered live, as it happens,
twenty-four hours a day, seven days a week.

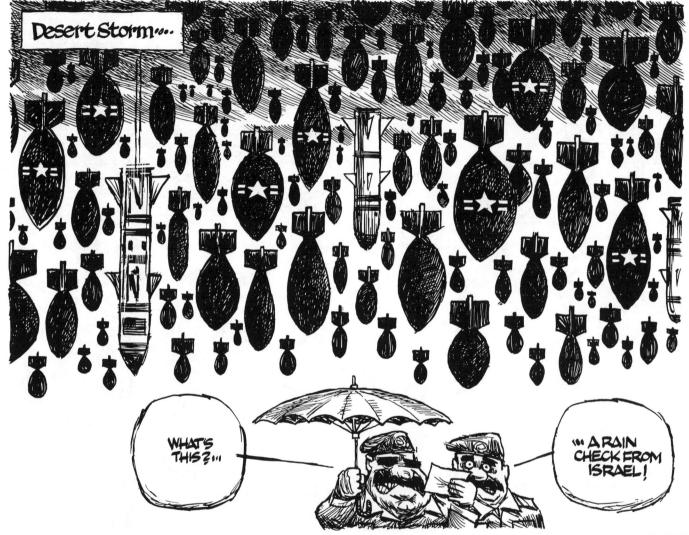

January 30, 1991

Iraq tries to draw Israel into the war by launching Scud missiles into Tel Aviv. Israel doesn't take the bait.

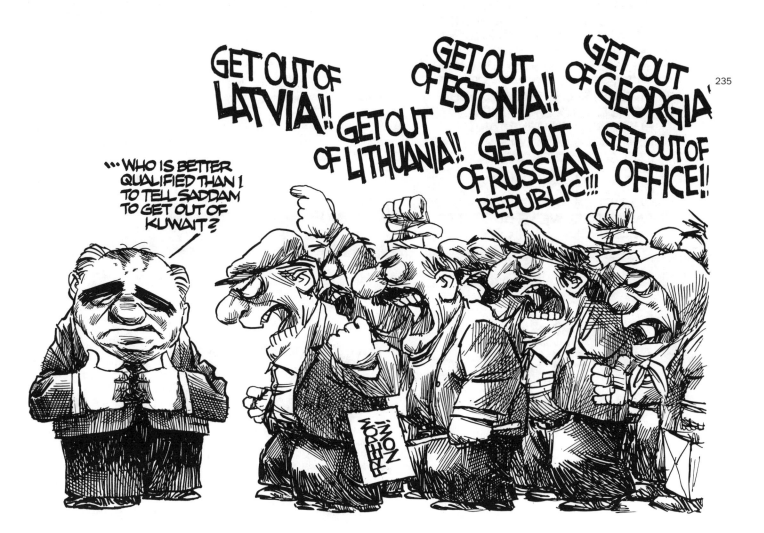

February 19, 1991

Mikhail Gorbachev vainly attempts to broker a last-minute peace.

236

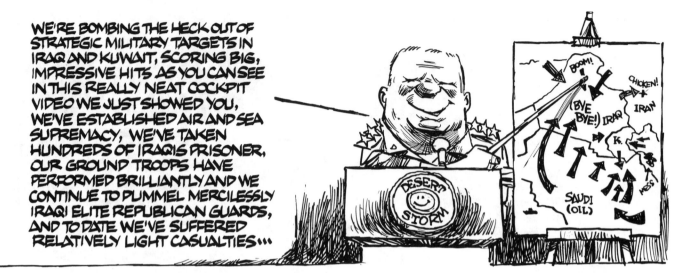

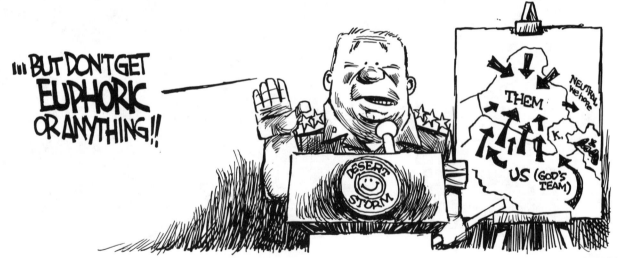

February 3, 1991

A combination of superior technology, air supremacy, tactical ingenuity, and superbly coordinated allied teamwork result in a devastating offensive . . .

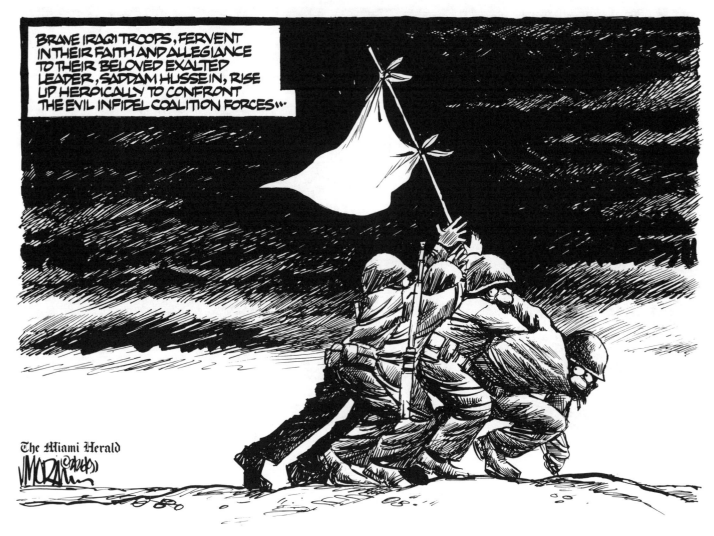

February 26, 1991

. . . and massive Iraqi troop surrenders.

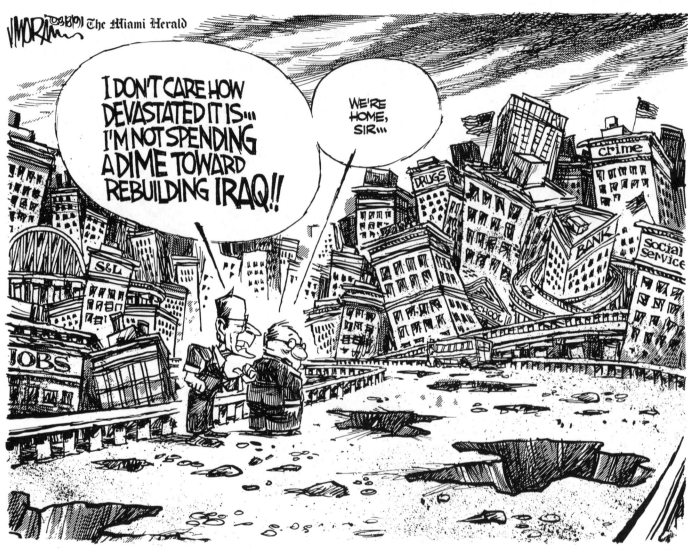

March 8, 1991

Coming home.

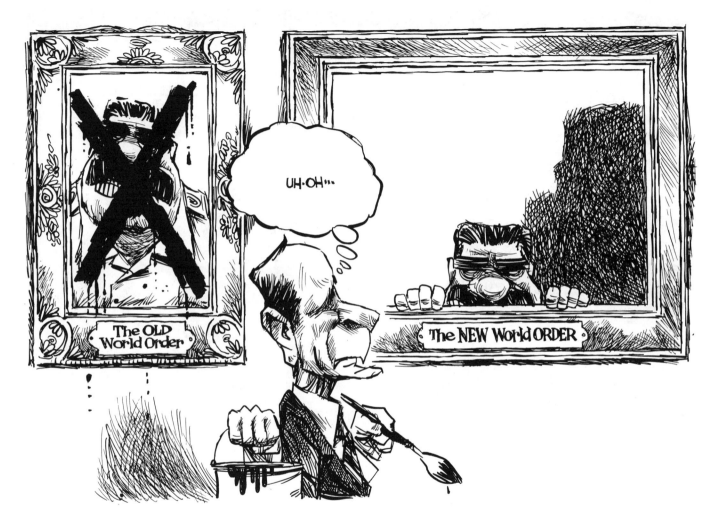

February 27, 1991

Saddam Hussein retains power . . . at least temporarily.

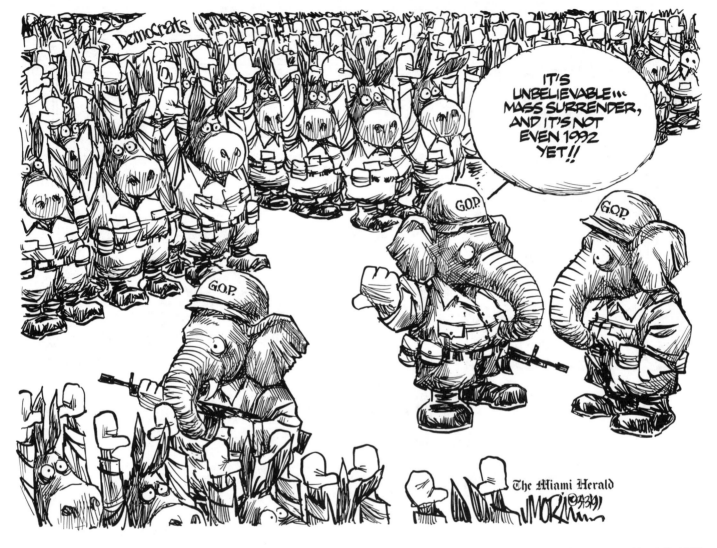

March 3, 1991

Meanwhile, the U.S. election primary season approaches.

WE GENEROUSLY SUPPLY IRAQ WITH WEAPONS AND TECHNOLOGY IN THEIR WAR WITH IRAN...

THEY USE THE WEAPONS AND TECHNOLOGY AGAINST US IN A WAR THAT WE WIN, DECIMATING THEIR MILITARY MACHINE...

SO WE CAN REBUILD A DEVASTATED IRAQ...

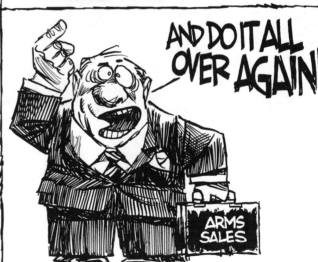

AND DO IT ALL OVER AGAIN!!

ARMS SALES

March 4, 1991

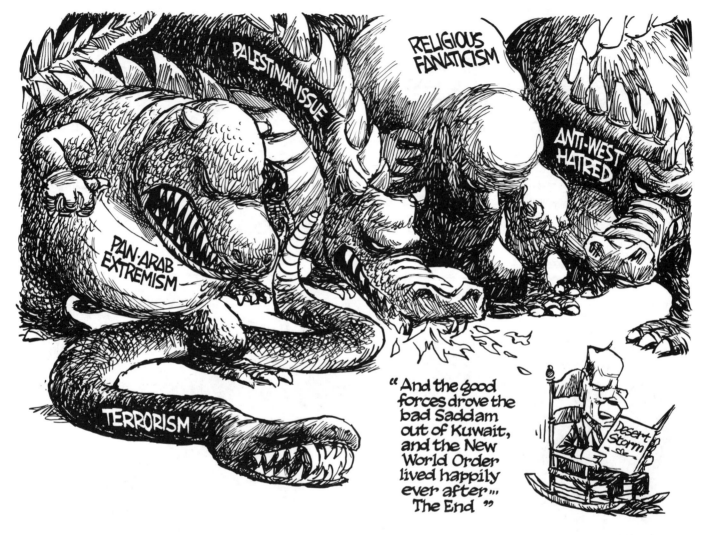

January 20, 1991

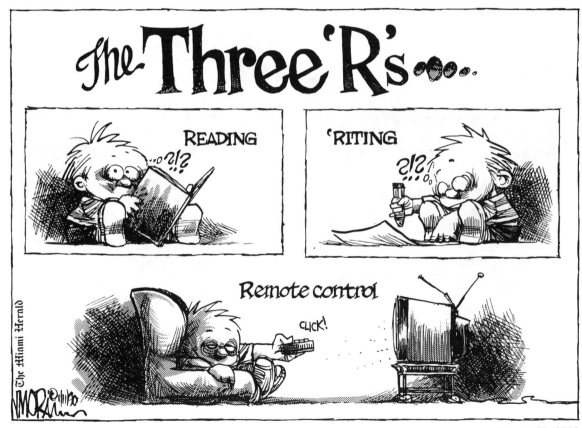

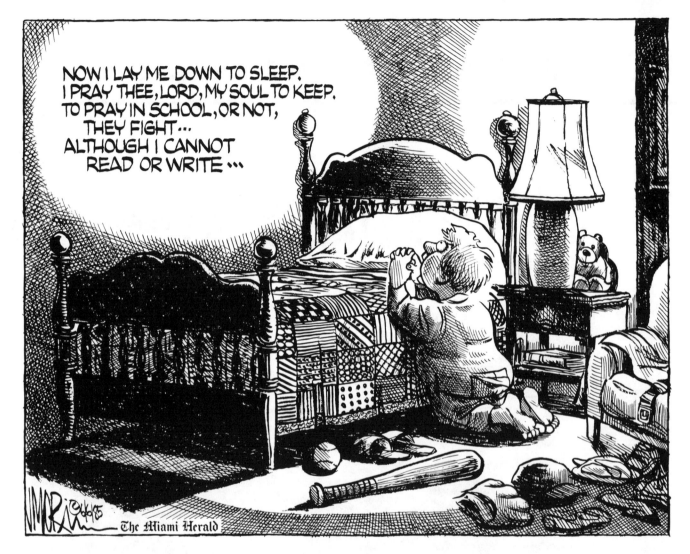

June 6, 1985

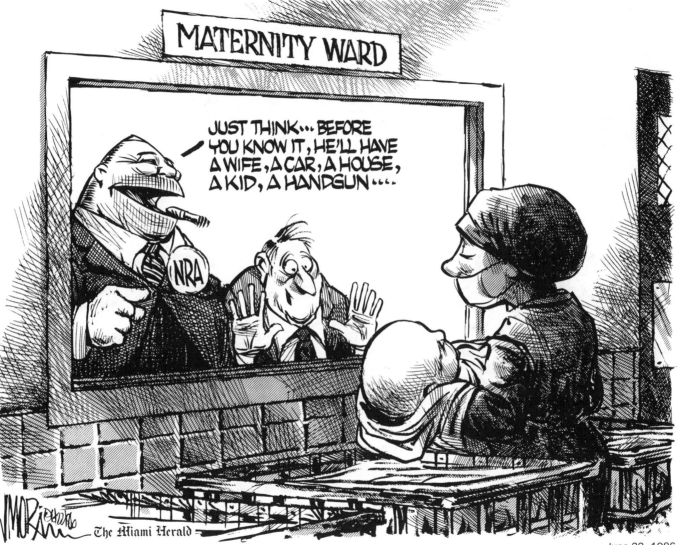

June 22, 1986

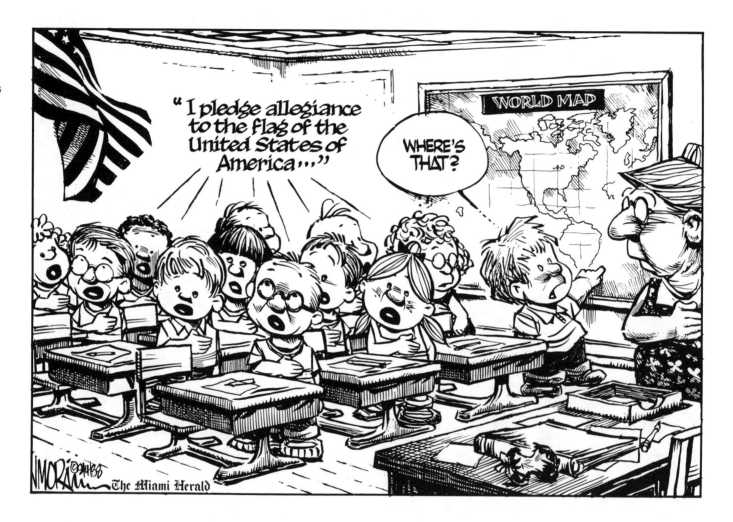

September 4, 1988

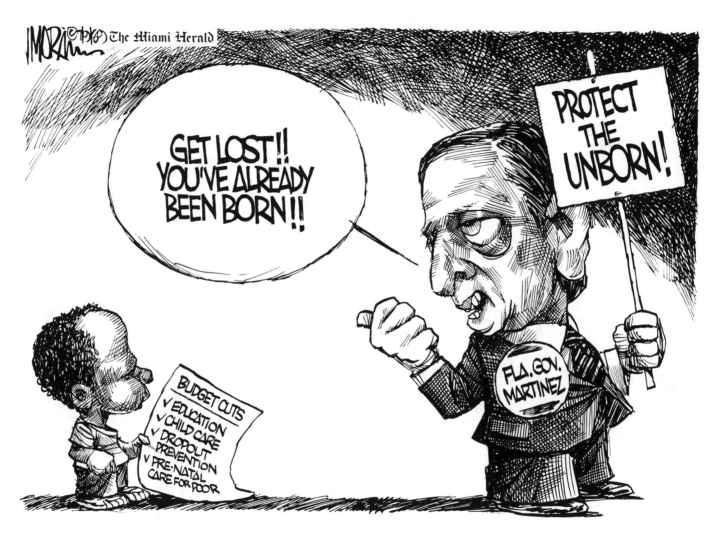

July 9, 1989

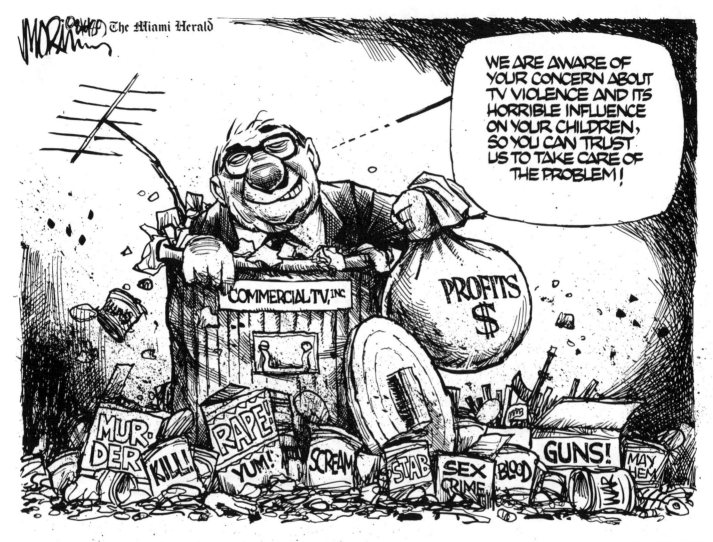

August 6, 1989

STAGES OF LIFE......

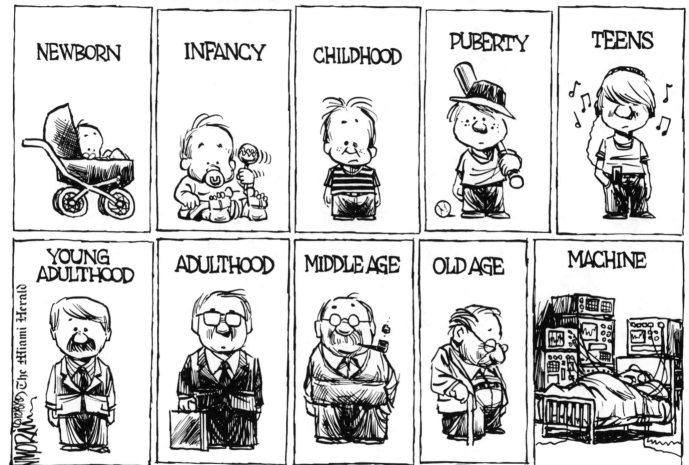

December 8, 1989

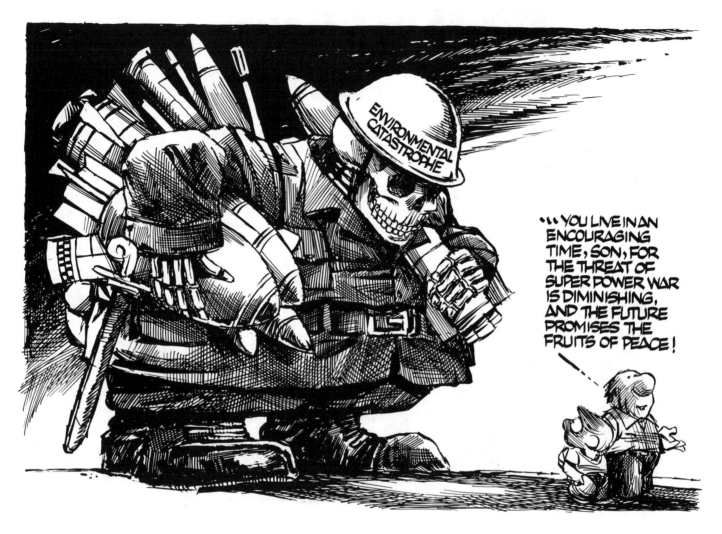

October 29, 1989